NEXT The New Generation in Graphic Design

NEXT The New Generation in

JESSE MARINOFF REYES

Graphic Design

NORTH LIGHT BOOKS
CINCINNATI, OHIO
www.howdesign.com

Dedication

To Ethel and Tony, and for Amy

Next: The New Generation in Graphic Design.
© 2000 by Jesse Marinoff Reyes.
Manufactured in China. All rights reserved.
No part of this book may be reproduced in
any form or by any electronic or mechanical
means including information storage and
retrieval systems without permission in writing
from the publisher, except by a reviewer, who
may quote brief passages in a review.
Published by North Light Books, an imprint of
F&W Publications, Inc., 1507 Dana Avenue,
Cincinnati, Ohio 45207. (800) 289-0963.
First edition.

Visit our Web site at www.howdesign.com for
more resources for graphic designers.

04 03 02 01 00 5 4 3 2 1

**Library of Congress Cataloging-in-
Publication Data**

Reyes, Jesse Marinoff, 1961–
 Next : the new generation in graphic
design / Jesse Marinoff Reyes.—1st ed.
 p. cm.
 Includes index.
 ISBN 0-89134-999-5 (alk. paper)
 1. Commercial art—Catalogs. 2. Graphic
arts—Catalogs. 3. Computer-aided design—
Catalogs. I. Title.
NC997 .R49 2000
741.6'074—dc21 00-029201

Edited by Donna Poehner, Lynn Haller and
Linda Hwang
Cover design by Jesse Marinoff Reyes
Interior design by Jesse Marinoff Reyes
Production coordinated by Emily Gross

The permissions on page 160 constitute an
extension of this copyright page.

Acknowledgments

No book project exists on the merits of a single individual alone, and certainly not an undertaking of this nature. Thanks go to Lynn Haller and Donna Poehner at North Light, for their patience, and in guiding me through the thickets of book creation despite my (unintentionally) blowing every schedule and trampling every deadline. And also to everyone working behind the scenes at North Light, in making this, my first book, a reality. Thanks to Art Chantry, who graciously assented to crafting the introduction, and whose advice, assistance, influence and recommendations have been invaluable.

Additionally, it would not have been possible to conceive this without the help and support of Luis de Jesus, Nathan Gluck, Richard Howell, Stephen Kroninger, Robert Newman, Pam Pollack and Christopher Sweet. A very special thanks to Grant Alden, and especially to Amy Bowman, who gave freely of their time and skills in the execution of this volume. I am forever in your debt. Finally, a heartfelt thanks to the artists and designers who provided their work, and were so generous in telling their stories on paper.

Table of Contents

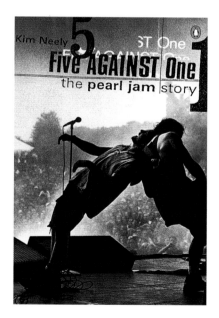

Introduction

Nowadays it seems everybody, and I mean EVERYBODY, is a graphic designer. I see people who were working on loading docks suddenly start earning six figures as Webmasters. All they had to do was purchase the latest, hot software program and PRESTO! They're functioning graphic designers. Back in the good ol' days, when you saw some kid walking down the street dressed in black, wearing sunglasses and a beret, chances were that he was a painter or poet. Now he is most likely a graphic designer. It's cool—even glamorous—to do graphics. It's sort of like being a rock star or something. I even hear stories of groupies. Times have sure changed.

The big problem is that most contemporary graphic design practiced today is not really graphic design, but graphic decoration. Design denotes function, history, planning, problem solving, communication and, dare I say, language. Decoration is just making things look nice. If you do your decorating carefully it will even look like design, but that doesn't mean it is design. Where's the sense of history and shared cultural experience in contemporary design? Where are the IDEAS? If you look in the design annuals you will see an incredible level of production sophistication, but you also see a dulling uniformity of high quality work. A ceiling has been reached; it all looks the same. Occasionally an individual piece will pop right off the page at you. It sticks out like a huge, sore thumb. That's because it contains a great idea, well-executed, and it is dramatically set apart from the rabble. This is where the future of graphic design will have to head, at least until they invent an IDEA button on your keyboard.

I blame the computer. It has changed graphic design forever. It is such a powerful design tool that virtually anyone can pick it up and pound out some basic level of visual imagery. It's an incredible hammer, made of solid gold. It looks fantastic and, boy, does it pound nails. Unfortunately, having a hammer—even a great hammer made of gold—doesn't make you an architect. Whenever powerful new technology is introduced into the popular dialogue of graphic design, there is an extended learning curve that the creative community must endure before that technology is assimilated. The more imposing the technology, the longer the learning curve. In the late 1960s, when inexpensive and easily accessible typesetting was introduced—largely through Compugraphic—typographic design and, consequently, graphic design took a nosedive in quality. For over a decade, we suffered through really terrible typography and design work until the new generation of self-styled graphic designers mastered the basics of the centuries-old art and craft of typesetting. Finally, the popular design culture integrated that powerful new technology into their design vocabulary and understood what it took to create great design—to become journeymen typographers. It took time. This very same process is currently happening with the advent of the computer. This marvelous new tool is such a monster that it may take years yet to wrestle it into submission.

I think that the young designers and illustrators represented in this book may well be the first of the new breed of communicators that truly integrate computer technology into traditional graphic design language. I'm sure many of these people began their interest in design emulating the surface work of pop culture design heroes like David Carson, Neville Brody or even Frank Kozik. Quickly, they became aware of the limitations of hero worship and began to look beyond their idols and discover their sources—the roots of all graphic design that lay in the popular culture interchange that is the primal history of graphic language. I see the people in this book as representative of an avant garde of future graphic design. They are beginning to master ideas developed beyond the box, language that incorporates the computer just as a tool, not THE tool. These people rely upon their hands as much as their screens. The idea is the product, and how they achieve that idea is only limited by their knowledge and resourcefulness. Most of these folks can do better work with a stick in the dirt than many current mainstream designers can execute with a staff of tech-heads.

To be honest, I've known many of the people in this book for years. In some cases, they are dear old friends or former co-workers, or former students of mine. As a result, my opinion is biased. However, many are people I only know through their work, which I see emerging from many of the same sub-cultural arenas in which I've practiced my own design—often for the same clientele. So, are these designers my progeny or my competition? It seems to me that they are my co-conspirators in an attempt to redefine the direction of graphic design. I dunno. You call it.

Whatsamatta with kids these days? Not much, really. They seem pretty darn savvy to me.

—Art Chantry

BOOK COVERS & JACKETS

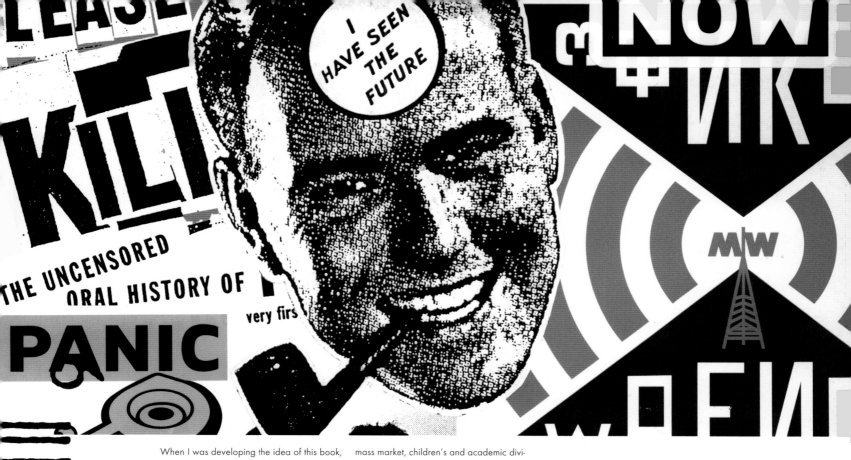

When I was developing the idea of this book, I was struck by the lack of documentation addressing the design of paperback book covers and hardcover book jackets. Aside from the design annuals, Graphis Books or the AIGA's 50 Books/50 Covers, very little space has been devoted to such a notable extension of package design—compared to, say, contemporary CD graphics or vintage record album covers. Not since Steven Heller and Anne Fink's 1993 *Covers and Jackets!* has a survey book regarded the single topic of contemporary book cover/jacket design. Many of the designers featured in that volume (Carol Devine Carson, Louise Fili, Carin Goldberg, Barbara de Wilde and Chip Kidd, to name a few) remain significant contributors to book packaging. In the seven years following, countless more have greatly affected design in the book publishing industry. I could very well have overflowed this book with their work alone.

Instead, this book presents one section of book cover/jacket design—the work of a new generation of talent, from established publishing conglomerates; small, independent presses and a few places in between.

In the 1990s the designers of Random House's Knopf imprint were responsible for earmarking book publishing as "the place to be" for innovative design, as evidenced by the work of some of the designers mentioned above and a few featured in this section, and are known for both the most cutting-edge and the most classic-looking book jackets. Despite its reputation in design circles, Knopf is by no means the only source for excellence. Over the better part of the last five years, I've been associated with the Viking Penguin Design Group: designers of the adult trade division of Viking hardcover and Penguin softcover books (art directed by Paul Buckley). Like many large publishing houses, Penguin, which includes several trade divisions, as well as mass market, children's and academic divisions, generates a vast amount of often mediocre material—to the degree that the output of a single design group tends to be lost in the overall impression made by the company. The work rendered by the Viking Penguin Design Group has been of a singular high design standard, and I unapologetically—and happily—feature work here by a selection of current and former members.

I've always viewed book covers as posters, writ small (as are baseball cards, writ even smaller). And like posters, the covers in this section draw the eye, lure the viewer and occasionally startle. In spite of the publishing meat grinder of product packaging conferences filled with carping editors, indifferent sales representatives and superstitious publishers, the designers shown here have contrived and persuaded—and gotten away with—work that lives up to comparison with the best of poster design. The following collection of covers and jackets, all by young men and women in their twenties and thirties, suggests a truly innovative idea, that the standard paint-by-number beliefs and comfort zones of the visually illiterate are not acceptable packaging for modern literature.

Cover *The Physics of Christmas*

Art director Michael Ian Kaye
Designer John Fulbrook III
Illustrator John Pirman/Art Department
Studio Little, Brown
Client Little, Brown
Typeface Eurostyle
Software QuarkXPress, Adobe Illustrator
Colors 6/C flat on foil stock with gloss lamination
Print run 33,000

Concept "The challenge was to develop a 'special-feeling' package with an effect comparable to a built-in working light. One of the chapters in the book describes the various parts of the 'Super Christmas Tree,' and it made me think immediately of a diagram. I thought John Pirman would have a cool take on it, and I was right. I designed the type to reflect the scientific, futuristic feel of his illustration, and decided it would pop off the shelves if it was printed on foil. It is rare that a Christmas book can be groovy—I had fun working on it."

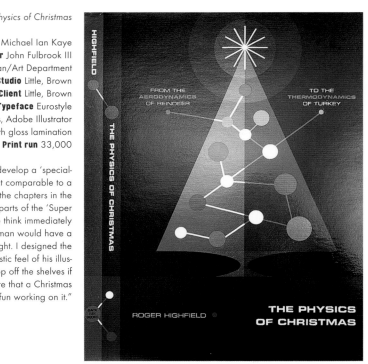

Cover *1717 Jerome*

Art director Jamie Keenan
Designer Jamie Keenan
Photographer Rick Bairam/ Wonderland Studios
Studio Random House UK
Client Jonathan Cape/Random House UK
Typeface Trade Gothic
Software QuarkXPress
Colors 4/C process
Print run 2,500

Concept "Set against the backdrop of the Los Angeles riots, *1717 Jerome*—an address in the Hollywood Hills—is the story of a couple that, on the surface, epitomizes the suburban American Dream, and what happens when the cracks begin to appear. After hunting around for the most American-looking man and woman in Random House's London office, we set off for a local High Street photographer—the sort of place you go when you've passed your exams or want to celebrate your fiftieth wedding anniversary—and told him that the young couple were very much in love (I'd only introduced them to each other ten minutes earlier), and that as their best friend, I was treating them to a beautiful photograph to mark the occasion (I felt that if I admitted it was for a book cover the photographer might try too hard, and it was important we got that authentic feel). One of the photographs was then scanned in, and by using lots of small picture boxes and selecting a slightly different part of the big picture each time—with slight rotations and changes of scale—it

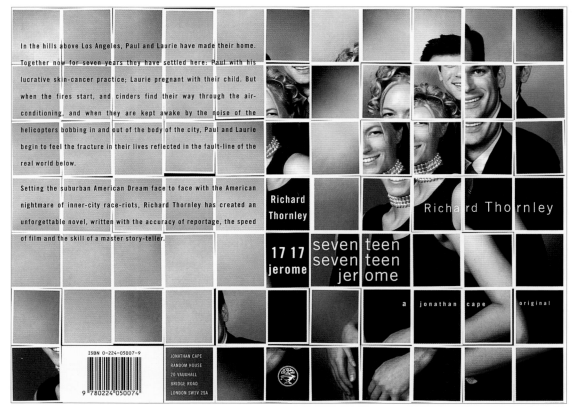

was possible to imply that everything was not quite so perfect for the happy couple. The typography echoes the angles and gaps of the main image, and is kept deliberately understated to appear slightly cold. The obvious Hockney reference was also helpful as a clue to the setting of the book." The photographer charged £80 (about $130), and took less than an hour from start to finish.

Jacket *Herrings Go About the Sea in Shawls*

Art director Paul Buckley
Designer Paul Buckley
Illustrator Dr. Seuss (Theodore Geisel)
Studio The Viking Penguin Design Group
Client Viking
Typefaces Benguiat, Newlock Condensed, Trade Gothic
Software QuarkXPress, Adobe Illustrator
Colors 4/C flat transparent ink on acetate
Print run 10,000

Concept Since this edition would be marketed to adults, Viking wanted a jacket that would have all the charm that attracted kids to Seuss, but would also work for an older crowd. Buckley comments, "Since we paid next to nothing to acquire rights to republish the book, we were able to spend some money on bells and whistles for the jacket—an acetate cover with transparent ink. The thinking was that if this book worked, we would similarly publish a number of Dr. Seuss classics and make lots of money. It failed miserably."

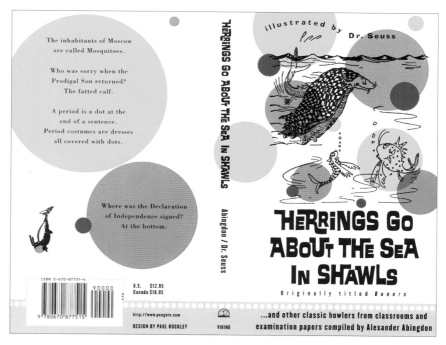

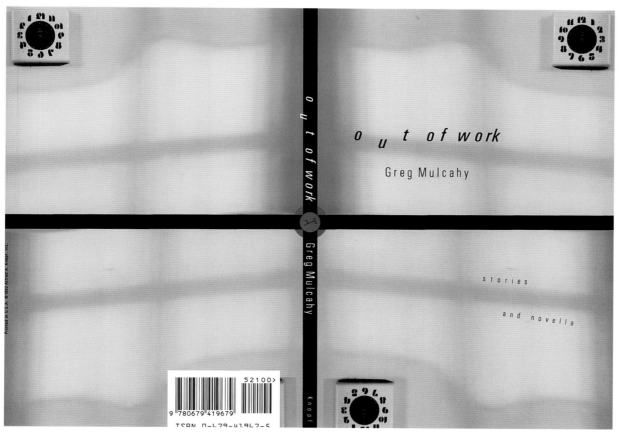

Jacket *Out of Work*

Art director Carol Devine Carson
Designer Archie Ferguson
Photographer Anne Turyn
Studio Alfred A. Knopf, Inc.
Client Alfred A. Knopf, Inc.
Typeface Univers
Software QuarkXPress, Adobe Photoshop
Colors 4/C process
Print run 2,000

Concept Ferguson's goal was "to express the apathy of terminal unemployment. This was a book that no one was paying any attention to, so I seized the opportunity to have some fun while no one was looking."

Cover *The Hundred Brothers*

Art director John Gall
Designer John Gall
Studio Vintage Books
Client Random House
Typefaces Clarendon, Dead History, Trade Gothic
Software QuarkXPress, Adobe Photoshop
Colors 4/C plus 1/C flat metallic
Print run 10,000

Concept Says Gall, "*The Hundred Brothers* is a wonderfully surreal novel about kinship, sibling rivalry, indoor football and ritual sacrifice. The cover is an ode to the eldest brother, ninety-three-year-old authoritarian Hiram, and his massive, black, wing-tipped right shoe that momentarily becomes the object of affection for Doug, one of the other ninety-nine brothers. Although the design contains Dada and Pythonesque references, there is nothing like putting a really big shoe on a cover."

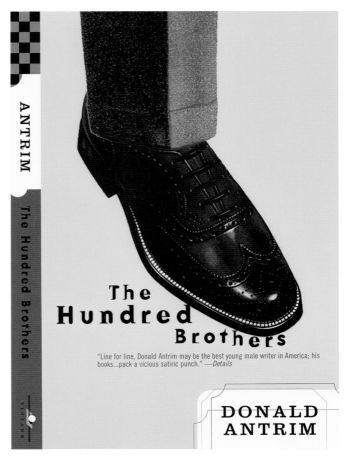

Jacket *Looking for Mo*

Art director Susan Mitchell
Designer Rodrigo Corral
Photograph The New York Public Library Picture Collection
Studio Farrar, Straus and Giroux
Client Farrar, Straus and Giroux
Typeface Keedy Sans
Software QuarkXPress
Colors 4/C plus 2/C flat
Print run 10,000

Concept Corral explains that the author's characters are rock-climbing enthusiasts and "Deadheads" (fans of the psychedelic band The Grateful Dead). "I juxtaposed the repeated images of the rock climber, along with the radical arrangement of the type forms, in an attempt at reflecting the hallucinogenic nature of the story. Although the title type is fragmented, broken apart and dressed up, it remains remarkably easy to read."

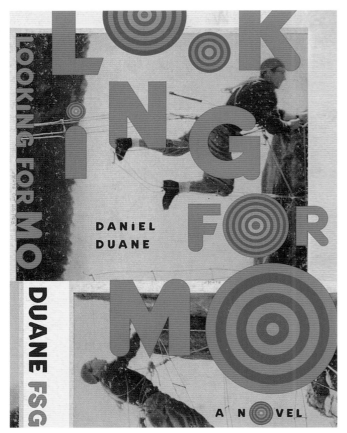

BlueBossa

a novel

BART SCHNEIDER

BLUEBOSSA

BART SCHNEIDER

VIKING

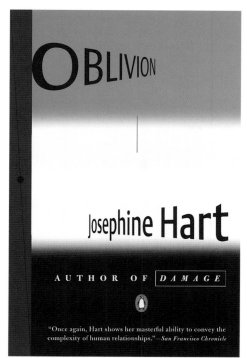

Jacket *Oblivion*

Art director Paul Buckley
Designer Martin Ogolter
Studio The Viking Penguin Design Group
Client Penguin
Typefaces DTL ARG, Bulmer
Software QuarkXPress, Adobe Photoshop
Colors 4/C flat
Print run 6,000

Concept The main character in the story is plagued by guilt, suffering through a relationship that he feels betrays the memory of his dead wife. Moments in time from both the past and present dominate the novel. Ogolter attempted to represent those differences between past and present, darkness and light, happiness and sadness. He also "tried to approximate the simple, uncluttered directness of the author's writing style."

Jacket *Blue Bossa*

Art director Paul Buckley
Designer Martin Ogolter
Photographer William Claxton
Studio The Viking Penguin Design Group
Client Viking
Typefaces House Gothic, Lightline Gothic
Software QuarkXPress, Adobe Photoshop
Colors 3/C flat
Print run 7,500

Concept This is a novel written in scattered fashion befitting a stereotypical jazz character of the 1950s. Ogolter wanted to convey a simple visual style that would pay homage to 1950s album covers, and also use "contemporary" 1970s typefaces to capture the timeline of the story.

Cover *Hunger*

Art director Susan Mitchell
Designer Rodrigo Corral
Illustrator Donna Mehalko
Studio Farrar, Straus and Giroux
Client The Noonday Press
Typeface Franklin Gothic
Software QuarkXPress
Colors 2/C flat
Print run 5,000

Concept As he struggled on the brink of starvation, the author submitted this book as an incomplete, last-ditch attempt to earn a dime and get himself a bite to eat. "The random beauty of the cover illustration against the backdrop of an unfriendly matte gold represents unpleasant circumstances and uncertain times."

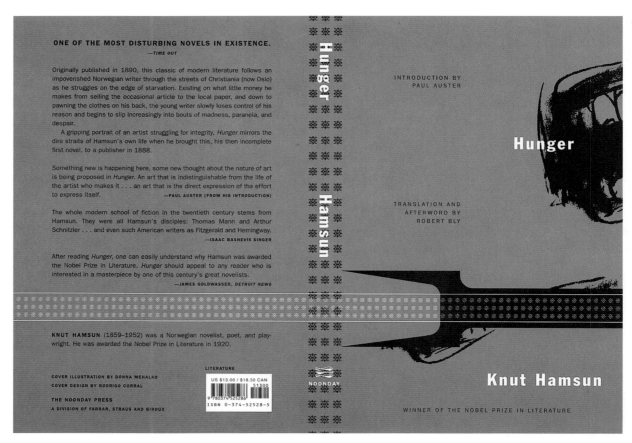

ONE OF THE MOST DISTURBING NOVELS IN EXISTENCE.
—*TIME OUT*

Originally published in 1890, this classic of modern literature follows an impoverished Norwegian writer through the streets of Christiania (now Oslo) as he struggles on the edge of starvation. Existing on what little money he makes from selling the occasional article to the local paper, and down to pawning the clothes on his back, the young writer slowly loses control of his reason and begins to slip increasingly into bouts of madness, paranoia, and despair.

A gripping portrait of an artist struggling for integrity, *Hunger* mirrors the dire straits of Hamsun's own life when he brought this, his then incomplete first novel, to a publisher in 1888.

Something new is happening here, some new thought about the nature of art is being proposed in *Hunger*. An art that is indistinguishable from the life of the artist who makes it . . . an art that is the direct expression of the effort to express itself. —**PAUL AUSTER (FROM HIS INTRODUCTION)**

The whole modern school of fiction in the twentieth century stems from Hamsun. They were all Hamsun's disciples: Thomas Mann and Arthur Schnitzler . . . and even such American writers as Fitzgerald and Hemingway. —**ISAAC BASHEVIS SINGER**

After reading *Hunger*, one can easily understand why Hamsun was awarded the Nobel Prize in Literature. *Hunger* should appeal to any reader who is interested in a masterpiece by one of this century's great novelists. —**JAMES GOLDWASSER,** *DETROIT NEWS*

KNUT HAMSUN (1859–1952) was a Norwegian novelist, poet, and playwright. He was awarded the Nobel Prize in Literature in 1920.

LITERATURE

COVER ILLUSTRATION BY DONNA MEHALKO
COVER DESIGN BY RODRIGO CORRAL

THE NOONDAY PRESS
A DIVISION OF FARRAR, STRAUS AND GIROUX

US $13.00 / $18.50 CAN
51300
ISBN 0-374-52528-5
9 780374 525286

Hunger
Hamsun

INTRODUCTION BY
PAUL AUSTER

Hunger

TRANSLATION AND
AFTERWORD BY
ROBERT BLY

NOONDAY

Knut Hamsun

WINNER OF THE NOBEL PRIZE IN LITERATURE.

Case cover Steven Cerio's ABC Book: A Drug Primer

Art director Katherine Gates
Designers Steven Cerio and Andrea Dezso
Illustrator Steven Cerio
Studio Steven Cerio/Happy Homeland Studio, Andrea Dezso Design
Client Gates of Heck
Typefaces Thickhead; hand-rendered typography
Software traditional mechanical; QuarkXPress
Colors 4/C process
Print run 10,000

Concept While designing this cover for an adult's ABC book of drug terms, Cerio was under the influence of the look and design of the Little Golden Book series, especially the no-dust-jacket, case-cover-only format. "I tried to find a balance between something that had an obvious psychedelic, counterculture look and an innocent, friendly children's book. My work tends to be influenced by one or the other—and is already a fusion of the two as it is—but I may have succeeded too well. Based on the angry letters I've received, I'm finding out that people are purchasing it in the mistaken belief that it is an educational children's book. However, aside from the obvious subject matter, my contention is that it does nothing but poke fun at drug culture, and is thereby harmless." Cerio hand-rendered his byline in the form of little pink worms.

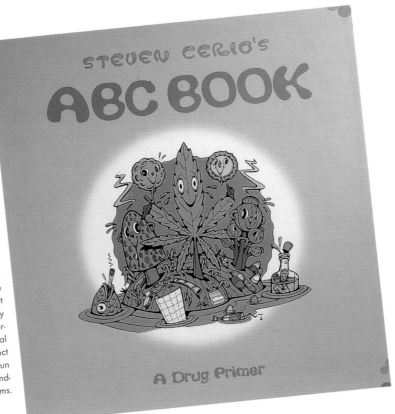

STEVEN CERIO's
ABC BOOK
A Drug Primer

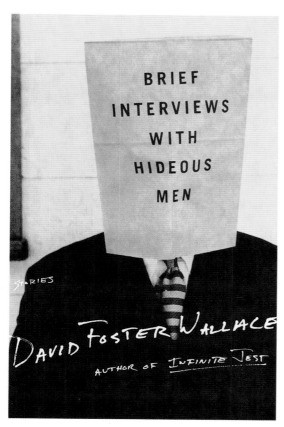

BRIEF
INTERVIEWS
WITH
HIDEOUS
MEN

STORIES

DAVID FOSTER WALLACE
AUTHOR OF INFINITE JEST

Jacket *Brief Interviews With Hideous Men*

Art director Michael Ian Kaye
Designer John Fulbrook III
Photographer Karen Beard
Studio Little, Brown
Client Little, Brown
Typefaces Trade Gothic; hand-rendered lettering
Software QuarkXPress
Colors 4/C process
Print run 25,000

Concept "I have always been a fan of David Foster Wallace's unique voice. He has the ability as a writer to take the reader into worlds of emotional complexity and comedic power. I wanted something striking and strange for this jacket, to represent Wallace's wild mind. The silk-screened bag over the head seemed straightforward, yet powerful and funny. That, combined with Karen Beard's photography and gritty hand-lettering, created a total package I was very pleased with."

Cover *The Ibis Tapestry*

Art director John Gall
Designer Chin-Yee Lai
Photographer Allan Montaine/Photonica
Studio Vintage Books
Client Vintage Books/Random House
Typeface Alternate Gothic
Software QuarkXPress, Adobe Photoshop
Color 4/C process
Print run 6,500

Concept "Inspired by the title, the image of the girl and the image of the book intertwine into a fabric pattern. By definition, a tapestry is a 'mosaic of dyed threads' that exhibits a 'richness of color and exquisite gradation of tints.' Echoing this complexity of design, the dream diary in the story is the result of the social, political and personal tapestry woven by the main character."

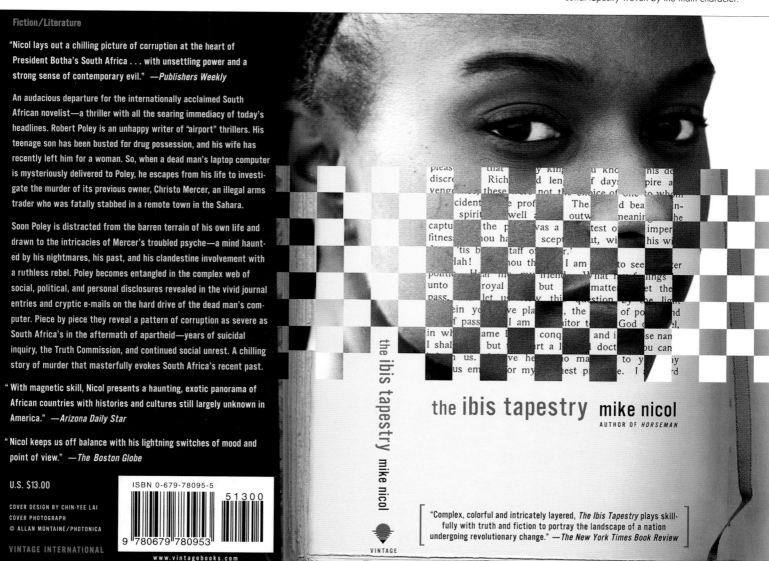

Fiction/Literature

"Nicol lays out a chilling picture of corruption at the heart of President Botha's South Africa . . . with unsettling power and a strong sense of contemporary evil." —*Publishers Weekly*

An audacious departure for the internationally acclaimed South African novelist—a thriller with all the searing immediacy of today's headlines. Robert Poley is an unhappy writer of "airport" thrillers. His teenage son has been busted for drug possession, and his wife has recently left him for a woman. So, when a dead man's laptop computer is mysteriously delivered to Poley, he escapes from his life to investigate the murder of its previous owner, Christo Mercer, an illegal arms trader who was fatally stabbed in a remote town in the Sahara.

Soon Poley is distracted from the barren terrain of his own life and drawn to the intricacies of Mercer's troubled psyche—a mind haunted by his nightmares, his past, and his clandestine involvement with a ruthless rebel. Poley becomes entangled in the complex web of social, political, and personal disclosures revealed in the vivid journal entries and cryptic e-mails on the hard drive of the dead man's computer. Piece by piece they reveal a pattern of corruption as severe as South Africa's in the aftermath of apartheid—years of suicidal inquiry, the Truth Commission, and continued social unrest. A chilling story of murder that masterfully evokes South Africa's recent past.

"With magnetic skill, Nicol presents a haunting, exotic panorama of African countries with histories and cultures still largely unknown in America." —*Arizona Daily Star*

"Nicol keeps us off balance with his lightning switches of mood and point of view." —*The Boston Globe*

U.S. $13.00

ISBN 0-679-78095-5

COVER DESIGN BY CHIN-YEE LAI
COVER PHOTOGRAPH
© ALLAN MONTAINE/PHOTONICA

9 780679 780953
51300

VINTAGE INTERNATIONAL

www.vintagebooks.com

the ibis tapestry mike nicol
AUTHOR OF HORSEMAN

VINTAGE

"Complex, colorful and intricately layered, *The Ibis Tapestry* plays skillfully with truth and fiction to portray the landscape of a nation undergoing revolutionary change." —*The New York Times Book Review*

Cover Beatniks

Art director Jamie Keenan
Designer Jamie Keenan
Illustrator Jamie Keenan
Studio Random House UK
Client Vintage Books/Random House UK
Typefaces Latin, Journal
Software QuarkXPress, Adobe Photoshop
Colors 4/C process
Print run 6,500

Concept "Beatniks is a story of a group of young English people in the 1990s attempting to recreate America of the 1960s and go 'on the road.' The idea behind the cover is to use elements of then and now, such as false leopard skin (often seen on car seat covers in Britain) and an outline drawing of a Vauxhall Chevette (not the sort of car Jack Kerouac is normally associated with), to illustrate the gap between their overactive imagination and the less glamorous reality."

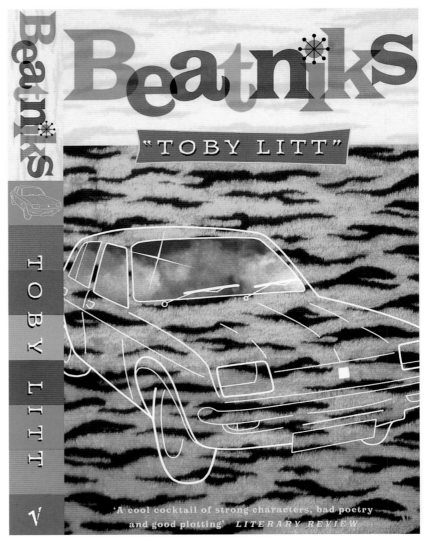

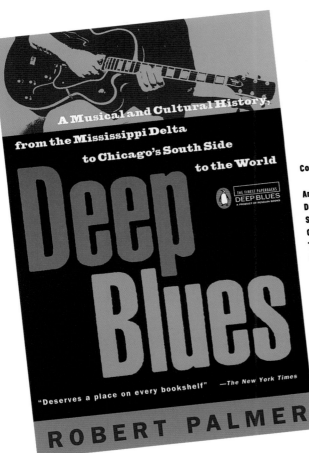

Cover Deep Blues

Art director Paul Buckley
Designer Edward ODowd
Studio The Viking Penguin Design Group
Client Penguin
Typefaces Aurora Condensed, Franklin Gothic, Egiziano
Software QuarkXPress, Adobe Photoshop
Colors 5/C flat
Print run 5,000

Concept "Obviously inspired by 1950s album covers from the Blue Note jazz label, this cover has a lot of little 'extras' that the average person would never notice. Not having access to anything other than a Mac at the time, I altered most of the type on the book by means of photo-copying, to slightly distort it and give it a more 'vintage' feel. The really exciting aspect of this cover was the color, which I had two colors specially mixed for. It's a great feeling knowing you've put something out there that no one can match to a Pantone® chip!"

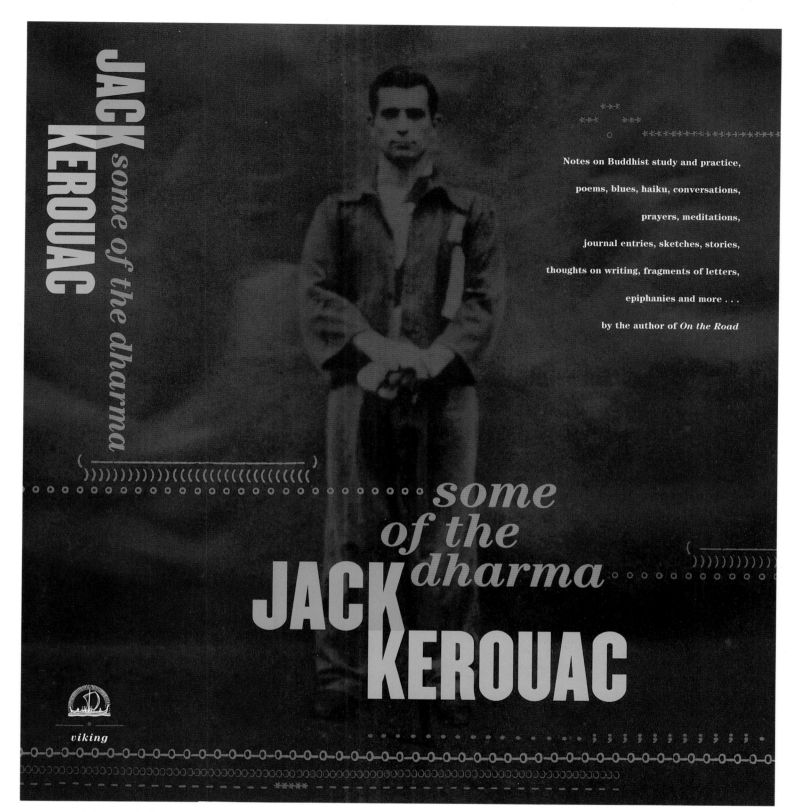

JACK KEROUAC
some of the dharma

Notes on Buddhist study and practice,

poems, blues, haiku, conversations,

prayers, meditations,

journal entries, sketches, stories,

thoughts on writing, fragments of letters,

epiphanies and more . . .

by the author of *On the Road*

some of the dharma
JACK KEROUAC

viking

Jacket *Some of the Dharma*

Art director Paul Buckley
Designer Gail Belenson
Photographer Photograph courtesy of the estate of Jack Kerouac
Studio The Viking Penguin Design Group
Client Viking
Typefaces Champion, Century
Software QuarkXPress, Adobe Photoshop
Colors 4/C flat (1/C fluorescent and a custom-created burgundy background)
Print run 15,000

Concept "The typewriter ornamentation was quite literally lifted from Kerouac's interior page layouts, and then maneuvered. The type was inspired by 1950s jazz album covers—the work of Reid Miles at Blue Note, as well as the design done for the Impulse! and Prestige record labels. The colors were chosen to suggest Tibet."

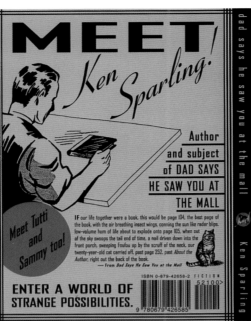
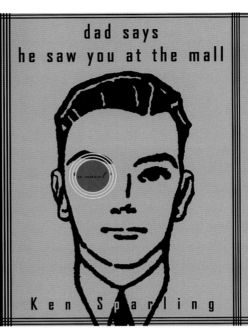

Ken Sparling lives with his wife and two sons in Toronto, where he works in the public relations department of the North York Public Library.

Jacket and binding design by Archie Ferguson

Alfred A. Knopf, Publisher, New York

MEET!
Ken Sparling!

Author and subject of DAD SAYS HE SAW YOU AT THE MALL

Meet Tutti and Sammy too!

IF our life together were a book, this would be page 104, the best page of the book, with the air breathing insect wings, canning the sun like radar blips, low-volume hum of life about to explode onto page 105, when out of the sky swoops the tail end of time, a nail driven down into the front porch, sweeping Foufou up by the scruff of the neck, our twenty-year-old cat carried off, past page 252, past *About the Author*, right out the back of the book.
—from *Dad Says He Saw You at the Mall*

ENTER A WORLD OF STRANGE POSSIBILITIES.

ISBN 0-679-42658-2 FICTION
52100>
9 780679 426585

dad says he saw you at the mall

Ken Sparling

dad says he saw you at the mall

a novel

Ken Sparling

FPT U.S.A. $21.00
Canada $28.95

"There are things I never resolved in my life. But at least the weather was good," writes Ken Sparling—author and subject of DAD SAYS HE SAW YOU AT THE MALL, a gentle, funny, and sometimes desperately sad novel from a bright new young voice in contemporary fiction.

The fictional Sparling is a more than slightly befuddled everyman. He works in an office where people appear to do nothing but shuffle paper and carry boxes of files from one room to another. He's married to Tutti, who spends her evenings engrossed in reruns of *Star Trek*, and whose bedtime ritual consists of constructing food charts for the next day's meals. He looks back on his parents' failed marriage with no small measure of regret. And—most important—he is father to Sammy, the little boy upon whom he lavishes all the seemingly boundless affection he's able to summon from the depths of his quietly aching heart.

In his attempt to find his place in a banal and sometimes not very pretty universe, Sparling seeks solace and validation not only in his interaction with his son, but also in language—a language all his own that is by turns repetitive, imagistic, even hallucinatory. He tells this traditional story in a very untraditional way by reciting interior monologues, spinning anecdotes so funny they often border on the painful, and tossing off random thoughts in between—all the while reveling in the absurdities of human relations.

DAD SAYS HE SAW YOU AT THE MALL is a poignant charting of a man's attempt to be the ideal son, husband, and father while fighting a strong impulse to run screaming away from the adult life he has suddenly found himself steeped in—with no clue as to how he got there.

AN IMPRESSIVE DEBUT, AND A SPECIAL NOVEL UNLIKE ANY OTHER.

Jacket *Dad Says He Saw You at the Mall*

Art director Carol Devine Carson
Designer Archie Ferguson
Illustrator Archie Ferguson
Studio Alfred A. Knopf, Inc.
Client Alfred A. Knopf, Inc.
Typefaces Agency Gothic, Ribbon 131
Software QuarkXPress, Adobe Photoshop
Colors toyo 0155, toyo 0096 and toyo 183, plus black, with matte lamination
Print run 2,000

Concept "I struggled with this one for a while. Then, one morning while getting dressed, I found myself staring at a collar-holder package that I had picked up about a year earlier for a dollar at a local flea market. There was Dad—not mine, but everyone's—omnisciently watching me, every morning. Scary. I borrowed Dad and some of his elements of style, and carried the theme around to the back. I worked with the editor, who came up with copy to fit the concept and layout."

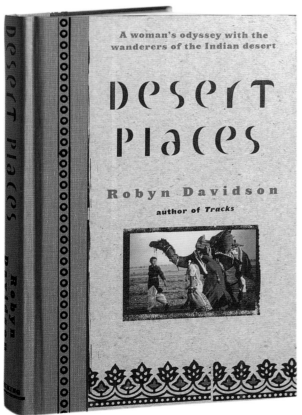

A woman's odyssey with the wanderers of the Indian desert

Desert Places

Robyn Davidson

author of *Tracks*

Case cover *Desert Places*

Art director Paul Buckley
Designer Martin Ogolter
Photographer Photograph courtesy of Robyn Davidson
Studio The Viking Penguin Design Group
Client Viking
Typefaces Decoder, Leviathan
Software QuarkXPress, Adobe Photoshop, Adobe Illustrator
Colors 4/C process
Print run 10,000

Concept The book is a memoir describing the experiences of a white Australian woman traveling alone in India. Ogolter's intention was "to mimic a travel diary or scrapbook bought in India—the sort of common, everyday journal made cheaply using low-tech, old-fashioned production. The title type was created by using Decoder with a contemporary experimental font to suggest Sanskrit."

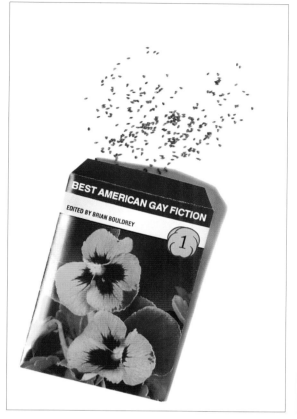

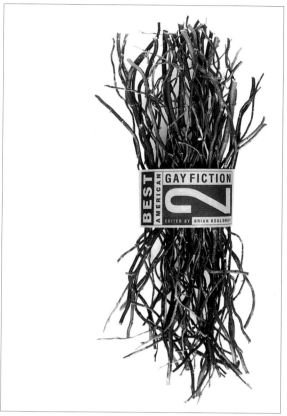

Covers *Best American Gay Fiction* (series)

Art director Michael Ian Kaye
Designer John Fulbrook III
Photographers Marc Tauss (Book 2); Dan Bibb (Books 1 and 3)
Studio Little, Brown
Client Little, Brown
Typefaces Helvetica, Odeon, Univers, Quorum
Software QuarkXPress, Adobe Photoshop
Colors 4/C process
Print run 10,000 per title

Concept "I ran around town on these projects, gathering card decks, seeds, curly twigs, etc. It was great to be able to put a faggot on the cover of a gay book—and to make such humorous props. Michael [the art director] and I worked together closely to make these come to life, and I wish we could have continued, but my publisher no longer wanted the series. I guess fruitcake, or fairies, would have been next. I am glad people 'got it,' and even happier that the concept made it to press."

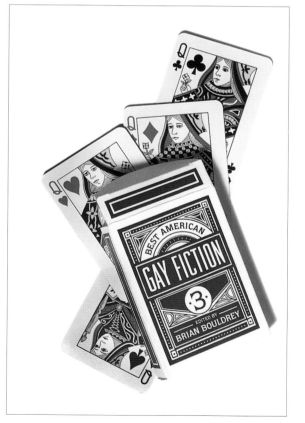

Cover *Five Against One: The Pearl Jam Story*

Art director Jesse Marinoff Reyes
Designer Jesse Marinoff Reyes
Photographer Kevin Westenberg
Studio The Viking Penguin Design Group
Client Penguin
Typefaces Compacta, Anzeigen Grotesk (altered and redrawn)
Software QuarkXPress
Colors 2/C flat with 1 flat metallic
Print run 10,000

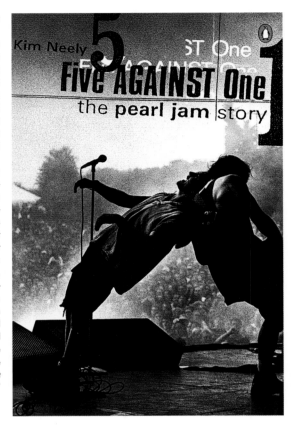

Concept Pearl Jam is one of the few rock bands that emerged from the late 1980s/early 1990s "grunge" music scene in Seattle to survive and become a music industry mainstay—and the subject of much journalistic documentation. "I tried to recruit the work of certain photographers who were close to the band, who had uncommon access and amazing shots. I wanted to design this with a sense of what Seattle's music subculture was about and demonstrate the talent that came out of that. Unfortunately, those guys were off-limits, working on a band-approved book of their own." Reyes, a former Seattle native, had once been a part of creating the visual identity of the then nascent music/pop culture milieu and could draw upon other options: "One of the best talents working in Seattle then was Kevin Westenberg, now a top London-based music photographer and someone I've worked with many times over the years." Reyes rousted Westenberg in England: "He had new, museum-quality prints of the band in concert, capturing the iconic quality of their live performance with startling power and beauty." He adds, "The project also brought us both full circle, reflecting upon the scene we both came from."

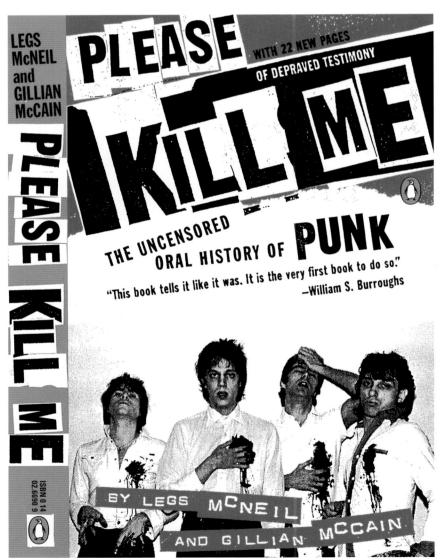

Cover *Please Kill Me*

Art director Paul Buckley
Designer Jesse Marinoff Reyes
Photographer Roberta Bayley
Studio The Viking Penguin Design Group
Client Penguin
Typefaces Dyna labelmaker; headline letters from the *New York Post;* Franklin Gothic
Software traditional mechanical, QuarkXPress
Colors 3/C flat
Print run 15,000

Concept "I was just a bit too young to have designed graphics during the heyday of punk, though I began my career only a few years later. I knew the look, I could walk the walk—so this was a way to have the same fun as my older peers." Reyes expresses annoyance with many contemporary designers who can't get it right: "Hell, look at the old records, or it's all been documented in books. Look at the work of Jamie Reid, Gary Panter, Winston Smith, Peter Belsito, Raymond Pettibon, Art Chantry and a host of others. Every so often, a punk rock history comes out and it looks just awful—postmodern with Photoshop filter effects that some Mac designer is trying to pass off as punk. Ugh!" Oddly, Reyes encountered a bit of initial resistance from the authors: "Legs McNeil was trying to tell me that the New York punk scene documented in *Please Kill Me* was more stylish, slicker than in ripped-and-torn London or Los Angeles—until I managed to find back-issues of *Punk,* the New York magazine he edited. Most of *Punk* was typewritten, with Magic Marker® headlines. And then suddenly, the design became 'really great' when I reworked it with Roberta Bayley's (an author fave) really cool photo of Richard Hell and The Heartbreakers (c. 1975)."

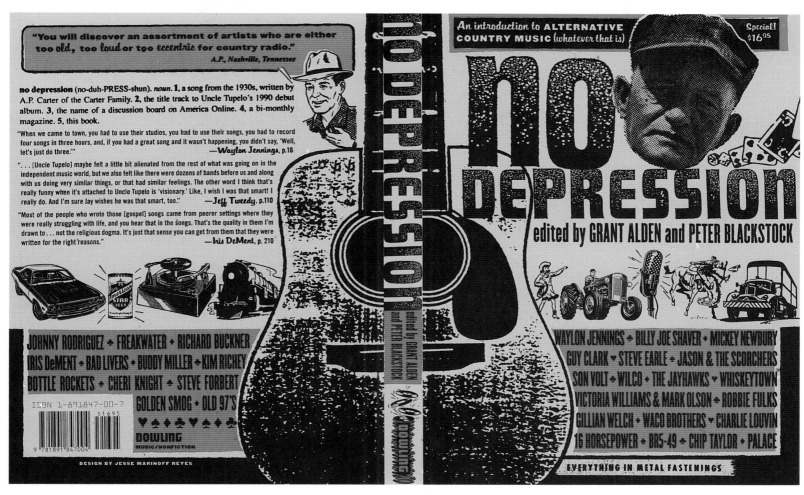

Cover *No Depression*

Art director Jesse Marinoff Reyes
Designer Jesse Marinoff Reyes
Studio Jesse Marinoff Reyes Design
Client Dowling Press
Typefaces Champion, Homer; the acquired masthead/title is redrawn Futura Display
Software traditional mechanical, QuarkXPress
Colors 2/c flat
Print run 2,500

Concept *No Depression*, an "alternative country music" anthology derived from the magazine of the same name, presented the designer with an opportunity to work with a client already predisposed to his work. Co-editor Grant Alden was an old friend and colleague, and Reyes notes, "He gave me a very specific mandate—make it look like a 1940s farm supplies catalog." Rough-hewn industrial paper stock was selected and printed with only two colors. "I spent days searching out the right kind of clip art that captured some aspect of country-and-western culture, but still suggested music, then setting up the mechanical traditionally and treating everything as if the inks were going down imprecisely and off-register. I left copious instructions for the printer, noting that 'mistakes' were intentional. Accordingly, as the book sits around, the uncoated stock will acquire just the right patina of scuffing, although without damaging the cover because of its thickness. That way, it'll look just like that old farm catalog that was found lying in the barn after fifty years."

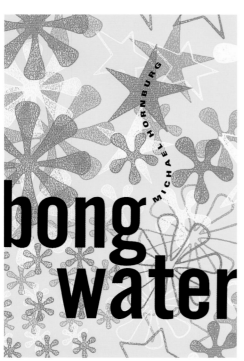

Jacket *Bongwater*

Art director John Gall
Designer John Gall
Studio Grove/Atlantic
Client Grove/Atlantic
Typeface Trade Gothic
Software QuarkXPress, Adobe Photoshop
Colors black and 3/C flat Day-Glo
Print run 20,000

Concept This title is described on the flap as a "neo-beat, grungeiosie love story." Gall explains, "In a way, the cover design is a reference to the cut-and-paste, intentionally out-of-register cheap printing of some of the old Grove Press books; then I added a little bit of 1990s 'grungeiosie' flavor for good measure."

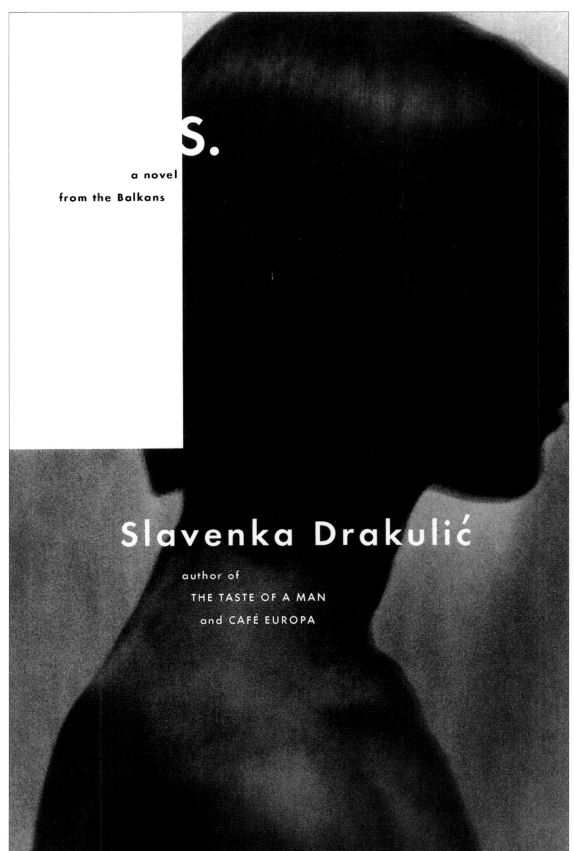

S.

a novel

from the Balkans

Slavenka Drakulić

author of

THE TASTE OF A MAN

and CAFÉ EUROPA

Jacket S.

Art director Paul Buckley
Designer Paul Buckley
Photographer Marc Atkins
Studio The Viking Penguin Design Group
Client Viking
Typeface Futura
Software QuarkXPress
Colors 3/C flat
Print run 15,000

Concept This is a novel about enslaved comfort women in the Balkans. Buckley remarks on the fortuitousness of the design: "After finding the right stark and severe photo, this cover fell into place in about twenty minutes. Though the cropping and tension of the photo seem appropriate and obvious to me now, I may have glossed over this detail had the photo not imported itself into my Quark layout in exactly this way."

Cover *The Drowning Room*

Art director Paul Buckley
Designer Martin Ogolter
Illustration Jan Vermeer, *The Procuress* (detail),
1656
Studio The Viking Penguin Design Group
Client Penguin
Typefaces Decoder, Leviathan
Software QuarkXPress, Adobe Photoshop,
Adobe Illustrator
Colors 4/C process
Print run 7,500

Concept A fictional account of the "first whore of
New York City" and how she arrived from
Holland, this novel illustrates the rough, unpre-
dictable life of New Amsterdam. The painting
sets "the unmistakable Dutch mood. Then the
radical cropping and obliteration of the painting
gives the cover a different, more messy quality."

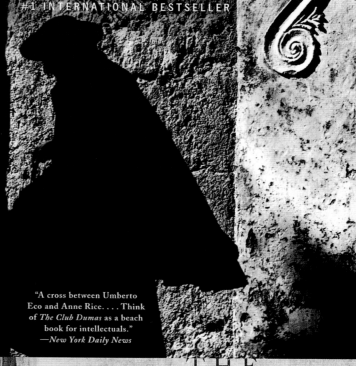

Cover *The Club Dumas*

Art director John Gall
Designer Chin-Yee Lai
Photographer Ernst Haas/Magnum Photos
Studio Vintage Books
Client Vintage Books/Random House
Typefaces Caslon, Trade Gothic
Software QuarkXPress, Adobe Photoshop
Color 4/C process plus 1/C flat
Print run 50,000

Concept "Throughout the novel, a mysterious
man, seemingly behind the scenes, shadows
the main plot. It is only appropriate to display
a dark figure on the cover to accurately
describe the thrill, the mystery and the intrica-
cy it gives to the story."

"A thriller of marvelous intricacy." —*The New York Times Book Review*

Fiction

Lucas Corso, middle-aged, tired, and cynical, is a book detective,
a mercenary hired to hunt down rare editions for wealthy and
unscrupulous clients. When a well-known bibliophile is found
hanged, leaving behind part of the original manuscript of
Alexandre Dumas's *The Three Musketeers*, Corso is brought in to
authenticate the fragment.

The task seems straightforward, but the unsuspecting Corso is
soon drawn into a swirling plot involving devil worship, occult
practices, and swashbuckling derring-do among a cast of characters
bearing a suspicious resemblance to those of Dumas's masterpiece.
Aided by a mysterious beauty named for a Conan Doyle heroine,
Corso travels from Madrid to Toledo to Paris in pursuit of a sinister
and seemingly omniscient killer. Part mystery, part puzzle, part
witty intertextual game, *The Club Dumas* is a wholly original intel-
lectual thriller by the internationally bestselling author of *The
Flanders Panel* and *The Seville Communion*.

"Erudite, funny, loopy, brilliant . . . action-adventure spiced with dollops
of idiosyncrasy—and some very good talk." —*Philadelphia Inquirer*

"A noir metafiction. . . . Even a reader armed with a Latin dictionary
and copy of *The Three Musketeers* cannot anticipate the thrilling twists
of this stylish, Escher-like mystery." —*The New Yorker*

#1 INTERNATIONAL BESTSELLER

THE CLUB DUMAS

PÉREZ-REVERTE

"A cross between Umberto
Eco and Anne Rice. . . . Think
of *The Club Dumas* as a beach
book for intellectuals."
—*New York Daily News*

U.S. $13.00
Can. $17.95

Cover photograph:
© Ernst Haas/Magnum Photos

Cover design:
Chin-Yee Lai

ISBN 0-679-77754-7

9 780679 777540 51300

www.randomhouse.com

VINTAGE

VINTAGE INTERNATIONAL

THE
CLUB DUMAS

ARTURO PÉREZ-REVERTE
author of *The Flanders Panel*

Jacket *Chairman Mao Would Not Be Amused*

Art director John Gall
Designer John Gall
Illustrator Zhang Hongtu
Studio Grove/Atlantic
Client Grove/Atlantic
Typeface Triplex
Software QuarkXPress, Adobe Photoshop
Colors 4/C process
Print run 15,000

Concept "This book was the first collection of stories to come out of post-Tiananmen China, so the cover needed to address China's past in some rebellious way. I was introduced to this amazing artist, Zhang Hongtu, who almost exclusively made paintings and sculptures of Chairman Mao—as in a Mao made out of corn or a Mao made out of soy sauce. Although this piece looks rather whimsical and irreverent, it is actually a bit more serious than it appears."

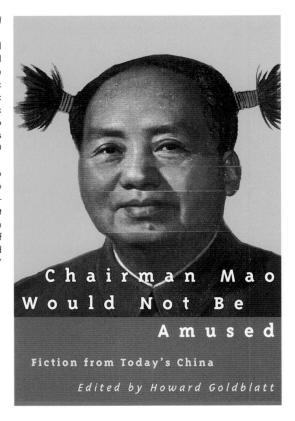

MALCOLM BRADBURY

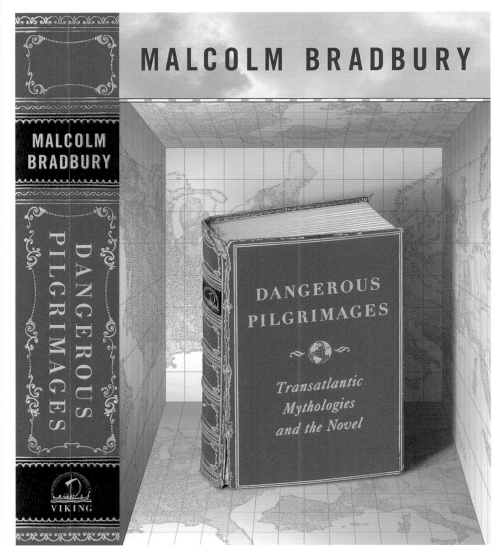

Title *Dangerous Pilgrimages*

Art director Paul Buckley
Designer Gail Belenson
Illustrator Shasti O'Leary
Studio The Viking Penguin Design Group
Client Viking
Typefaces Trade Gothic, Bauer Bodoni
Software QuarkXPress, Adobe Photoshop
Colors 4/C process
Print run 6,000

Concept "This was an attempt to make a potentially dry subject—transcontinental literary comparisons—look intriguing. The perfect old, red book was found in a used bookstore, photographed and superimposed with the type treatment." Belenson created the map texture, which the illustrator turned into a box and incorporated into the final collage in Photoshop.

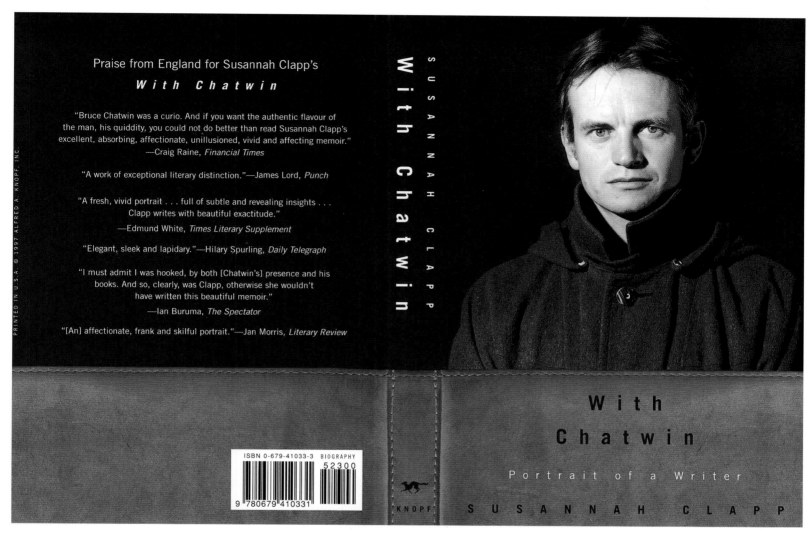

Praise from England for Susannah Clapp's

With Chatwin

"Bruce Chatwin was a curio. And if you want the authentic flavour of the man, his quiddity, you could not do better than read Susannah Clapp's excellent, absorbing, affectionate, unillusioned, vivid and affecting memoir."
—Craig Raine, *Financial Times*

"A work of exceptional literary distinction."—James Lord, *Punch*

"A fresh, vivid portrait . . . full of subtle and revealing insights . . . Clapp writes with beautiful exactitude."
—Edmund White, *Times Literary Supplement*

"Elegant, sleek and lapidary."—Hilary Spurling, *Daily Telegraph*

"I must admit I was hooked, by both [Chatwin's] presence and his books. And so, clearly, was Clapp, otherwise she wouldn't have written this beautiful memoir."
—Ian Buruma, *The Spectator*

"[An] affectionate, frank and skilful portrait."—Jan Morris, *Literary Review*

SUSANNAH CLAPP

With Chatwin

With

Chatwin

Portrait of a Writer

KNOPF S U S A N N A H C L A P P

ISBN 0-679-41033-3 BIOGRAPHY
52300
9 780679 410331

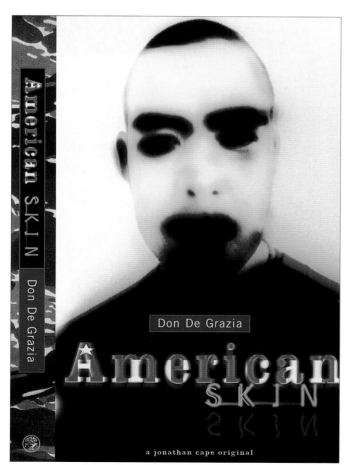

American SKIN

Don De Grazia

Don De Grazia

American
SKIN
SKIN

a jonathan cape original

Jacket *With Chatwin*

Art director Carol Devine Carson
Designer Archie Ferguson
Photographer Robert Mapplethorpe
Illustrator Archie Ferguson
Studio Alfred A. Knopf, Inc.
Client Alfred A. Knopf, Inc.
Typeface Trade Gothic Bold
Software QuarkXPress, Adobe Photoshop
Colors black halftone with 4/C process, with overall matte lamination and spot varnish over photograph
Print run 2,500

Concept "The hardest part of this project was deciding whether to use the print of Bruce with the wisp of hair falling over his forehead or the one without. After getting over that hurdle, I had my leather attaché photographed, and crossed my fingers that I wouldn't have to make the type any bigger."

Cover *American Skin*

Art director Jamie Keenan
Designer Jamie Keenan
Photographer Kjell Ekhorn
Studio Random House UK
Client Jonathan Cape/Random House UK
Typefaces Franklin Gothic, Letter Gothic, Egyptian
Software QuarkXPress, Adobe Photoshop
Colors 4/C process
Print run 3,500

Concept "This book, set in Chicago, tells the story of a young skinhead gang member. Photographs of skinheads are usually shot in black and white in a fairly worthy reportage style, so it was good to find an image that conveyed the vulnerability as well as the aggression of the central character and looked less like the memoirs of a Hitler Youth. The type is based on Perspex (a sort of transparent plastic) and neon signs to convey the seedy clubs and bars where large sections of the book take place."

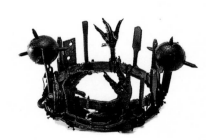

**WINNER OF THE EUROPEAN ARISTEION
PRIZE FOR LITERATURE 1996**

'A grandiose alternative chronicle of post-war Europe…An
irresistible and a visionary book'

MICHAEL HOFMANN, *TIMES LITERARY SUPPLEMENT*

'A wild imagination…Ransacking comics, cult movies, magic
realism and modern German fiction for his vivid writing,
Ransmayr has delivered the goods'

BRIAN CASE, *TIME OUT*

'Powerful…His vision is his own, customised…out of the kind
of bits and pieces that make up so many postmodern fictions,
but done here with a seriousness and passion that's rare'

LORNA SAGE, *LITERARY REVIEW*

'Ransmayr's writing takes us finally into the personal, into
new hopes and new horizons, and does so brilliantly…Here
the writing itself becomes the fulsome, strident evocation of
what endures, transcends and is best in the human condition'

TOM ADAIR, *SCOTLAND ON SUNDAY*

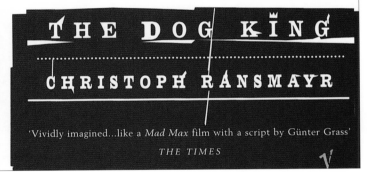

THE DOG KING

CHRISTOPH RANSMAYR

'Vividly imagined…like a *Mad Max* film with a script by Günter Grass'
THE TIMES

VINTAGE

ISBN 0-09-976691-4

Fiction

9 780099 766919

UK £6.99
AUS $14.95* *recommended price

Cover illustration:
Sophie Marsham

VINTAGE U.K. Random House

C H R I S T O P H
R A N S M A Y R

Cover *The Dog King*

Art director Jamie Keenan
Designer Jamie Keenan
Model maker/Photographer Sophie Marsham
Studio Random House UK
Client Vintage Books/Random House UK
Typeface Egyptian
Software QuarkXPress
Colors 1/C custom flat
Print run 5,500

Concept "To portray the idea of the King and
the crude environment he lives in, a full-size
crown was made but, in place of the usual
materials, old drill bits, nails, wire and hen's
feet were used. The image of the crown was
deliberately underdeveloped, so it appears
almost in silhouette, and laid out in lots of
white space to create a stark, uncomfortable
feel. The typography then echoes the jagged
feel of the crown: Bits are added to each let-
ter to break up the normal curves of each
character, and the whole thing is reversed out
of a nasty-looking shape that looks like it may
have once been square. The whole cover is
then printed in one color—a mixture of a dark
metallic bronze and black, specially mixed by
the printer."

Cover *The Dog King*

Art director John Gall
Designer John Gall
Photographer Elliott Erwitt (inset of dog)
Studio Vintage Books
Client Vintage Books/Random House
Typeface Dead History
Software QuarkXPress, Adobe Photoshop
Colors 4/C process
Print run 8,000

Concept *The Dog King* is a piece of specula-
tive fiction set in Central Europe after World
War II, amid the pre-industrial conditions to
which this area has been reduced by the
Allies. Living in a decrepit villa, surrounded by
half-wild hounds, the Dog King and his
accomplices create their own surreal universe.
Gall notes, "The collage cover is a reference
not only to the main character's degenerative
eye disease, but also to the way [he and his
companions] have assembled lives for them-
selves using whatever debris they are able to
forage from the devastated landscape."

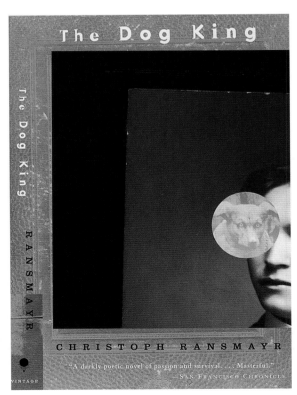

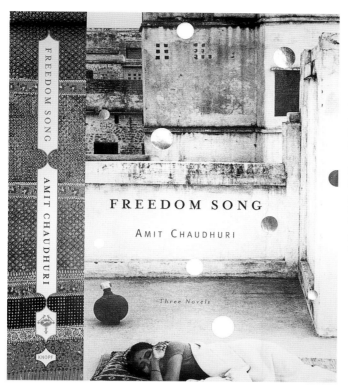

Jacket *Freedom Song*

Art director Carol Devine Carson
Designer John Gall
Photographer William Gedney
Studio John Gall Graphic Design
Client Alfred A. Knopf, Inc.
Typefaces Mrs. Eaves, Meta
Software QuarkXPress, Adobe Photoshop
Colors 4/C process with silver foil stamping
Print run 20,000

Concept "What I liked best about this design is how beautifully it reflects the languorous, gemlike quality of the writing contained inside." Gall's also pleased to have been "able to use a classic, horrible book-cover printing effect (foil stamping) in a way that is conceptual, subtle and still eye-catching."

Cover *Busted Scotch*

Art director Ingsu Liu
Designer Paul Buckley
Studio Paul Buckley Design
Client W.W. Norton
Typefaces Numskill, Platelet, Barmeno
Software QuarkXPress
Colors 5/C flat
Print run 7,000

Concept For this book of stories about the Scottish working class and their money troubles, Buckley explains, "My task was to repackage an older, existing novel and to freshen up its look. The one constraint was that I had to work with this uninspiring piece of art, which looked like a rusty piece of metal with rows of holes punched out of its surface. I created a design that played off of this, and when I deleted the picture box containing the art, I was left with a much stronger design. Luckily, the client thought so as well."

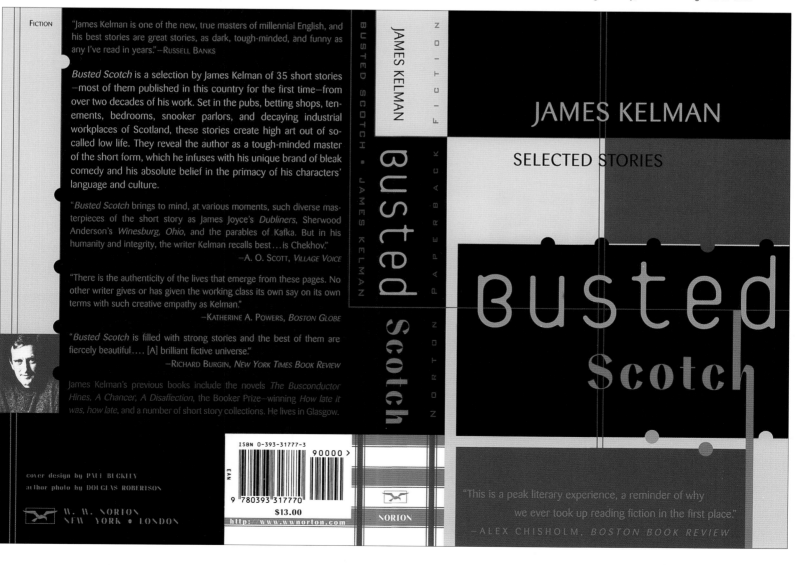

Cover *The Fight*

Art director John Gall
Designer John Gall
Photographer Thomas Hoepker/Magnum
Photos
Studio Vintage Books
Client Vintage Books/Random House
Typeface Trade Gothic
Software QuarkXPress, Adobe Photoshop
Colors 3/C flat
Print run 10,000

Concept "This 'in-your-face' cover seems
appropriate for a book that has Norman
Mailer writing about Muhammad Ali."

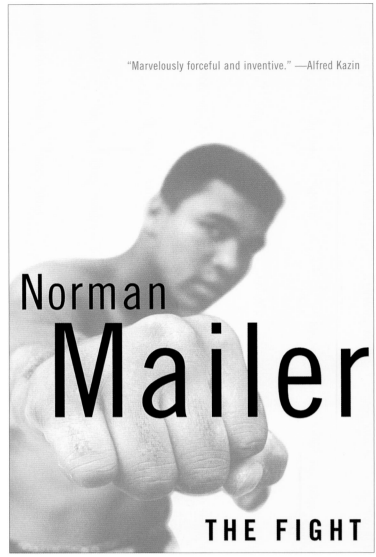

"Marvelously forceful and inventive." —Alfred Kazin

Norman
Mailer

THE FIGHT

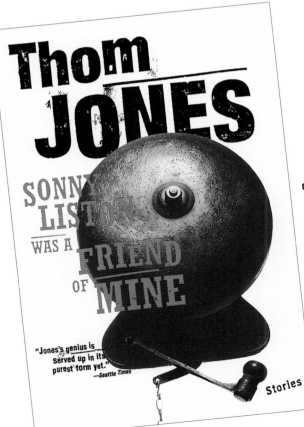

Cover *Sonny Liston Was a Friend of Mine*

Art director Michael Ian Kaye
Designer John Fulbrook III
Photographer Kenneth Willardt/Nonstock
Studio Little, Brown
Client Little, Brown
Typefaces Helvetica, Rockwell
Software QuarkXPress
Colors 4/C process with press varnish on uncoated cream stock
Print run 10,000

Concept "I wanted to say boxing, but in a unique way—not closing the
door to a female market—while suggesting fiction and not a biography
of Sonny Liston. The bell not only looked like a large breast and went
'ding-ding' to me, but also said fiction and invited the reader in to
question the content of this book." The deconstructed type is meant to
reflect old boxing posters and the ferocity of Jones's writing.

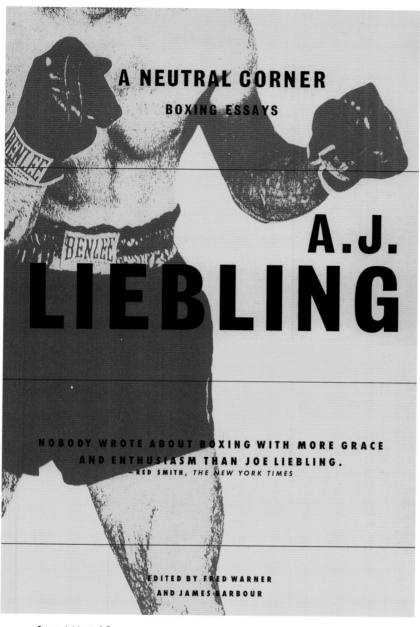

Cover *A Neutral Corner*

Art director Michael Ian Kaye
Designer Rodrigo Corral
Studio Farrar, Straus and Giroux
Client Northpoint
Typeface Mheadline Bold
Software QuarkXPress
Colors 2/C flat
Print run 5,000

Concept "Liebling's essays are often as lively and full of action as the fights and fighters he covered, and like the fight itself, the cover duotone image suggests a simplicity and classic grace that is not always represented in boxing literature. 'Float like a butterfly, sting like a bee.'"

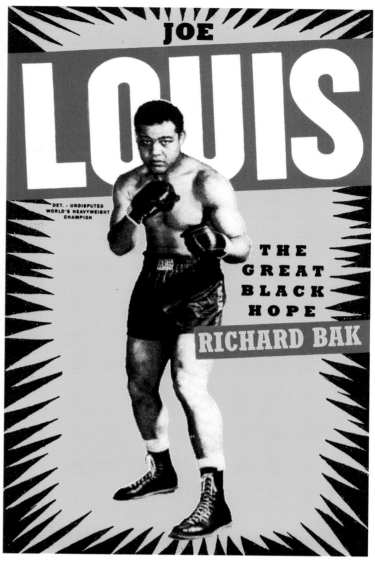

Jacket *Joe Louis*

Art director Jesse Marinoff Reyes
Designer Jesse Marinoff Reyes
Photograph Archive Photos
Studio Jesse Marinoff Reyes Design
Client Da Capo Press
Typefaces Champion, Rockwell
Software QuarkXPress; traditional mechanical elements
Colors 3/C flat
Print run 7,500

Concept Joe Louis was the Heavyweight Champion of the World from 1938 to 1949. He held the title longer than any man to date, defending it a record twenty-five times. Though a quiet, understated public presence, Louis was a devastating knockout puncher in the ring and a disciplined athlete, long held as the standard by which future champions would be compared. An icon who represented the aspirations of equality and self-determination sought by African Americans during the long struggle for civil rights at midcentury, he became a symbol for all Americans on the eve of World War II via his first-round knockout of Adolf Hitler favorite Max Schmeling. Reyes comments, "What better way to depict his biography than to craft the cover as a 1930s fight poster? Direct, defiant, unadorned."

Cover *Blood Acre*

Art director Paul Buckley
Designer Jesse Marinoff Reyes
Photographer Weegee (Arthur Fellig)/ICP
Studio The Viking Penguin Design Group
Client Penguin
Typefaces Elephant, Epaulet
Software QuarkXPress
Colors 2/C flat with 1 flat metallic
Print run 12,500

Concept The novel, a dark chronicle of murder set in the lower depths of Coney Island and other parts of Brooklyn, is atmospheric both enviromentally and emotionally—hard-bitten and charged with desperation and wanting, a modern *pulp noir*. For Reyes, the answer had to be dark and subtle, yet electric: "Fortunately, the author, Peter Landesman, is a rare wordsmith with a true eye for visuals (he's also an accomplished painter). Peter suggested the brilliant Weegee's *New York at Night* (c. 1942) as the jacket image. This was the second novel I'd designed for Peter, so there was a good working history in place. After jumping through a few flaming hoops for The International Center of Photography, which controlled the use of the image, we were set—he had enough trust in my judgment to let me work without interference."

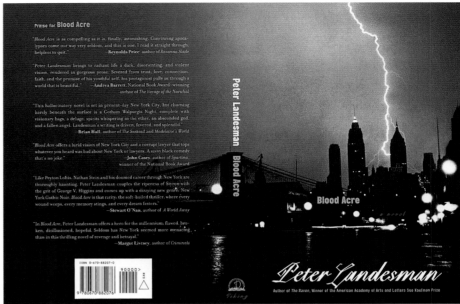

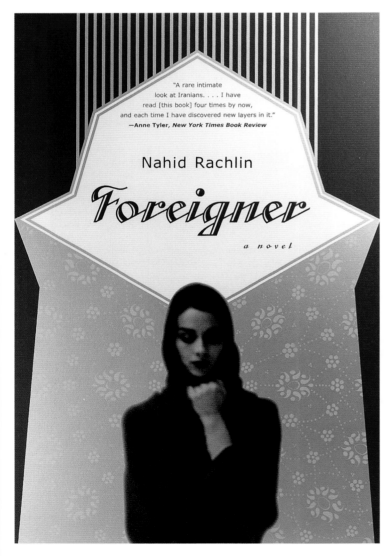

Cover *Foreigner*

Art director Ingsu Liu
Designer Jesse Marinoff Reyes
Photographer Gen Nishino/Tony Stone Images
Studio Jesse Marinoff Reyes Design
Client W.W. Norton
Typefaces Cabarga Cursiva, Verdana
Software QuarkXPress, Adobe Photoshop
Colors 2/C flat with 1 flat metallic
Print run 5,000

Concept The novel tells the story of a woman who returns to her native Iran to visit family after having lived for fourteen years in the United States. She unexpectedly finds herself drawn in by her old culture, in spite of the volatile atmosphere preceding the Islamic revolution. Reyes was inspired by the "border design and framework of a Muslim pamphet purchased at a used bookstore. It didn't look like a Middle Eastern cliché, though I chose more sumptuous colors to make it more literary." The story is essentially about identity and about the contrast between the freedom that Americans take for granted and the limits on personal freedom in a more structured, conservative society. "The image of the woman clutching at her veil—found by accident in a stock catalog—captured this idea very succinctly."

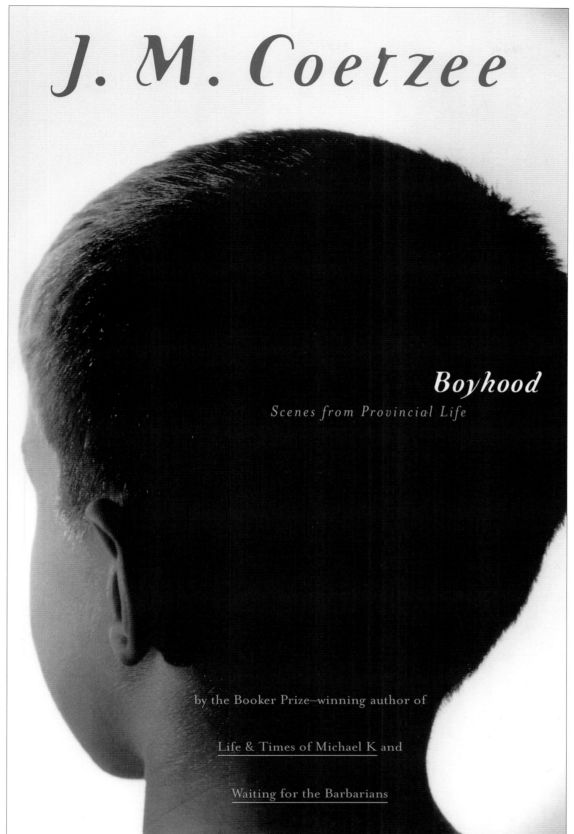

J. M. Coetzee

Boyhood

Scenes from Provincial Life

by the Booker Prize—winning author of

Life & Times of Michael K and

Waiting for the Barbarians

Jacket *Boyhood*

Art director Paul Buckley
Designer Martin Ogolter
Photographer Barbara Morgan
Studio The Viking Penguin Design Group
Client Viking
Typefaces Mrs. Eaves, Tema Contante
Software QuarkXPress, Adobe Photoshop
Colors 4/C flat
Print run 10,000

Concept The first part of the memoirs of J.M. Coetzee, the book describes in simple and powerful prose the hardships of a young boy torn by love, by fear and by art. "The Barbara Morgan photograph, in its simplicity, seemed to best evoke the notion of looking back at the tortures and pains of childhood. Stuck like a thorn in the back of the head is the typography."

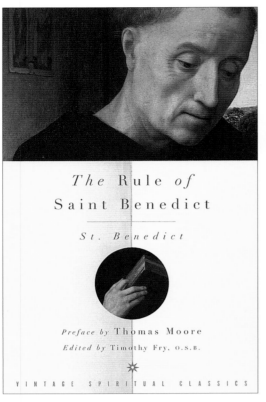

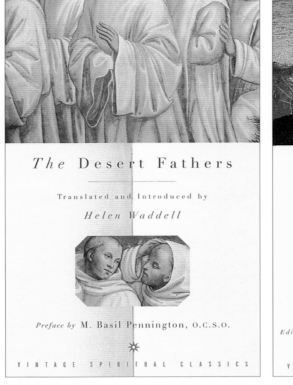

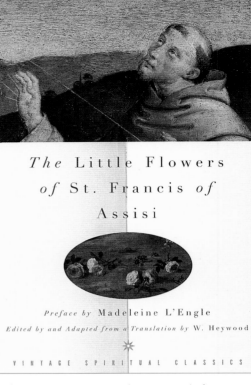

The Rule of
Saint Benedict

St. Benedict

Preface by Thomas Moore
Edited by Timothy Fry, O.S.B.

VINTAGE SPIRITUAL CLASSICS

The Desert Fathers

Translated and Introduced by
Helen Waddell

Preface by M. Basil Pennington, O.C.S.O.

VINTAGE SPIRITUAL CLASSICS

The Little Flowers
of St. Francis of
Assisi

Preface by Madeleine L'Engle
Edited by and Adapted from a Translation by W. Heywood

VINTAGE SPIRITUAL CLASSICS

Covers *Vintage Spiritual Classics* (series)

Art director John Gall
Designer John Gall
Illustrator historical sources (various picture archives)
Studio Vintage Books
Client Vintage Books/Random House
Typefaces Didot, Alternate Gothic
Software QuarkXPress, Adobe Photoshop
Colors 4/C process on special stock with gold foil stamping
Print run 25,000 per title

Concept "Although these books are referred to as 'spiritual classics,' what I was trying to convey in the covers was the fact that they were written by real live humans and have tremendous literary value beyond the religious content—not just for born-agains."

Cover *The Hundred Secret Senses*

Art director John Gall
Designer Chin-Yee Lai
Illustration personal collections
Studio Vintage Books
Client Vintage Books/Random House
Typefaces Trajan, Univers
Software QuarkXPress, Adobe Photoshop
Colors 4/C process plus 1/C flat metallic
Print run 15,000

Concept "'The hundred senses' is a phrase used to describe a situation in which all of a person's emotions rush to his or her heart at once—usually an event that evokes the person's past memories. The girl hiding behind the pillar represents the main character's concealment of past memories. Thus, those 'hundred senses' remain a secret to her American family."

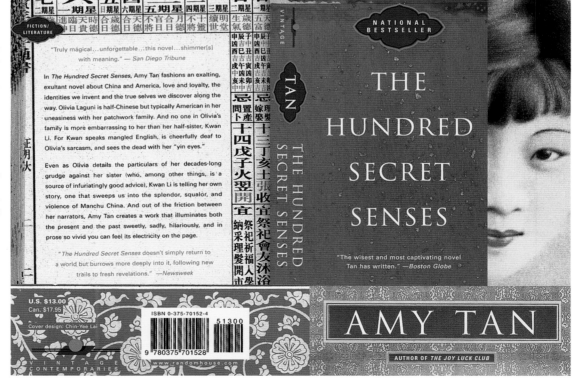

The Imitation of Christ

Thomas à Kempis

Preface by Sally Cunneen

Edited and Translated by Joseph N. Tylenda, s.j.

VINTAGE SPIRITUAL CLASSICS

Jacket *Demons*

Art director Carol Devine Carson
Designer Archie Ferguson
Illustrator Lynd Ward
Studio Alfred A. Knopf, Inc.
Client Alfred A. Knopf, Inc.
Typeface Letters culled and copied from an old Russian alphabet
Software QuarkXPress, Adobe Photoshop
Colors 3/C flat, printed on uncoated cream Tomahawk, with a press varnish
Print run 2,500

Concept "Lynd Ward stipulated in his will that none of his black-and-white woodcuts should ever be reproduced in anything other than in their original black and white— of which this is one. It's always worse when there's an estate involved, much less two aged generations thereof. Luckily, however, the granddaughter liked how I used the woodcut so much that she was able to persuade the widow into rolling old Mr. Ward over in his grave."

DEMONS

FYODOR DOSTOEVSKY

A NEW TRANSLATION BY
RICHARD PEVEAR AND LARISSA VOLOKHONSKY

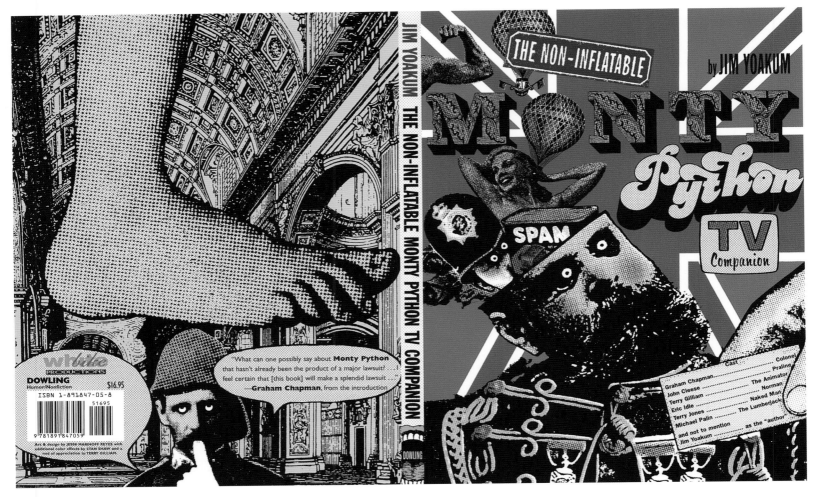

Cover *The Non-Inflatable Monty Python TV Companion*

Art director Jesse Marinoff Reyes
Designer Jesse Marinoff Reyes
Illustrator Jesse Marinoff Reyes, with special color effects by Stan Shaw
Studio Jesse Marinoff Reyes Design
Client Dowling Press
Typefaces Candice (redrawn), Havana, Franklin Gothic Triple Condensed, Silvestre Foliated Caps
Software traditional mechanical; QuarkXPress, Adobe Photoshop
Colors 4/C process
Print run 5,000

Concept "Terry Gilliam's work in Monty Python has always been an influence on me as a designer, so it was an absolutely fun project from the start." Utilizing the oversize format, Reyes conceived the design as a "Monty Python's Flying Circus" circus poster. Reyes used a florid, nineteenth-century wood display face along with late 1960s type forms, and rendered a Gilliam-influenced illustration "without directly mimicking his collage/animation style in favor of the xerox-driven, post-punk style that I prefer to work in—sort of Terry Gilliam meets Art Chantry." Later, Reyes decided the best way to use color would be with big-dot benday screens, like an old comic book. "For slightly more complex coloring, I called in airbrush illustrator Stan Shaw, who foolishly allowed me to convert his subtle tones into more big dots." Shortly before completing the job, Reyes encountered Gilliam himself at a New York booksigning. "We meandered into a conversation on graphic design and he asked if I had any of my work on me. I sheepishly admitted to having a working printout of this particular project stuffed into my carry bag. I showed it to him, and he asked if he could keep it and if I'd autograph it for him ('...uh, OK'). He either really liked it, or he will sue me."

Cover *Winnie Ille Pu*

Art director Paul Buckley
Designer Edward ODowd
Illustration Ernest H. Shepard
Studio The Viking Penguin Design Group
Client Penguin
Typefaces Trajan, Martin Gothic
Software QuarkXPress, Adobe Photoshop
Colors 5/C flat (including 1 metallic)
Print run 5,000

Concept "I received this assignment with just about no information. Looking for inspiration, I started flipping through the manuscript, and there it was—this hilarious little illustration of Winnie the Pooh, by E.H. Shepard, all done up like Julius Caesar. The rest is history. Another specially mixed ink and presto! We had a cover! The funniest thing about this job was the fact that I designed it in about an hour and ended up receiving two awards for it. Go figure...."

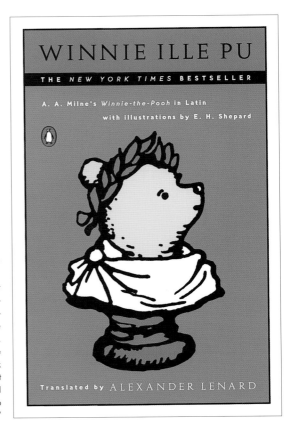

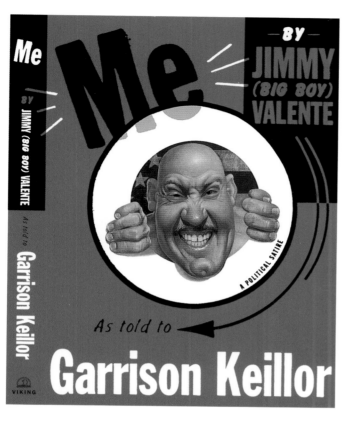

Jacket *Me*

Art director Paul Buckley
Designers Paul Buckley, Mark Melnick
Illustrator C.F. Payne
Studio The Viking Penguin Design Group
Client Viking
Typefaces Brush Script, Champion, Franklin Gothic
Software QuarkXPress
Colors 4/C with 1 flat
Print run 50,000

Concept Mark Melnick elaborates: "Assigned a conference room at the Viking compound, Project Resistance set to work. Our methodology was deceptively simple: On one wall we hung the 1,370 45s that comprised Thomas Mann's *Magic Mountain*, and on the opposing wall we hung the hardcover. We would meet in the morning, take our seats, and sit staring alternately at one wall, then the other, back and forth for eight hours each day until, four months later, it became obvious. 'Of course,' we all announced in unison and, in truth, it really could not have been more plain.

"Our results, once published, would go on to become the single most important research document in recorded history. *The Square, Root of Success: Why Circles Will Never Sell* explained, in commonsense, everyday prose, why circles would never catch on with a public already so enamored with rectilinearity. We traced the circle's history from antiquity, when it was synonymous with homosexuality, to today, where it's still vaguely gay. We pointed to its prominence in witchcraft and drug abuse, prostitution and eclipses of the sun and moon.

"Conversely, we followed the square from its earliest manifestation as the template for the Ten Commandments to today, where it's commonly associated with Renaissance paintings, love letters, the silver screen and quadrophonic sound—but above all, books. Yes, we knew now where our advantage lay, and it was only a matter of time before we assumed dominance in the marketplace yet again."

Cover *After Yesterday's Crash*

Art director Paul Buckley
Designer Paul Buckley
Photographs front cover image, Charles Gupton; back cover from left to right: A.P. World Wide; A.P. World Wide; Charles Gupton; Paul Buckley; Katrina Del Mar; The Everett Collection; A.P. World Wide
Illustrator (spine art) Jerry Buckley
Studio The Viking Penguin Design Group
Client Penguin
Typeface Courier
Software QuarkXPress
Colors 4/C process
Print run 10,000

Concept "It's one of those covers that is what it is. An opportunity to have some fun and not explain why you did what you did. Though I'm sure the retro child is holding what looks like some sort of mini-satellite as an omen of [what] our information-dense future will be."

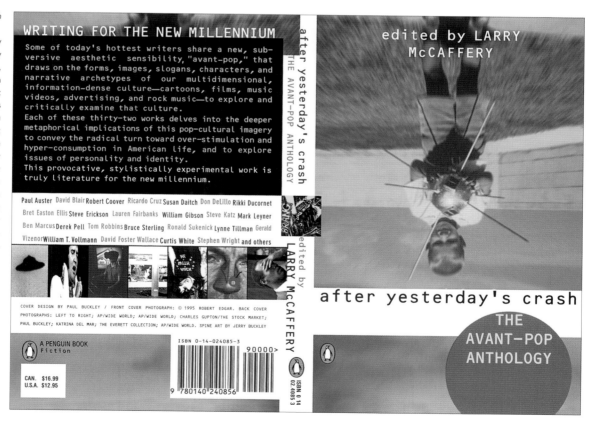

Cover *Wild at Heart*

Art director John Gall
Designer John Gall
Illustrator John Gall
Studio Grove/Atlantic
Client Grove/Atlantic
Typeface Trade Gothic Condensed
Software QuarkXPress, Adobe Photoshop
Colors 4/C flat
Print run 10,000

Concept "This book was the first in a trilogy of funny, but nightmarish, road novels that have the characters ending up in Mexico and Texas border towns. The idea was to create a series of covers resembling Mexican 'lotería' cards, only with darker themes. It worked quite well for the first two (particularly *Wild at Heart*), but by the third installment they wanted a babe on the cover."

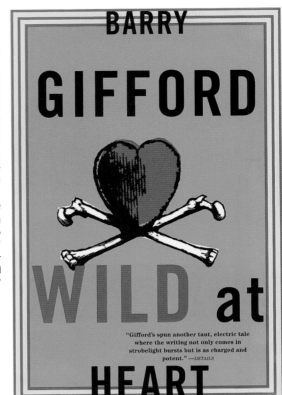

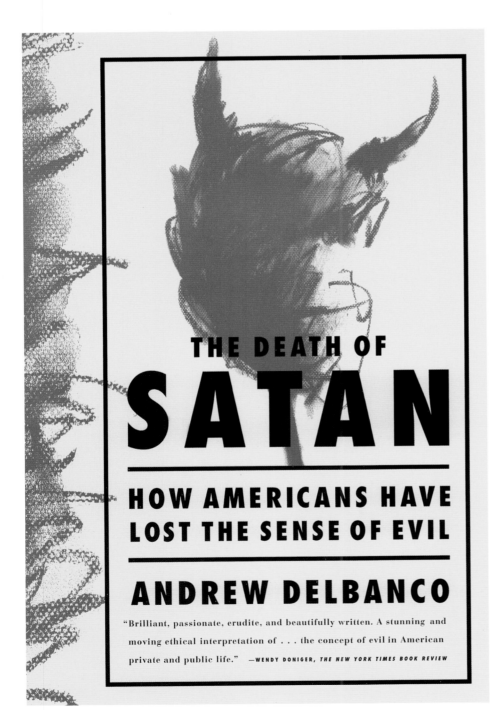

Cover *The Death of Satan*

Art director Michael Ian Kaye
Designer Rodrigo Corral
Illustrator Donna Mehalko
Studio Farrar, Straus and Giroux
Client Hill and Wang
Typeface Futura Bold
Software QuarkXPress
Colors 2/C flat
Print run 5,000

Concept "Delbanco's pronouncement that 'Satan is dead' is one I imagine appearing in newspaper headlines and on posters—tacked to lampposts and the doors of churches—done hastily to break the story. The cover, like the book, attempts to defy the threat of evil by simplifying it with a sketch, so as not to give form—and ultimately life—to the greatest of our fears."

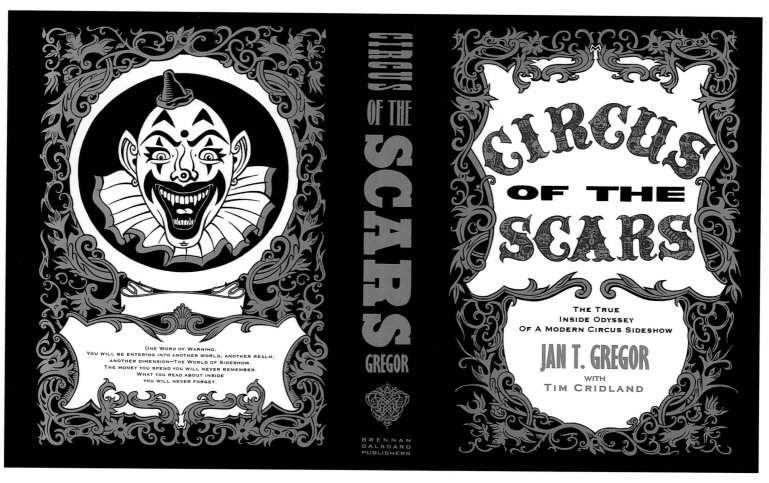

Case cover *Circus of the Scars*

Art director Ashleigh Talbot
Designer Ashleigh Talbot
Illustrator Ashleigh Talbot
Studio Ashleigh Talbot/Parlor XIII
Client Brennan Dalsgard Publishers
Typefaces hand-rendered, pen and ink; Calisto MT
Software traditional mechanical
Colors 2/C flat (including 1 metallic) on white stock
Print run 10,000

Concept As an antidote to all-too-often "flash-published" books—finished from concept to bound book in three to six months—Talbot took three years to design and illustrate this one, with all 450 pages laid out by hand. Wanting to create "something that would last," she employed Smyth-sewn binding and embellished the case cover with a gold-embossed clown. "We felt that the book itself was to be a work of art, and every detail was created all by hand. The dust jacket would be the most important aspect of the book, as folks do judge a book by its cover. All of the design and illustration was inspired by Victorian design elements and circus/sideshowesque motifs."

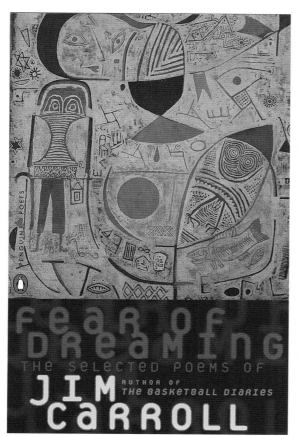

Cover *Fear of Dreaming*

Art director Paul Buckley
Designer Gail Belenson
Illustrator Paul Klee, *Picture Album*, 1937
Studio The Viking Penguin Design Group
Client Penguin
Typeface Platelet
Software QuarkXPress, Adobe Photoshop
Colors 4/C process
Print run 6,000

Concept The initial cover idea was to contemporize an early twentieth-century piece of art. Belenson explains: "The Paul Klee is wonderful on its own—but I wanted both to visually illustrate the suggestive title, and to make the entire package current. Hence the blurry, dreamlike quality of the type, which is marred by horizontal TV/video-like lines."

Jacket *High Fidelity*

Art director Ann Spinelli
Designer Archie Ferguson
Photographer Swavo Zulawinski
Studio Archie Ferguson Design
Client Riverhead Books
Typefaces Bank Gothic, Ribbon 131
Software QuarkXPress, Adobe Photoshop
Colors 3/C flat (black plus a dropout halftone of PMS 1795 over PMS 381) with matte film lamination
Print run 50,000 at least (it was a huge surprise best-seller, and then went into paperback and audio, all with the same cover)

Concept "Good books deserve cool art and good design. I found an appropriately outrageous photograph and did a good design—that's all. Sometimes there's no deep concept. Perhaps that is what the book was about, anyway."

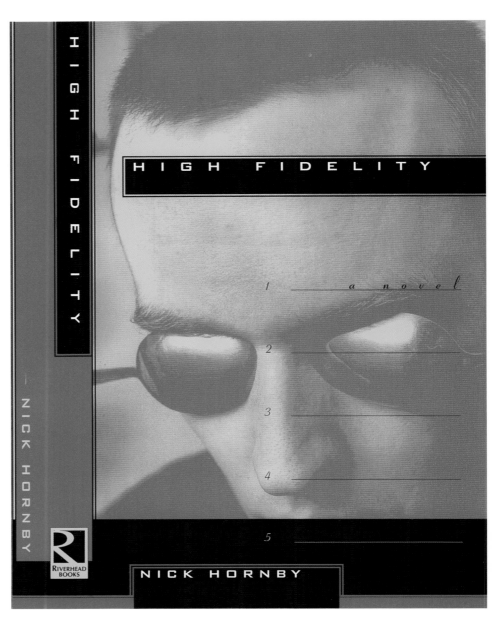

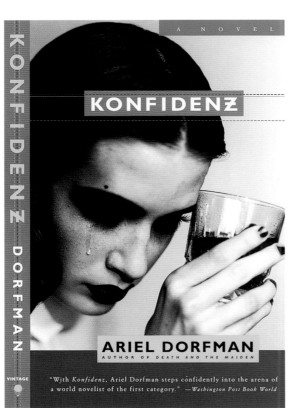

Cover *Konfidenz*

Art director Susan Mitchell
Designer Ingsu Liu
Photographer Michel Dubois
Studio Vintage Books
Client Vintage Books/Random House
Typefaces Gill Sans Bold Extended, Simoncini Garamond
Software Adobe Photoshop, QuarkXPress
Colors 4/C process
Print run 8,000

Concept "The panels and bright colors were utilized to represent the style and the pace of the author's writing."

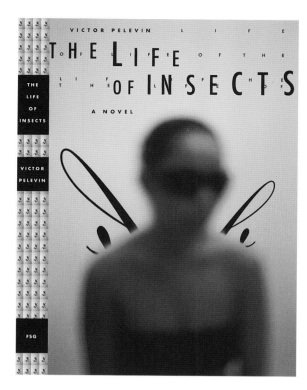

Jacket *The Life of Insects*

Art director Susan Mitchell
Designer Rodrigo Corral
Photographer Frederick S. Schmidt
Studio Farrar, Straus and Giroux
Client Farrar, Straus and Giroux
Typefaces Futura Demi, Bold and Medium Condensed
Software QuarkXPress
Colors 4/C process
Print run 8,000

Concept Corral explains, "The story depicts characters who alternate between human beings with buglike qualities and insects with human capabilities. My jacket solution depicts a character who's got it all."

Cover *Lamb*

Art director Ingsu Liu
Designer Ingsu Liu
Photographer Vance Gallert
Studio W.W. Norton Design Group
Client W.W. Norton & Co.
Typefaces Opti-Iting, Poetica Chancery, Bank Gothic
Software Adobe Photoshop, QuarkXPress
Colors 4/C process
Print run 5,000

Concept Liu explains that the book tells a poignant story about love and loss. "I wanted a cover that would allow the viewer to feel just that."

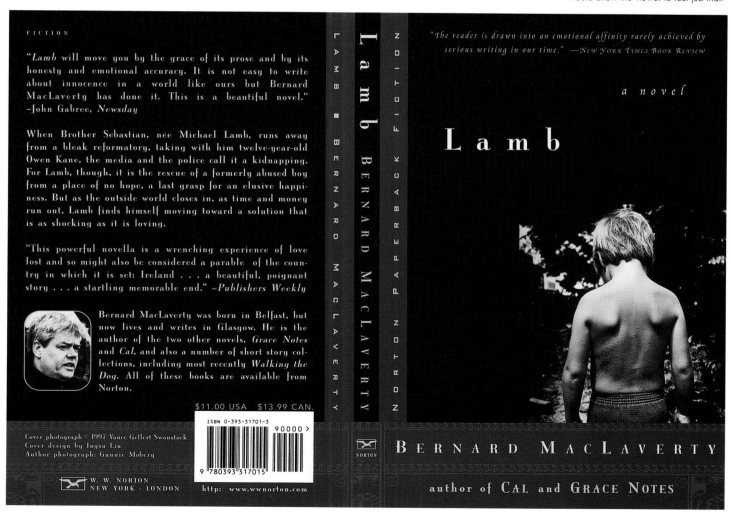

Jacket *In the Hat*

Art director Michael Accordino
Designer John Gall
Studio John Gall Graphic Design
Client Simon and Schuster
Software QuarkXPress, Adobe Photoshop
Colors 3/C flat plus Day-Glo yellow
Print run 15,000

Concept "A genre crime-mystery about prison, guns, drugs, naked girls, pimps, more prison and drugs, cockfighting and a guy with a pet alligator usually requires a cover that shows either prison, guns, drugs, naked girls, etc., or at the very least a guy with a pet alligator. Since I can't really draw a naked girl any more, and my Photoshop skills don't allow me to piece together an alligator wearing sunglasses, I had to go with the next best thing—tough, hard-hitting type that hints at the grit of the story without being obvious. Then again, if I could only draw a pimp...."

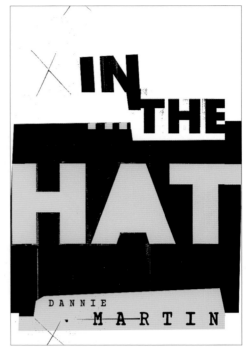

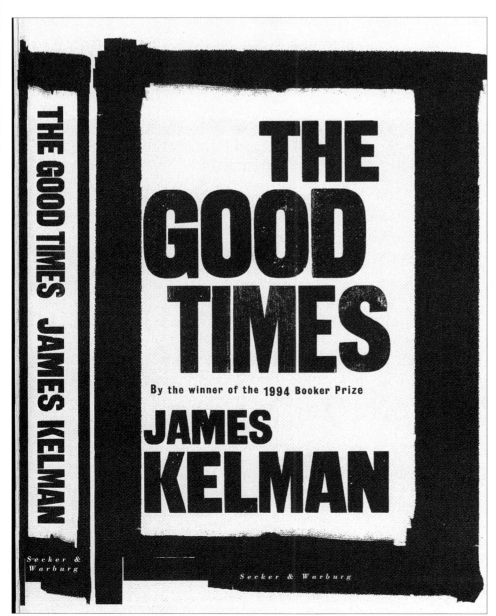

Jacket *The Good Times*

Art director Jamie Keenan
Designer Jamie Keenan
Typographer Alan Kitching
Studio Secker & Warburg
Client Secker & Warburg
Typefaces available wood type forms at the printer's shop
Software QuarkXPress
Color 1/C flat
Print run 8,000

Concept "The idea was to commission a printmaker who uses traditional letterpress techniques to produce a stark, austere and basically miserable cover at odds with the positive title. It may also have been influenced by the fact that the author will not allow images on his covers. The cover was printed in black on an uncoated, textured paper."

Conor Horgan

"There was Joyce's Dublin and now there's Roddy Doyle's: wholly contemporary, extremely funny, and wonderfully and energetically delinquent. Irresistible to the modern spirit." —Fay Weldon

"Doyle's trilogy on modern working-class Dublin life bursts with energy, and his writing leaps off the page." —The Boston Irish Reporter

"These Dubliners would have made James Joyce chuckle. . . . Roddy Doyle has hit the mother lode with the Rabbittes. Everyday life just doesn't get any better." —Boston Sunday Herald

"Roddy Doyle has captured the real spirit of Dublin—quick-witted, sharp, and inventive. His characters are drawn with great affection and love, and stay in the mind long after you have laughed your head off at the brilliant dialogue." —Colm Tóibín

"Earthy and exuberant, Roddy Doyle's novels are as hilarious as they are haunting. Rich, bittersweet slices of Dublin life, they chronicle the antics of the Rabbittes, a large and lively working-class family...with brash energy, cheerful irreverence, and a street idiom that reads like poetry." —San Francisco Chronicle

A trio of comic novels depicting the daily life and times of the Rabbitte family in working-class Dublin

A PENGUIN BOOK
Fiction

cover design by Paul Buckley

ISBN 0-14-025262-2

90000>

$16.95

9 780140 252620

ISBN 0 14 025262 2

RODDY DOYLE

THE COMMITMENTS • THE SNAPPER • THE VAN

The Barrytown Trilogy

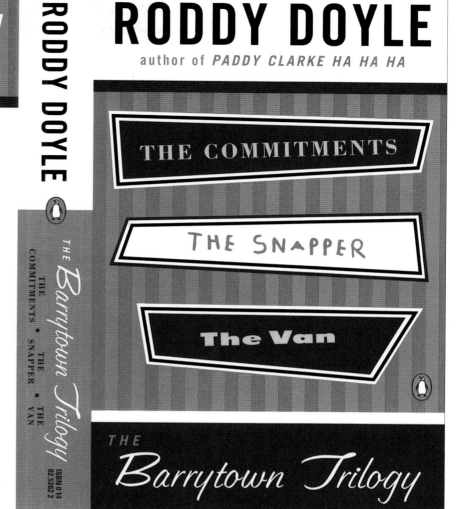

RODDY DOYLE
author of PADDY CLARKE HA HA HA

THE COMMITMENTS

THE SNAPPER

The Van

THE
Barrytown Trilogy

Jacket *The Barrytown Trilogy*

Art director Paul Buckley
Designer Paul Buckley
Photographer Marc Atkins
Studio The Viking Penguin Design Group
Client Penguin
Typefaces Bodoni, Child, Opti Lester, Trade Gothic
Software QuarkXPress
Colors 4/C flat
Print run 7,500

Concept "Roddy Doyle is one of our more talented authors, but he never seems to sell the quantity of books that some of his less talented contemporaries do. So whenever there is a new Doyle book to package, it goes through the usual jittery design-by-committee route. This collection of stories was just the opposite: It was a small backlist book that needed a new package. I tried to get across the sense of humor that runs throughout these stories, and it was the easiest Doyle approval I've had."

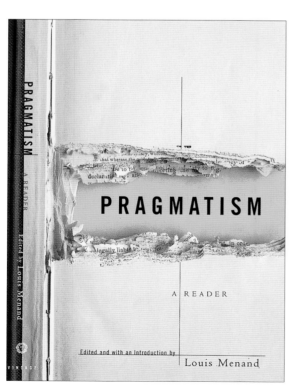

Cover *Pragmatism*

Art director John Gall
Designer John Gall
Photographer Katherine McGlynn
Studio Vintage Books
Client Vintage Books/Random House
Typefaces Trade Gothic Condensed, Centaur
Software QuarkXPress, Adobe Photoshop
Colors 4/C process
Print run 15,000

Concept "Occasionally I like to design covers (concept permitting) where the components of a book can function as the cover itself. In this case, the book is a collection of writing about 'pragmatism—an interesting topic, but potentially boring subject matter for a book cover." Gall adds, "My concept was to somehow depict a way of thinking that cuts through the malarky and gets to the point, but in a visually intriguing way."

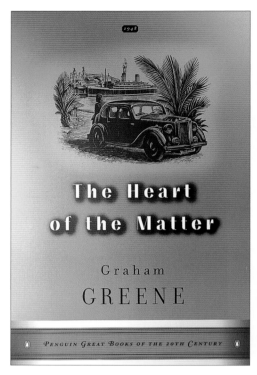

The Heart of the Matter

Graham
GREENE

PENGUIN GREAT BOOKS OF THE 20TH CENTURY

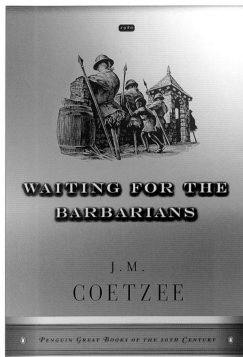

WAITING FOR THE BARBARIANS

J.M.
COETZEE

PENGUIN GREAT BOOKS OF THE 20TH CENTURY

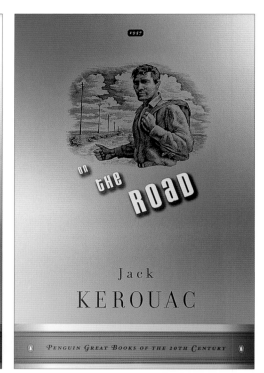

on THE ROAD

Jack
KEROUAC

PENGUIN GREAT BOOKS OF THE 20TH CENTURY

John Steinbeck (1902–1968) was born in Salinas, California. He studied at Stanford University but left without taking a degree and, after a series of jobs, began to write. His first book, *Cup of Gold*, was published in 1929.

Popular success came to him in 1935 with *Tortilla Flat*. That book's promise was confirmed by succeeding works—*In Dubious Battle*, *Of Mice and Men*, and especially *The Grapes of Wrath*, a novel so powerful that it remains an enduring American classic. Often set in California, Steinbeck's later books include *Cannery Row*, *The Wayward Bus*, *East of Eden*, and *Travels with Charley*.

In 1962, Steinbeck received the Nobel Prize for Literature. In announcing the award, the Swedish Academy declared: "He had no mind to be an unoffending comforter and entertainer. Instead, the topics he chose were serious and denunciatory, for instance, the bitter strikes on California fruit and cotton plantations. . . . His literary power steadily gained impetus . . . [until] the great work . . . the epic chronicle *The Grapes of Wrath*."

"To the red country and part of the gray country of Oklahoma, the last rains came gently, and they did not cut the scarred earth . . ."

Archive Photos

1939
GREAT BOOKS

STEINBECK • *The Grapes of Wrath*

A PENGUIN BOOK
Literature

U.S. $13.95
CAN. 19.99

ISBN 0-14-028162-2

90000>

9 780140 281620

EAN

Cover design by PAUL BUCKLEY
Cover art by ANDREW DAVIDSON

PENGUIN GREAT BOOKS OF THE 20TH CENTURY

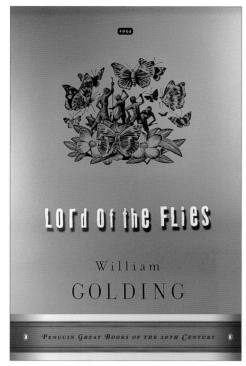

Jackets *Great Books of the 20th Century* (series)

Art director Paul Buckley
Designer Paul Buckley
Illustrator Andrew Davidson
Studio The Viking Penguin Design Group
Client Penguin
Typefaces Aquiline, Chancellaresca, Civilite, Engravers O.E., Escrita Mariachi, House Gothic, Huoncry, Jandoni, Mercury, Mrs. Eaves, Numskill, Opsmarckt, Platelet, Prophecy, Reporter 2. Format fonts: Filosofia, Hoefler Text
Software QuarkXPress, Adobe Illustrator, Adobe Photoshop
Colors 5/C flat (including one metallic) with French flaps and a rough front
Print run 10,000 each

Concept To mark the closing of the century, Penguin decided to produce its version of "the greatest books of the twentieth century," an offshoot of the staid Penguin Classics. "I wanted these titles to have a strong Penguin identity—hence the orange stripe—and to function as covers that would remain classic and elegant for years to come." Buckley commissioned Andrew Davidson for his excellent woodcuts, and after setting up the basic design parameters of the series, concentrated on color and various title type treatments to reflect each particular story. "So, having sunk money into the high production value, Penguin needed to charge a few dollars more. But the consumer is still buying the original Penguin Classic at a lesser price, so we have essentially competed against ourselves and lost."

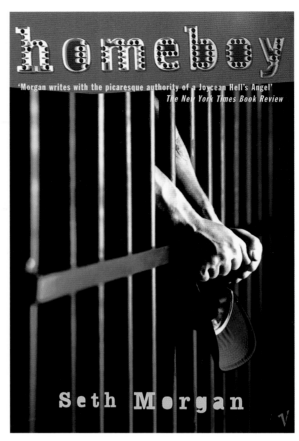

Cover *Homeboy*

Art director Jamie Keenan
Designer Jamie Keenan
Photographer Sara Morris
Studio Random House UK
Client Vintage Books/Random House UK
Typeface Sans Counter
Software QuarkXPress, Adobe Photoshop
Colors 4/C process
Print run 5,000

Concept "The two key settings of *Homeboy* are the porno-theater district of San Francisco and Coldwater High Security Penitentiary. The idea was to show both these sides, so I asked a photographer who I knew was pretty resourceful if she could think of some way to get into a prison for a few hours. She actually ended up building cell bars out of broomsticks, which she'd painted and distressed to appear metallic, and shot the prisoner, specially selected for his veiny, tattooed arms, at an angle that was not only dramatic, but conveniently meant that the background of the cell couldn't be seen—publishing budgets in the UK are fairly small and don't allow for the construction of complete prison institutions. The type began as a reference to the lights and signs of the sleazy areas described in the book: The effect of fairground signs where solid letters and rows of bulbs sit on top of each other. It also has a sharp, metallic feel that suits the violent nature of the book."

Cover *No Lease on Life*

Art director Jamie Keenan
Designer Jamie Keenan
Photographer Marc Atkins/Panoptica
Studio Secker & Warburg
Client Secker & Warburg
Typeface Trade Gothic
Software QuarkXPress, Adobe Photoshop
Colors 4/C process
Print run 3,000

Concept "Halfway through reading this book I saw this photograph of New York apartment blocks with their fire escapes, and felt straight away that the image was perfect for the feel of the novel. I like trying to get type and images to work together to create one unified thing, so I used the perspective of the photograph as a way of tying the two together, and as a way to imply the fast pace of the story. This idea of perspective is then carried through onto the spine and the back cover."

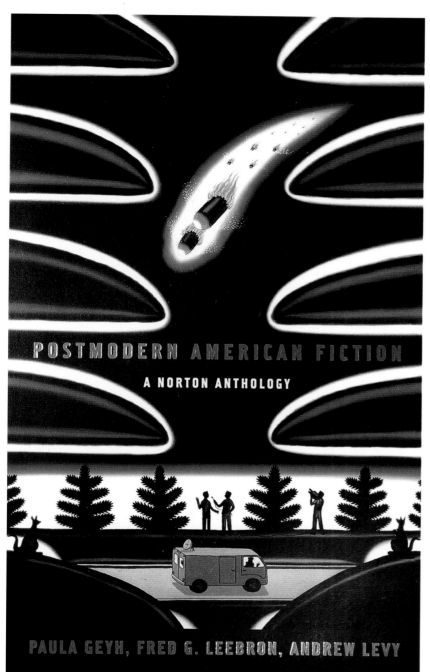

Jacket *Postmodern American Fiction*

Art director Ingsu Liu
Designer Ingsu Liu
Illustrator Roger Brown, *Skylab by Minicam*, 1979
Studio W.W. Norton Design Group
Client W.W. Norton & Co.
Typefaces Hamilton, Avenior
Software Adobe Photoshop, QuarkXPress
Colors 4/C process plus red foil
Print run 15,000

Concept Liu remarks, "I really liked this piece of art—I wanted a very simple type treatment, so I placed the type in the sky where the rocket is about to hit."

Jacket *Stories in the Worst Way*

Art director Carol Devine Carson
Designer Archie Ferguson
Photographer Nole Lopez
Studio Alfred A. Knopf, Inc.
Client Alfred A. Knopf, Inc.
Typefaces Trade Gothic, Trade Gothic Bold Condensed
Software QuarkXPress, Adobe Photoshop
Colors 4/C process, with spot varnish over sauce packets
Print run 2,000

Concept "This idea came to me while having dinner with friends one evening. I slipped the art into my pocket before making my way out—hopefully, my host didn't notice."

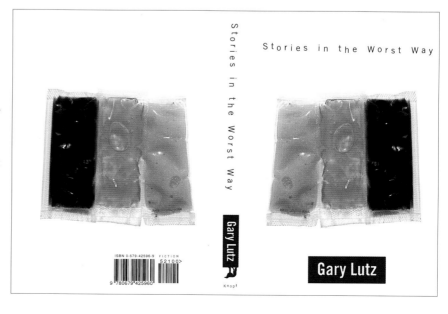

Cover *About a Boy*

Art director Ann Spinelli
Designer Archie Ferguson
Photographer Marcia Lieberman
Studio Archie Ferguson Design
Client Riverhead Books
Typefaces Futura, Bank Gothic, Berthold Script
Software QuarkXPress, Adobe Photoshop
Colors 4/C process plus 1/C flat and embossed eyes
with a spot varnish
Print run 10,000

Concept "I had done a design that I absolutely loved, involving a pacifier. Then the author changed the title from *Father Figure* to *About a Boy*. It seemed clumsy, and I wanted to hide it. The publisher wanted something hip and clever in two days—that's when I love/hate my job."

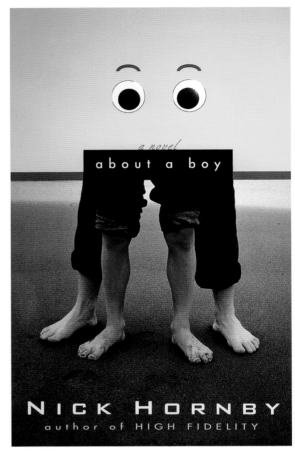

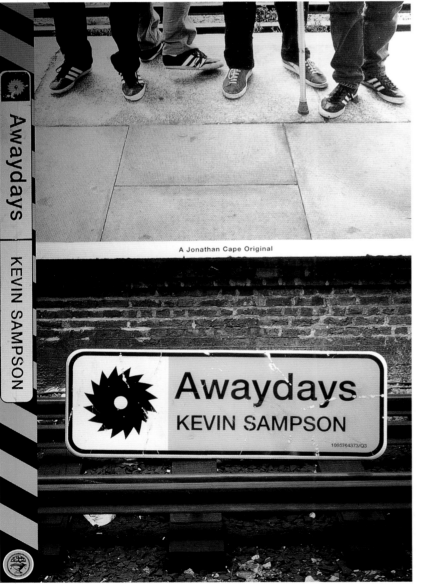

Cover *Awaydays*

Art director Jamie Keenan
Designer Jamie Keenan
Photographer Rankin
Studio Random House UK
Client Jonathan Cape/Random House UK
Typeface Helvetica
Software QuarkXPress, Adobe Photoshop
Colors 4/C process with embossed "sign"
Print run 8,000

Concept "*Awaydays*, set in 1979, is centered around English soccer hooligans and their music. The author's original idea was to show four characters from the book dressed in authentic fashion and with the right haircuts from the period. Eventually, I managed to persuade him that just showing the four characters' feet (getting hold of the right trainers [sneakers] and jeans would be just about possible) would suggest far more than a photograph showing them in full could ever do. The typography was based on British Rail signage, as large parts of the story take place on trains ferrying fans to and from away fixtures."

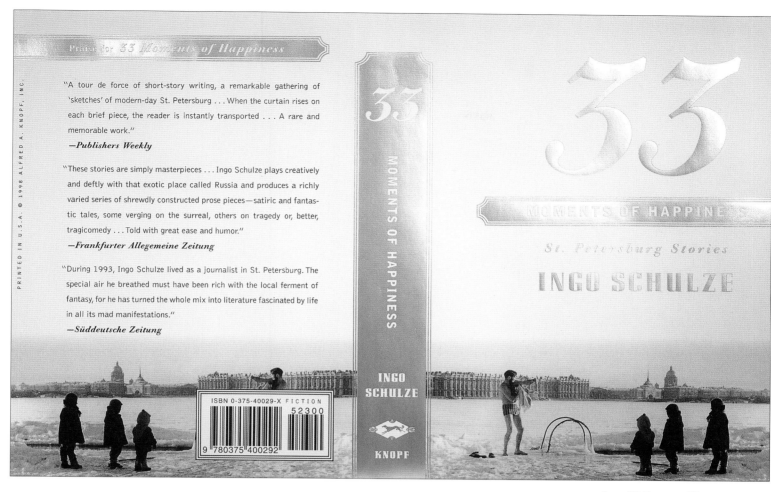

Printed for *33 Moments of Happiness*

"A tour de force of short-story writing, a remarkable gathering of 'sketches' of modern-day St. Petersburg . . . When the curtain rises on each brief piece, the reader is instantly transported . . . A rare and memorable work."
—*Publishers Weekly*

"These stories are simply masterpieces . . . Ingo Schulze plays creatively and deftly with that exotic place called Russia and produces a richly varied series of shrewdly constructed prose pieces—satiric and fantastic tales, some verging on the surreal, others on tragedy or, better, tragicomedy . . . Told with great ease and humor."
—*Frankfurter Allegemeine Zeitung*

"During 1993, Ingo Schulze lived as a journalist in St. Petersburg. The special air he breathed must have been rich with the local ferment of fantasy, for he has turned the whole mix into literature fascinated by life in all its mad manifestations."
—*Süddeutsche Zeitung*

PRINTED IN U.S.A. © 1998 ALFRED A. KNOPF, INC.

ISBN 0-375-40029-X FICTION
52300
9 780375 400292

Cover *33 Moments of Happiness*

Art director Carol Devine Carson
Designer Archie Ferguson
Photographer Lev Poliakov
Illustrator Archie Ferguson
Studio Alfred A. Knopf, Inc.
Client Alfred A. Knopf, Inc.
Typefaces Bodoni Old Face Medium Italic, Bell Gothic Bold, Corvinus, Skyline
Software QuarkXPress, Adobe Photoshop
Colors 2/C flat halftone plus matte silver foil stamping, printed on an uncoated, superwhite stock
Print run 2,000

Concept "Progressively strange stories about life in post-perestroika St. Petersburg—go figure. This is the first photograph I showed to the editor, who had me spend the next six months looking for something better. Two prints of the photograph had been smuggled out of Russia by Lev years earlier, before the iron curtain was parted. 'They' kept his negatives."

Jacket *Tough Jews*

Art director Jamie Keenan
Designer Jamie Keenan
Photograph Municipal Archives, Lower Manhattan, New York
Studio Random House UK
Client Jonathan Cape/Random House UK
Typeface Clarendon
Software QuarkXPress, Adobe Photoshop
Colors 4/C process
Print run 3,000

Concept "The starting point for *Tough Jews*, the little-known story of Jewish gangsters who operated in Manhattan in the 1930s and 1940s, was an old photocopy of a photograph, supplied by the author, taken by the New York Police at the time. My idea was that, rather than trying to repair the image (I'm not that good with Photoshop), I should use the slightly disturbing effect of the damaged photocopy, and try and get all the other elements of the cover to tie in with it. For the main title, I used a typeface that suggested a dramatic newspaper headline, and as a background to this I used a texture created by rolling out printing ink, which again conveyed the dark mood of the book. Most of the main elements of the cover are at very slight angles, not enough to be noticeable, but enough to look just slightly wrong."

Cover *Unfinished Business*

Art director Martin Ogolter
Designer Martin Ogolter
Photographer photo courtesy of Cinécittà
Studio Martin Ogolter/y design
Client Marsilio
Typefaces Pop, Interstate
Software QuarkXPress, Adobe Photoshop, Adobe Illustrator
Colors 4/C process
Print run 3,500

Concept For the cover of this book of essays, commentary and unfinished scripts, Ogolter used images from finished Antonioni projects and attempted to obscure them beyond immediate recognition. "Think *Blow-Up*."

Cover *The Story Teller*

Art director Paul Buckley
Designer Edward ODowd
Illustrator Mark Ryden
Studio The Viking Penguin Design Group
Client Penguin
Typeface hand-rendered lettering
Software QuarkXPress, Adobe Photoshop
Colors 4/C process
Print run 5,000

Concept "The process for this cover was fairly simple, since my art director at the time did all of the conversing with the illustrator. My challenge was what to do with the art. The illustration Mark did was so beautiful, I hated the idea of slapping some computer-generated type across it. I started painting type with ink on tracing paper over Mark's artwork, and I feel the end result was something far more powerful than any digital type could have been."

Jacket *The Ball*

Art director Paul Buckley
Designer Jesse Marinoff Reyes
Photographer Brad Wilson (the ball); Rich Pilling/MLB Photos (Mark McGwire)
Studio The Viking Penguin Design Group
Client Viking
Typefaces Brush Script, Champion, Franklin Gothic, Rockwell
Software QuarkXPress, Adobe Photoshop, Adobe Illustrator; traditional mechanical elements
Colors 4/C plus 1 flat metallic
Print run 12,500

Concept *The Ball* documents the collector frenzy that engulfed the auction of the single-season home run record ball, which sold for nearly three million dollars. Reyes explains, "I'm a big baseball fan, period. I've always loved old baseball graphics, programs, pennants and especially trading cards—from the old Topps cards that you remember from when you were a kid to the high-design, high-production value cards of today. Since *The Ball* had to do with collecting, the sports memorabilia biz and the objectification of cultural symbols, I thought, gee, why not treat the jacket as a collectible—a baseball card of *a baseball*, the collectible itself." Reyes aimed for a hybrid of those old 1950s and 1960s card designs—straightforward, sometimes naive, sometimes badly printed—and a modern trading card with a slick photomontage and a metallic ink. "Above and beyond the topic of the book, it was an irresistible solution and more fun than trying to represent an auction or something. The author liked where we were going with it, and he and the editor scratched their copy for the back cover and contributed new text that was in keeping with the concept."

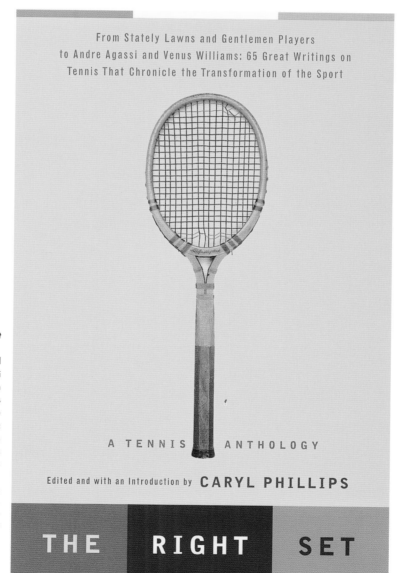

Cover *The Right Set*

Art director John Gall
Designer Chin-Yee Lai
Photographic source The Gurney Collection
Studio Vintage Books
Client Vintage Books/Random House
Typefaces Bell Gothic, News Gothic
Software QuarkXPress, Adobe Photoshop
Color 4/C process
Print run 8,000

Concept *The Right Set* is a collection of writings on tennis players as well as the history of the game. Lai explains, "The vintage tennis racket in the middle of the cover reminds readers of the changes that have taken place on, and off, the court. Using various colors derived from the racket not only vivifies the cover, but also symbolizes the evolution of the sport."

Jacket *The Last King of Scotland*

Art director Carol Devine Carson
Designer John Gall
Photographer Archive Photos
Studio John Gall Graphic Design
Client Alfred A. Knopf, Inc.
Typefaces Alternate Gothic, Clarendon
Software QuarkXPress, Adobe Photoshop
Colors 4/C process
Print run 20,000

Concept "With a title like *The Last King of Scotland*, you would not immediately think that this was a novel about Idi Amin. I thought the best thing to do was to let these two incongruous elements sit side by side on the cover, as a prelude to the bizarre story told within."

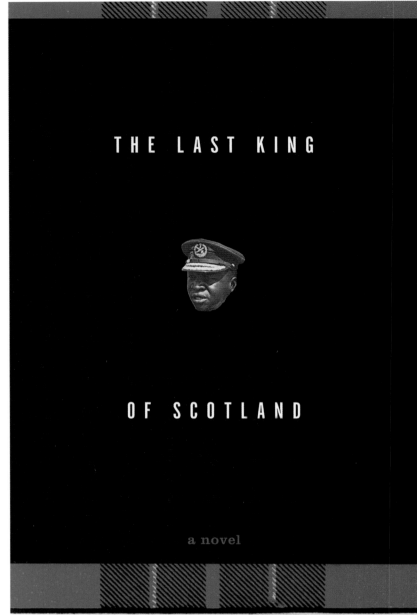

THE LAST KING

OF SCOTLAND

a novel

GILES FODEN

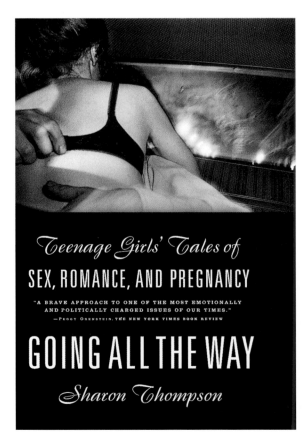

Cover *Going All the Way*

Art director Michael Ian Kaye
Designer Rodrigo Corral
Photographer Sylvia Plachy
Studio Farrar, Straus and Giroux
Client Hill and Wang
Typeface Mheadline Bold
Software QuarkXPress
Color 1/C flat
Print run 5,000

Concept "For a book that illustrates the sense of urgency that teenagers often experience when they first encounter sex, I tried to make the cover feel a little bit uncomfortable—a little risque....I wanted people to have mixed feelings, just like the kids in the photo."

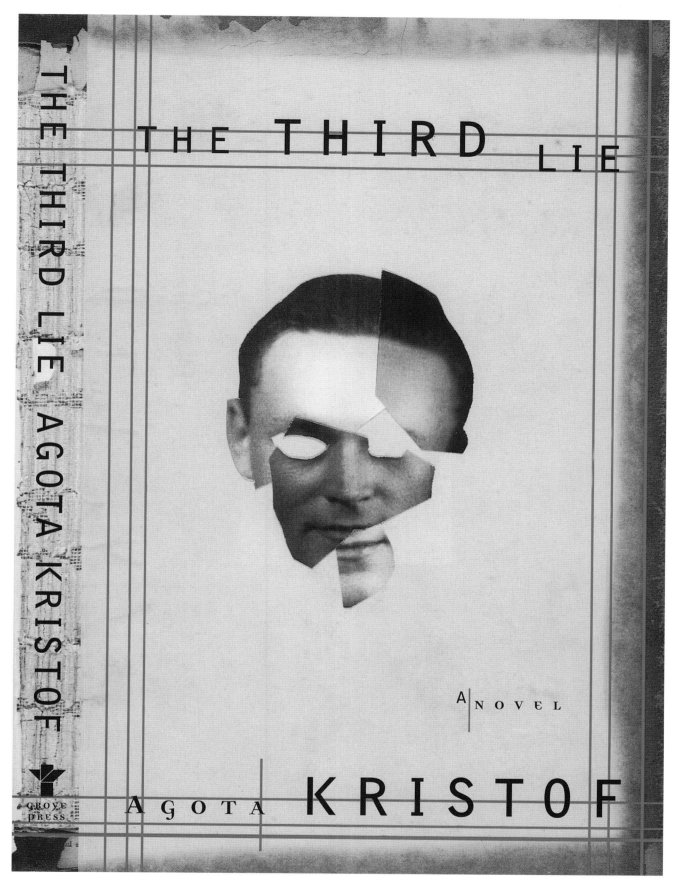

THE THIRD LIE

THE THIRD LIE AGOTA KRISTOF

A NOVEL

AGOTA KRISTOF

GROVE PRESS

Jacket *The Third Lie*

Art director John Gall
Designer John Gall
Illustrator John Gall
Studio Grove/Atlantic
Client Grove/Atlantic
Typefaces Bell Gothic, Democratica
Software QuarkXPress, Adobe Photoshop
Colors 4/C process
Print run 10,000

Concept A metaphor for post-World War II Europe, this novel describes a man's search for his long-lost twin brother, and the unexpected results. Gall remarks, "The inside-out book cover relates to the elliptical quality of the story, and the fact that the reader really never knows what is true and what is in the main character's imagination."

POSTERS

13

L A

Poster design has had a unique role in the history of graphic design: it is a medium in which the ideas of commercial art and the fine arts collide in an often spectacular manner with often spectacular results. Lester Beall and Paul Rand, Pablo Picasso and Joan Miró—masters of their respective disciplines— all designed posters. Not to mention that we know Henri de Toulouse-Lautrec as much for his graphic work in posters as we do his painting. Even now, in our busy, media-saturated world, the poster remains an effective attention-getter, be it a building-sized Broadway theater banner or a hand-photocopied rock show notice furtively stapled to a telephone pole.

Certain cities in the United States have stimulated the flowering of indigenous poster design talent. San Francisco, due in no small part to the punk rock and hard rock music scene of the 1970s and 1980s (not to mention the psychedelic 1960s), produced cutting-edge design and art talent such as Peter Belsito, Winston Smith and Winston Tong. Likewise, Los Angeles with Gary Panter, Raymond Pettibon and Shawn Kerri. And in Austin in the 1990s, plentiful music venues supported by the local college population fostered the talents of Frank Kozik, Lee Bolton and Lindsey Kuhn. Seattle has also been a big "poster town" because of the numerous public spaces (telephone poles, public notice kiosks, cafes or coffee shop windows) available to advertise its variety of alternative theater productions and rock music shows, instead of just traditional advertising venues like publications or billboards. Because of the need to promote cultural events that don't operate on a big budget, and despite the efforts of periodic "beautification" campaigns by misguided public officials (the "postering is an eyesore" mentality, an attitude that limits the vitality and economy of the grassroots community), Seattle has produced the likes of Art Chantry (author of the introduction to this book), Wes Anderson, Hank Trotter and Jeff Kleinsmith, who have gained attention for their work in national and, in the case of Chantry, international design competitions

and exhibitions. Given this same combination of circumstances, be the city Denver or Las Cruces, the result would be the same.

All of the work in this section has been created by designers under the age of forty, the majority focusing on the same topic, rock 'n' roll. Similarities in this generation's approach, or group-think, are evident: graphic design and popular culture influences echo from one to another despite geographic distance and (mostly) ignorance of one another's work; knowledgeable designers eschew current computer design programs in favor of traditional mechanical. Also, the advent of venues or other parties commissioning "touring" posters has birthed a new outlet for poster design where artists or design groups render posters as "commemorative stamps," instead of simply event promotion. Promoters were brought into the process only to legitimize the posters, to commission them or to agree to them, in exchange for a negotiated number to be sold or given away as the promoter saw fit. As this became a big business, it was increasingly rare even to see the posters before the show. Typically, they just showed up in catalogs for purchasing (and usually neither the bands themselves, nor their record labels, saw any of the profits). Design quality would vary as the identity of the bands featured superceded the actual appearance of the posters, although talented designers were able to distinguish themselves regardless. This phenomenon, pioneered in the late 1980s by Frank Kozik, created a cottage industry of limited-edition silkscreened "touring" posters, displayed and sold in galleries and on the Internet.

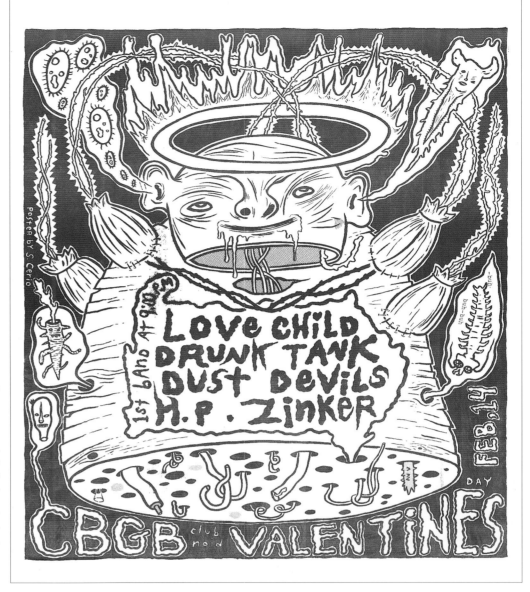

Event CBGB Valentine's Day

Art director Steven Cerio
Designer Steven Cerio
Illustrator Steven Cerio
Studio Steven Cerio's Happy Homeland
Client CBGB and featured bands
Typeface hand-rendered
Software traditional mechanical
Color 1/C offset litho
Print run 400

Concept "This was a seven-hour rush project, produced under the influence of biology book illustrations and psychedelic poster greats Rick Griffin and Lee Conklin." Cerio, educated as a painter and illustrator, began designing by accident and did not realize (at the time) that by incorporating typography into a hand-drawn image, he had gone beyond illustration. This was the first significant piece created in this vein, circa 1993. His other posters included in this book build upon this innocent beginning. While a magazine art director, this poster motivated me to hire Cerio not only as an illustrator, but as a designer of custom type treatments as well. Even now Cerio's design is purposefully counter-intuitive and possesses a spontaneity that I usually find lacking in the work of many formal designers.

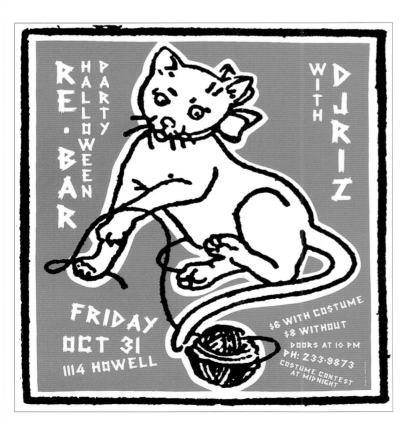

Event Re-bar Halloween

Art director Hank Trotter
Designer Hank Trotter
Studio Twodot Design
Client Re-bar
Typeface Latex Display
Software traditional mechanical;
Macromedia FreeHand
Colors 2/C flat, silkscreen
Print run 100

Concept "Oooh, Halloween is scary! Because most would tend toward ghosts and monsters for their Halloween poster, I used a kitten playing with a ball of yarn. But you know it's Halloween because, look, orange and black! This piece has a hefty dose of 'clunk' to it, which is good. I try not to have my designs go clunk, but they always seem to. If I were to get a tattoo, it would be of this kitty playing with a ball of yarn."

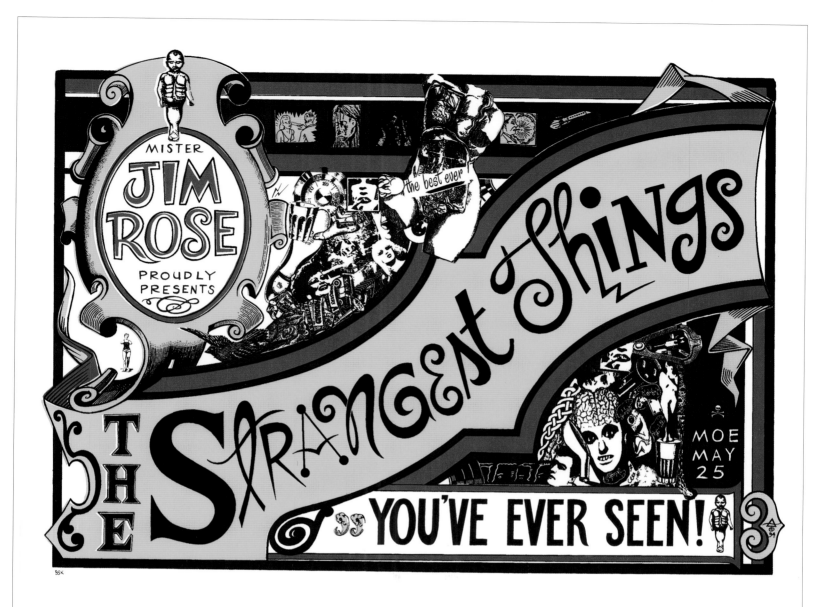

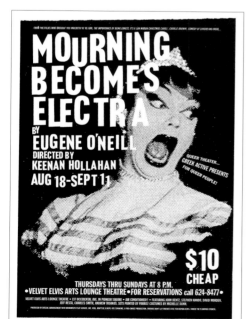

Event *Mourning Becomes Electra*

Art director Hank Trotter
Designer Hank Trotter
Studio Twodot Design
Client Greek Active
Typefaces Headline Gothic, Franklin Gothic
Software traditional mechanical;
Macromedia FreeHand
Color 1/C offset
Print run 200

Concept Greek Active was a theater company started by nationally syndicated sex advice columnist Dan Savage ("Savage Love"). In his productions, traditional plays are updated and played for laughs with women in men's roles and men in women's roles. Hank Trotter says, "The art came from a 1960s drag queen magazine that I had been given to use for a CD cover I was doing at the time. Hand-setting the type with an irregular baseline and running lines of type out from the mouth as shout lines helps communicate the frenetic pacing and camp of the show."

Event Jim Rose

Art director Ashleigh Talbot
Designer Ashleigh Talbot
Illustrator Ashleigh Talbot
Studio Ashleigh Talbot/Parlor XIII
Client Vox Populi Gallery
Typeface hand-rendered pen and ink
Software traditional mechanical
Colors 3/C flat, silkscreen
Print run 50

Concept "Inspired by an old absinthe label design, I wanted to create something that looked as if it were from the 1880s—a recurrent theme in much of my work—with a bit of sexy-creepy appeal thrown in. Admittedly, I am a purist, using the same tools that were used then: pen and ink, with amberlith overlays for the color, and then silkscreened by hand, not mass-produced by computerized, calibrated machinery."

Event Chill Freez

Art director George Estrada
Designer George Estrada
Illustrator George Estrada
Studio Ames
Client Art Bar
Typefaces hand cut from rubylith
Software traditional mechanical
Colors 2/C flat, silkscreen
Print run 50

Concept Says Estrada, "I used two colors the best I could—with knock-outs and overprints. I wanted a jazzy, street feel (like 'Paul-Rand-in-the-hood')."

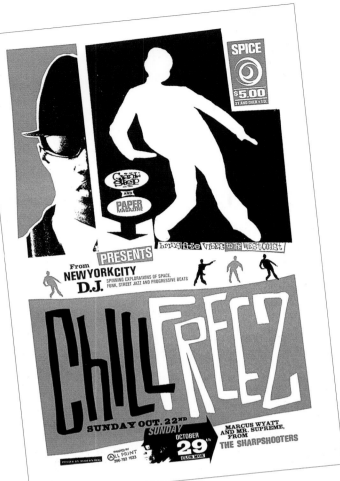

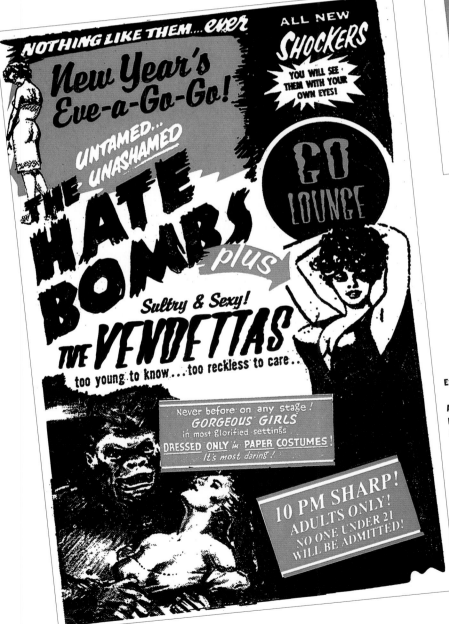

Event Hate Bombs/Vendettas New Year's Eve

Art directors Steve Carsella, Chris Jones, Scott Sugiuchi
Designer Scott Sugiuchi
Studio Backbone Design
Client Go Lounge
Typefaces Zombie, Brody, Horror Hotel, various photocopied and hand-manipulated newspaper headlines
Software Adobe Illustrator, Adobe Photoshop
Colors 4/C process
Print run 50

Concept The designer created "a train wreck cross-pollination of vintage Z-movie horror film posters and striptease advertisements found in the back of late 1950s/early 1960s men's magazines. Artwork was photocopied, scanned, output, repasted up and rescanned to achieve maximum 'old school' effect."

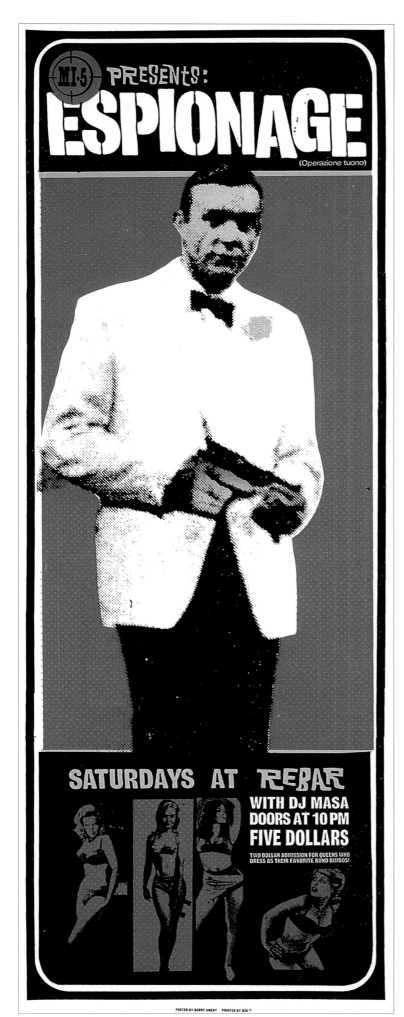

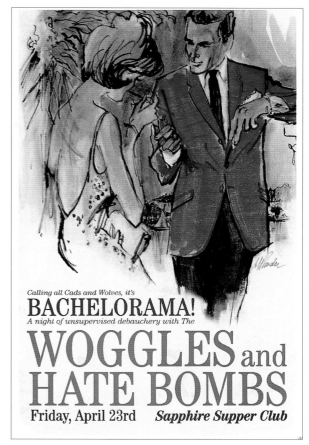

Event Bachelorama!

Art directors Steve Carsella, Chris
Jones, Scott Sugiuchi
Designer Scott Sugiuchi
Studio Backbone Design
Client Sapphire Supper Club
Typefaces Century Schoolbook,
Century Schoolbook Italic
Software Adobe Illustrator,
Adobe Photoshop
Colors 4/C process
Print run 50

Concept The intent for this "poster
for a bachelor party and garage
go-go-rama," was to reproduce the
look of "classic 'under-the-counter'
publications of the 1960s."

Event Espionage

Art director Kara Harris
Designer Barry Ament
Illustrator Barry Ament
Studio Ames
Client Kara Harris (Re-bar)
Typefaces hand-rendered; Helvetica, Clarendon
Software traditional mechanical ("a lot of happy
mistakes in this one")
Colors 3/C flat, silkscreen
Print run 200

Concept "Somewhere between the *macarena* and
Ricky Martin came the 'cocktail nation.' The Rat
Pack, cocktail napkins and the Cold War have all
been rediscovered, along with all that 'yeah,
baby' secret agent cool. Everyone wants to style
like Sean Connery! I was lucky enough to do my
first silkscreen poster for this dance night: It has it
all—guns, broads, and all things 'manly.'"

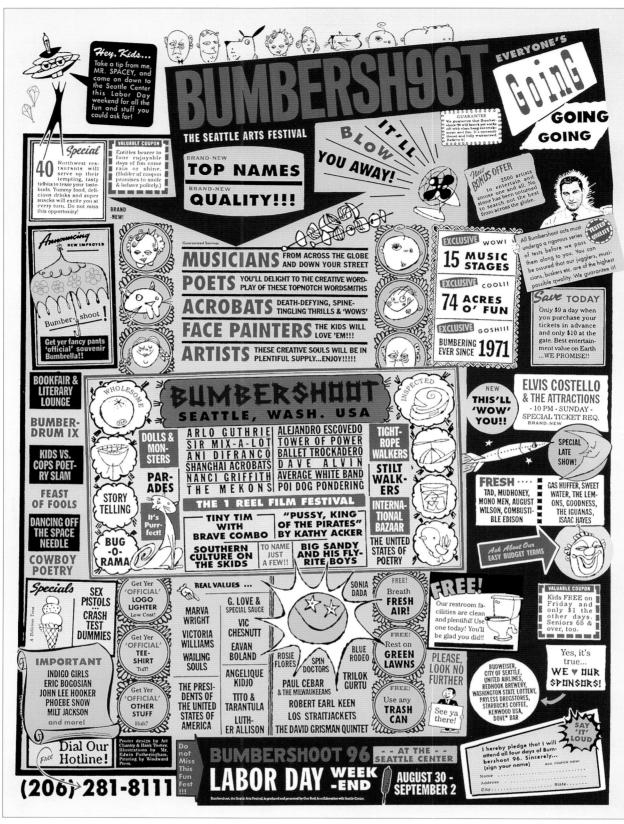

Event Bumbershoot 96

Art director Hank Trotter
Designers Art Chantry, Hank Trotter
Illustrator Ed Fotheringham
Studio Twodot Design
Client One Reel
Typefaces Futura, Franklin Gothic, Brush Script, Latex Display, Century Expanded, Venus Extrabold Condensed
Software traditional mechanical; Macromedia FreeHand
Colors 6/C flat (offset)
Print run 5,000

Concept Trotter says, "Doing Bumbershoot is a rite of passage for a Seattle designer. Bumbershoot is a four-day arts festival held Labor Day weekend. Each year a new designer is hired and a fresh campaign is used. The designer does everything from letterhead to billboards. The pay is barely tolerable, but the exposure and breadth of the job are exciting. For the poster, I wanted to take the colors and chaos of ads I had seen in 1950s photography magazines and apply them to Bumbershoot (a sprawling chaos of music, arts, readings, performance and food). I brought in Art Chantry, a great inspiration and teacher to me, to lay down a masterful grid of frilly, garish borders and arrows. I scanned the letter-size paste-up into my computer and set type to fit. We then took the type, made Mr. Fotheringham draw us some doodles to fill empty spaces, and pasted the piece together as a mechanical. We tissued the mechanical and used colored markers to plan our colors, which were set up mechanically by cutting out amberlith overlays. This piece is one of my proudest achievements. I thought for sure it would be recognized as one of the best pieces of the year in the design annuals. It failed to be noticed."

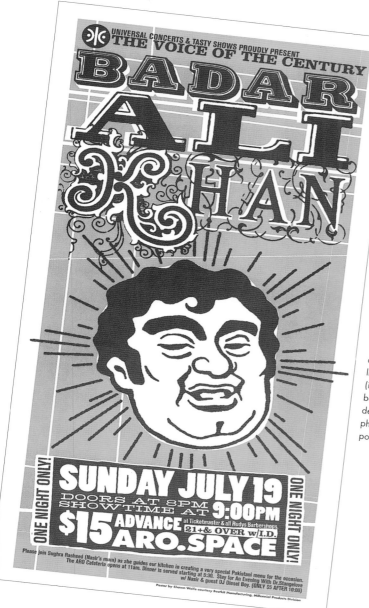

Event Badar Ali Khan

Art director Shawn Wolfe
Designer Shawn Wolfe
Illustrator Shawn Wolfe
Studio Shawn Wolfe Company
Client ARO.space
Typefaces assorted (unidentified) nineteenth-century display fonts from Dover's Handbook of Early Advertising Art: Typographical Volume
Software Macromedia FreeHand, Adobe Photoshop
Colors 2/C flat
Print run 1,000

Concept "Badar Ali Khan, like his older brother Nusrat before him, is an extremely large man. Both have enjoyed this odd sort of crossover success here in the States. I thought that a grand pop idol treatment was called for, that the poster should convey a bit of a sense of hoopla and spectacle—as though it was a poster for a state fair performance. 'The big guy is coming to town'—that sort of thing. The phrase 'voice of the century' came straight from Khan's press kit and went perfectly well with the carnivalesque treatment. Some loved this poster. Others didn't (and told me so), deeming it 'inappropriate.' But I think the people who liked it did so because it was slightly inappropriate (i.e., too cartoony; looking a bit too much like a cross between P.T. Barnum and Fat Albert). It was also designed to look as though it belonged on a telephone pole, despite the fact that postering telephone poles in Seattle has been illegal since 1993."

Event Monster Magnet

Art directors Steve Carsella, Chris Jones, Scott Sugiuchi
Designer Scott Sugiuchi
Illustrator Scott Sugiuchi
Studio Backbone Design
Client Figurehead Promotions
Typeface Fink Heavy
Software hand illustration redrawn in Adobe Illustrator
Colors 4/C process
Print run 50

Concept This was designed for a "quasi-scary rock band with a 'stoner' attitude, represented by a 'stoner' teenage Frankenstein (modeled after teenage 'stoner' Matt Dillon in My Bodyguard)."

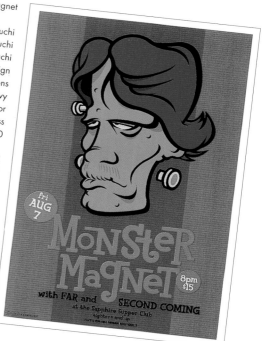

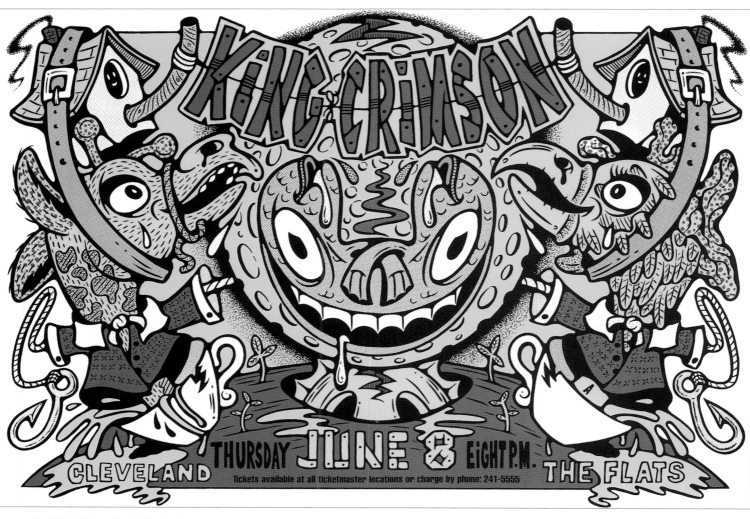

Event King Crimson Live in Cleveland

Art director Steven Cerio
Designer Steven Cerio
Illustrator Steven Cerio
Studio Steven Cerio's Happy Homeland
Client C-POP Gallery
Typeface hand-rendered
Software traditional mechanical
Colors 4/C flat, silkscreen
Print run 250

Concept "My fascination with (children's book illustrator) Richard Scarry's work becomes quite evident here. The type is hand-drawn. And yes, that's Zip-a-Tone."

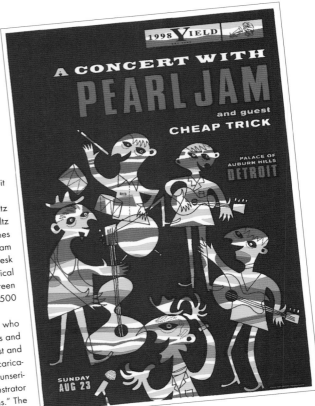

Event Pearl Jam '98 Detroit

Art director Coby Schultz
Designer Coby Schultz
Studio Ames
Client Pearl Jam
Typefaces hand-rendered, Akzidenz Grotesk
Software Adobe Illustrator; traditional mechanical
Colors 3/C flat, silkscreen
Print run 500

Concept Mimicking the drawing style of Jim Flora, who did old jazz records (RCA and others) in the 1940s and 1950s, Schultz was also "inspired by fellow artist and good buddy, Vito Costarella (the king of offbeat caricatures). I decided it couldn't hurt to do a completely unserious, and as nonrock as possible, poster. I used Illustrator to set type and added hand-drawn illustrations." The poster was printed by Joe Barella.

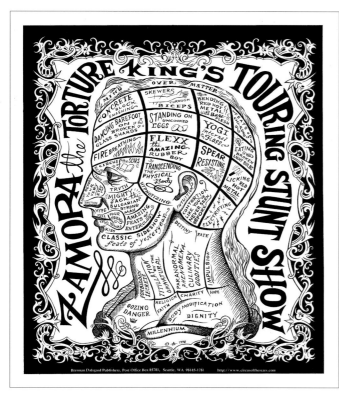

Event Zamora's Touring Stunt Show

Art director Ashleigh Talbot
Designer Ashleigh Talbot
Illustrator Ashleigh Talbot
Studio Ashleigh Talbot/Parlor XIII
Client Zamora the Torture King
Typefaces hand-rendered pen and ink
Software traditional mechanical
Color 1/C (black) offset on glossy white stock
Print run 1,000

Concept Talbot explains, "I wanted to create something that harkened back to the Victorian era, using the same materials that were used them. Also, I wanted to utilize simplicity in colors, and I think black and white best describes 'old sideshow,' much like it does *film noir*. I also feel strongly that computerized graphics do not hold the soul of the artist as simple pen and ink does."

Event Dia de los Muertos (Day of the Dead)

Art director Ronnie Garver
Designer Ronnie Garver
Illustration various sources of Mexican Dia de los Muertos folk art
Studio Ronnie Garver
Client Las Cruces Museum of Natural History
Typefaces adapted from the political posters of nineteenth-century Mexican artist José Posada
Software traditional mechanical
Colors 3/C flat, silkscreen
Print run 75

Concept "The Las Cruces Museum of Natural History wanted a poster to celebrate Dia de los Muertos, the traditional holiday to honor the dead," explains Garver. "It's celebrated mostly in Mexico (and the southwestern states) with lots of skeleton imagery that is often very quirky. I found images that I felt worked better than anything I could draw myself, but most of the illustrations I found were pretty small. So I enlarged them on my favorite mechanism, a copier—thus the overexposed, exaggerated halftone look. The client also wanted me to do a demonstration on screen printing, which resulted in my being sort of a live display at the museum as I was working."

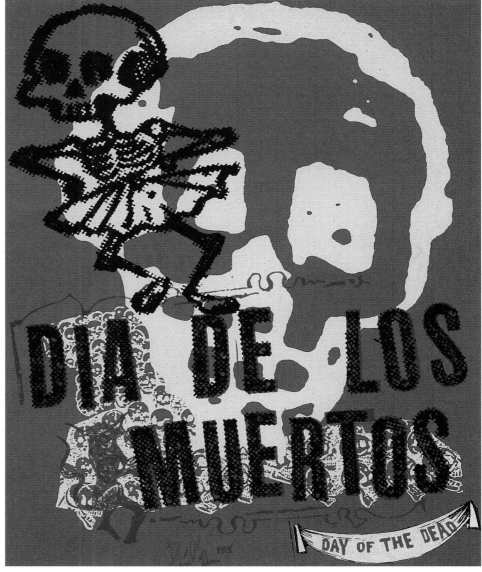

Event Massive Attack

Art director Shawn Wolfe
Designer Shawn Wolfe
Illustrator Shawn Wolfe
Studio Shawn Wolfe Company
Client ARO.space
Typefaces custom-created
Software Macromedia FreeHand,
Adobe Photoshop
Colors 2/C flat
Print run 1,000

Concept Wolfe says, "The promoter wanted a picture of a scarab-type bug, based on the imagery from Massive Attack's *Mezzanine* album, which seemed redundant and pointless to me. I like the various interpretations going on with this illustration: The Japanese 'salarymanz' is a massive figure along the lines of a Godzilla, and is inadvertently attacking a building—not out of malice, but apparently because he's crippled by a massive coronary that seems to be triggered by communications satellites that are overloading his pager with too many incoming calls. Funny."

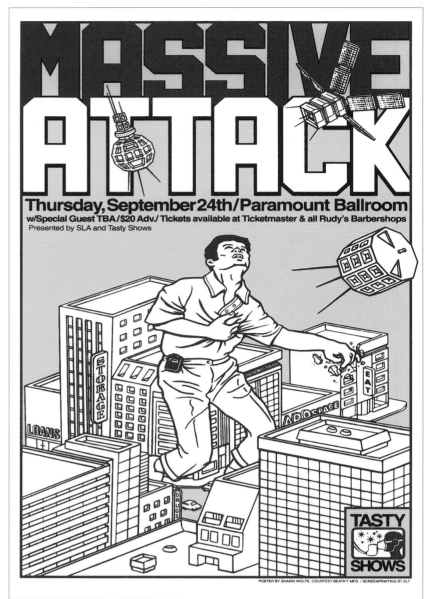

Shawn Wolfe / Beatkit™ Paintings

April 4th–May 6th, 1998

Milky World Gallery
111 Battery, Seattle

Exhibit Shawn Wolfe Beatkit Paintings

Art director Shawn Wolfe
Designer Shawn Wolfe
Illustrator Shawn Wolfe
Studio Shawn Wolfe Company
Client Milky World Gallery
Typeface Akzidenz
Software Macromedia FreeHand
Colors 2/C flat
Print run 1,000

Concept Wolfe took a typically oddball approach to this exhibit poster: "This was an announcement for a small solo show of my painted works, which feature these odd, stylized robots, like the monkey robot featured on this 'traffic' sign."

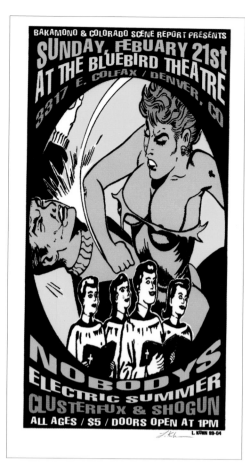

Event Nobodys

Art director Lindsey Kuhn
Designer Lindsey Kuhn
Studio Swamp
Client Bakamono
Typeface Baby
Software Microsoft Publisher, CorelDRAW; traditional mechanical
Colors 3/C flat, silkscreen
Print run 125

Concept Kuhn was pressed for time, and reused an old drawing he'd originally done for a 1994 Godbullies flyer—"Hey, DIY and it works perfectly." Kuhn calls it "aggression, rebellion and sex!"

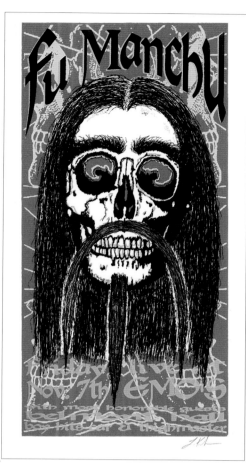

Event Fu Manchu

Art director Lindsey Kuhn
Designer Lindsey Kuhn
Studio Swamp
Client Emo's
Typefaces Karavan Displayed (altered)
Software Lettering, cut and pasted on original drawing; traditional mechanical
Colors 5/C flat, silkscreen
Print run 200

Concept As is true of many contemporary rock posters, the designer has only to capture a sense of attitude or style, reflecting a band's place in rock music (or in its particular subgenre) and filter it through the designer's take on popular culture and approach to his body of work. Or, as in Kuhn's case, he just wanted to use "the ancient master supervillain, Fu Manchu, resurrected!"

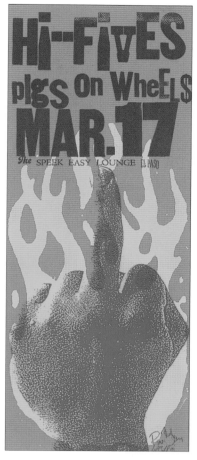

Event Hi-Fives/Pigs on Wheels

Art director Chad Ballard
Designer Ronnie Garver
Photographer Michael Kiernan
Studio Ronnie Garver
Client Pigs on Wheels
Typefaces Various unidentified type from a small letterpress collection
Software Traditional mechanical
Colors 3/C flat (2/C silkscreened plus 1/C letterpressed)
Print run 40

Concept "It's been done before, but nothing has the same attitude or impact as a plain ol' middle finger. This poster was to promote a show by some friends in the band Pigs on Wheels, who were opening for the Hi-Fives at a rock-and-roll show in El Paso, TX." All design and printing had been done by the designer and Chad Ballard.

Event Scenic tour of the
West Coast

Art director Bruce Licher
Designer Thomas Scott
Photographer Bruce Licher
Studio Eye Noise
Client Independent Project
Records
Typefaces URW Egyptienne,
Bovine Poster, Eagle Bold,
Brush Script
Software Adobe Photoshop,
Adobe Illustrator
Colors 2/C flat, silkscreen
(1 metallic screen print on
chipboard)
Print run 400

Concept "The image came from
some photocopies Bruce Licher
[guitarist for Scenic and the brains
behind Independent Project
Records] provided me of his
desert photography. Bruce had
already established the connec-
tion of the desert to Scenic's music,
so for me, the road image was a
natural way to relate the desert to
the band (being 'on the road'). I
treated the graphics and type with
a road sign influence without it
being an obvious pastiche."

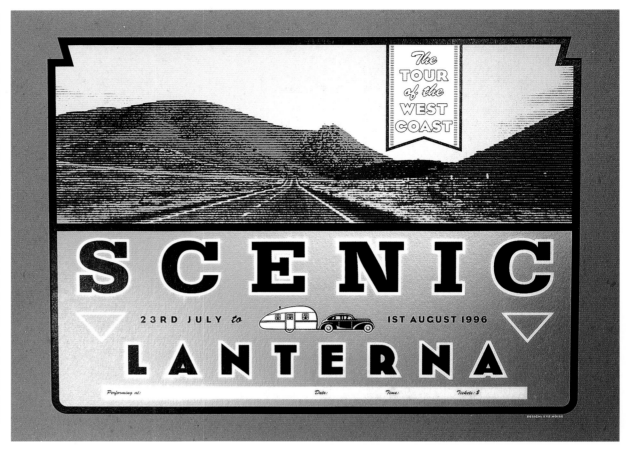

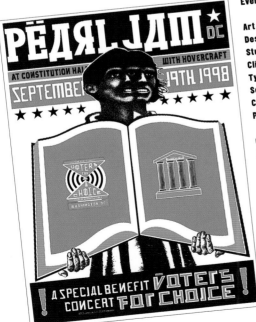

Event Pearl Jam Voters for Choice (Washington, D.C.)

Art director Barry Ament
Designer Barry Ament
Studio Ames
Client Pearl Jam
Typefaces All fonts custom-created in Adobe Illustrator
Software traditional mechanical; Adobe Illustrator
Colors 3/C flat silkscreen
Print run 800

Concept "Props to Rodchenko and Lissitzky—in particular,
Lissitzky's poster for the Russian exhibition at the Applied Art
Museum in Zurich in 1929," Ament says. "A few nibbles
and some big bites are taken out of the Russian construc-
tivist movement. It's a perfect style for a pro-choice concert
on the White House lawn, because this form of design has
an automatic association with [a certain kind of] govern-
ment propaganda. Here, it's thrown back at the machine."

Event Jesus Lizard

Art director Thomas Scott
Designer Thomas Scott
Studio Eye Noise
Client Figurehead Promotions
Typefaces Ideograph, News Gothic
Software Adobe Photoshop, Adobe Illustrator
Colors 2/C flat, silkscreen
Print run 100

Concept Scott explains his inspiration for Jesus Lizard: "Godzilla is a visual theme that's always interested me. I'd used Godzilla many years ago on a punk flyer. I guess Jesus Lizard, who can be sloppy and loose, inspired a cavalier design where I intentionally used 'bad' type. I photocopied Ideograph from an old display type book; although it has since been issued digitally, I don't think I had seen it used before. So Japanese pop culture in general wasn't an influence, really. I wanted to do the type thing. I thought Godzilla was a funny interpretation of the band's name; by the way, I wanted to get away from the real meaning of 'Jesus Lizard....'"

Event Fat Boy Slim

Art director Shawn Wolfe
Designer Shawn Wolfe
Illustrator Shawn Wolfe
Studio Shawn Wolfe Company
Client ARO.space
Typefaces Egyptian, Helvetica
Software Macromedia FreeHand, Adobe Photoshop
Colors 3/C flat
Print run 1,000 limited run

Concept "Phenomenally successful British DJ plays huge live show at Seattle's grand old Paramount Ballroom. I thought that a 1960s style, mod, sorta British Invasion, pop art motif was as suitable as any. This poster was accompanied by a handbill version, which was a little die-cut fold-up box based on the box I used as a graphic element in the poster. The idea of buying a reserved seat to sit and watch a DJ perform live on stage seemed damned peculiar to me, but it was a spectacle like any other, I suppose. This show sold out in a hurry, and this poster was produced more as a commemorative than as a promotional material."

Music promotion Toilet Boys, *Sinners and Saints*

Art director Edward ODowd
Designer Edward ODowd
Photographer Michael Halsband
Logo illustrator Rocket/Monkey/Dome Productions
Studio Edward ODowd Graphic Design
Client Coldfront Records
Typefaces Mathematical Pi, News Gothic
Software QuarkXPress, Adobe Photoshop, Adobe Illustrator
Colors 4/C process
Print run 3,000

Concept "The record label was really insistent on showing that the group is hard-rocking and not just a bunch of 'pretty boys.' I developed the 'regal' type crests across the top of the poster with sweaty, less flattering live photo insets to contrast with the clean studio photography that dominates most of the page. I feel the end result really gives a sense of what this band is about."

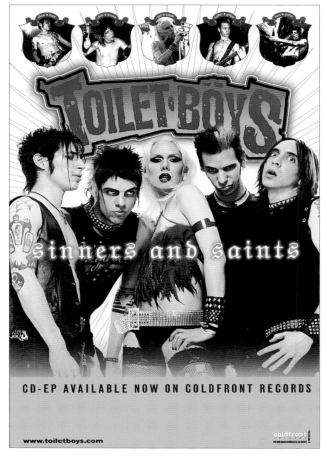

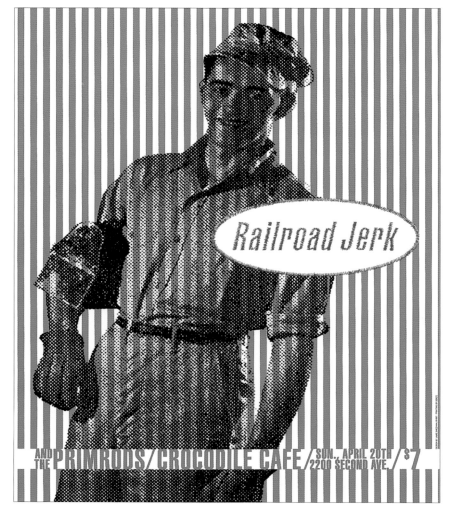

Event Railroad Jerk

Art director Jamie Sheehan
Designer Jamie Sheehan
Studio Sheehan Design
Client Jim Gibson/ Noiseville Gallery
Typefaces Adobe Garamond, Helvetica Ultra Compressed, hand-rendered type to look like embroidered lettering
Software photocopier, Macromedia FreeHand
Colors 2/C flat, silkscreen
Print run 250

Concept "The band Railroad Jerk conjures up obvious iconography. I wanted a working-class guy with an OshKosh B'Gosh look of railroad worker clothing. The type works with the stripes to keep the rhythm."

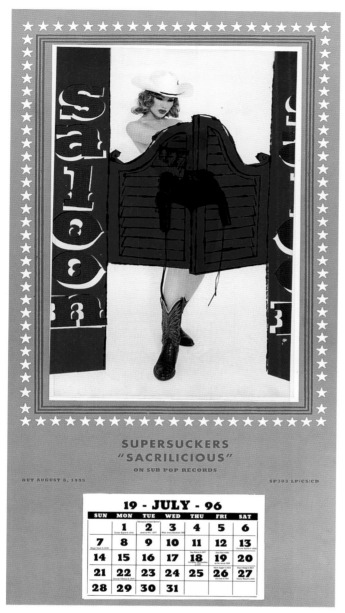

SUPERSUCKERS
"SACRILICIOUS"
ON SUB POP RECORDS

OUT AUGUST 3, 1995 SP303 LP/CS/CD

| 19 - JULY - 96 | | | | | | |
SUN	MON	TUE	WED	THU	FRI	SAT
	1	2	3	4	5	6
7	8	9	10	11	12	13
14	15	16	17	18	19	20
21	22	23	24	25	26	27
28	29	30	31			

Event Supersuckers "Sacrilicious" calendar

Art director Hank Trotter
Designer Hank Trotter
Photographer Michael Lavine
Illustrator Ed Fotheringham
Studio Sub Pop Records
Client Sub Pop Records, The Supersuckers
Typefaces Cg Davison Americana, Cg Beton Bold, Futura, Century
Software Macromedia FreeHand
Colors 1/C offset for backing card; 2/C offset for calendar pad; 2/C offset for acetate; 4/C offset for photograph
Print run 1,500

Concept "This is a play on the archetype of the traditional men's 'nudie' calendar for a hard-rocking band of cowboy wannabes. I specifically had in mind that the calendars could hang behind the counter of a respectable gas station or hardware store. So, when the acetate is lifted, the true nature of the photo is revealed. In this case, Sub Pop's radio and marketing departments would not allow us to use shots where the model's pasties were clearly visible. Thus we used a photo where the model's extended arm conceals most of her pastied breasts. Michael Lavine provided the great picture. I twisted Mr. Fotheringham's arm until he gave me a five-minute doodle of the swinging doors."

Event Boss Hog

Art director Lindsey Kuhn
Designer Lindsey Kuhn
Studio Swamp
Client Emo's
Typefaces hand-rendered
Software traditional mechanical
Colors 5/C flat, silkscreen
Print run 700

Concept "I met the girls from Boss Hog about eight months before the show and they were way cool and 'hotties.' So, I wanted to do something new for their poster. I decided to make it look like a record (a picture disc). The idea went over great, and a company called Tilt wanted a series to sell, so I went all out and had the posters die cut with the center hole, of course! The image came from an old underwear catalog. Love those missile bras!"

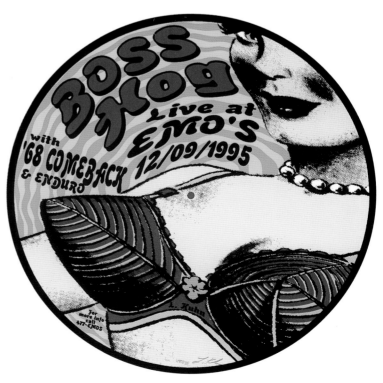

Event EAR (Experimental Audio Research)

Art director Todd Lovering
Designer Todd Lovering
Photographer Todd Lovering
Studio Half a Tail Studios
Client Club Moe
Typefaces hand-rendered
Software traditional mechanical
Colors 3/C flat
Print run 200

Concept Experimental Audio Research's (EAR) music is electronic audio-noise predicated on mathematical composition—envisioning the music of an uncertain technological future—much like the mathematically derived messages that NASA uses to attempt contact with extraterrestrial life. Inspired in part by Rick Griffin's 1960s psychedelic poster designs for The Fillmore and trends in popular science fiction, Lovering "wanted to illustrate an idea that extraterrestrial life would be insect-like, and will roam the earth presently. This species would be an evolved, advanced life form much like the human race. The strange music of Experimental Audio Research will allow us to have first contact."

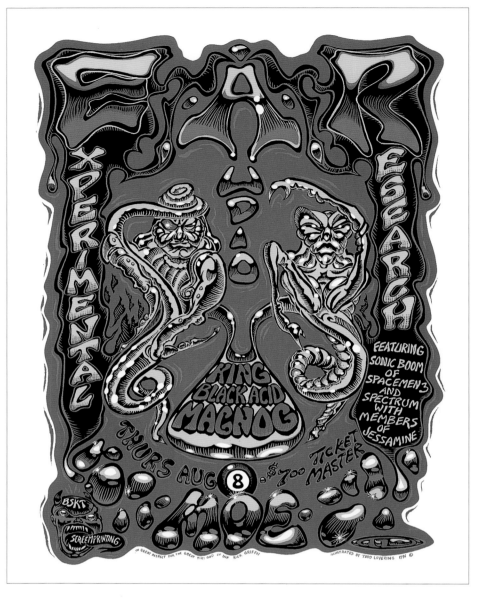

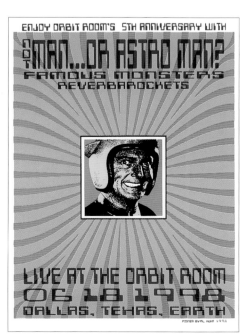

Event Not Man...or Astro Man?

Art director Lindsey Kuhn
Designer Lindsey Kuhn
Studio Swamp
Client Orbit Room
Typeface Keypunch
Software CorelDRAW; traditional mechanical
Colors 6/C flat, silkscreen
Print run 225

Concept Kuhn's idea was simple: "The image came to me because all bands are colorful and fun." But there was also a practical consideration behind the visual candy. Kuhn says he wanted something to "bother the eye" because he knew that the show was not going to be advertised long before the date.

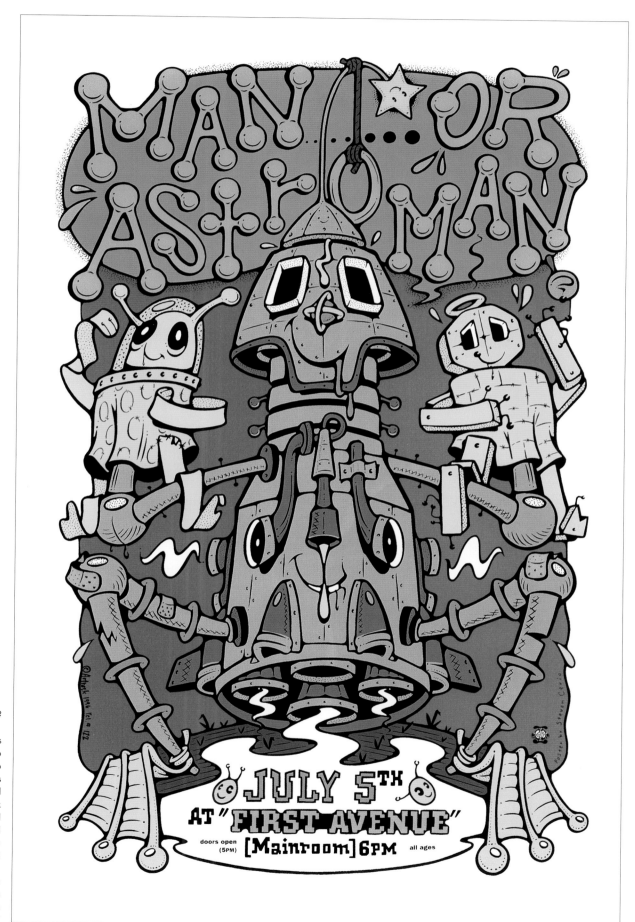

Event Man...or Astroman?

Art director Dave Ewars
Designer Steven Cerio
Illustrator Steven Cerio
Studio Steven Cerio's
Happy Homeland
Client Artrock
Typeface hand-rendered
Software traditional mechanical
Colors 8/C flat, silkscreen
Print run 250

Concept "My first good excuse to
use a metallic Pantone® ink. Type
was all hand-drawn. Imagery takes
a curtsy to cereal box prize spots."

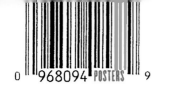
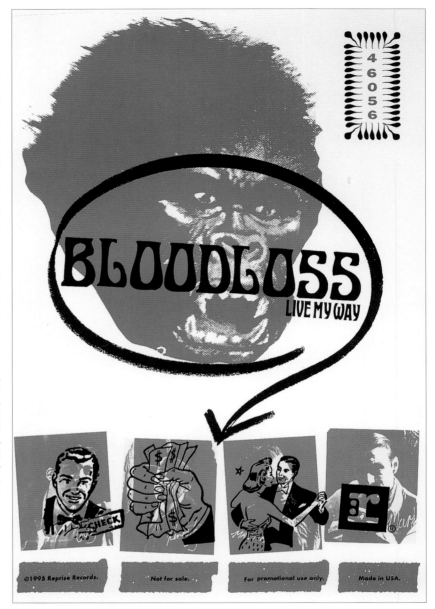

Event Bloodloss

Art director Hank Trotter
Designer Hank Trotter
Photographer Jim Collier
Studio Twodot Design
Client Reprise Records
Typefaces Legrad, Herold Normal, Futura
Software traditional mechanical;
Macromedia FreeHand
Colors 2/C flat
Print run 3,000

Concept "Bloodloss is a Captain Beefheart-inspired band featuring members of Mudhoney, Monroe's Fur and The Monkeywrench. They are an ugly lot. I had just completed their CD design, which they had heavily art directed. When it came time to do the poster, however, they gave me the reins, which I gladly grabbed and ran in the direction I thought most appropriate for the band (that being a nonsensical, overlapping pastiche of iconography and aggression). I laid line art of money over two of the band members to play on the punk bias against major-label bands as motivated by money (that is the last thing Bloodloss is). Similarly, the Reprise logo over the fourth member was another self-aware poke in the ribs. The label-required legal information was prominently displayed across the bottom, one phrase under each band member, as though they themselves were saying: 'Not for sale,' 'For promotional use only,' 'Made in USA.' I had tried to put my design credit on this piece. The label pulled it without my knowledge. Also, the prepress department did not understand the photocopied photos I had used as live art for each band member. When the poster came back I found they had diligently halftoned, in a 150-line screen, those crappy photocopies."

Event Black Eyed Peas/Outkast

Art director George Estrada
Designer George Estrada
Illustrator George Estrada
Studio Ames
Client The Showbox
Typefaces hand cut from rubylith; Clarendon
Software traditional mechanical;
Adobe Illustrator
Colors 3/C flat offset
Print run 100

Concept Estrada describes this poster as a kind of cultural hybrid: "I wanted the poster to have a hip-hop-meets-lounge feel. I wanted the event to have a 1970s-retro, small, cozy club environment." If one can imagine such a thing!

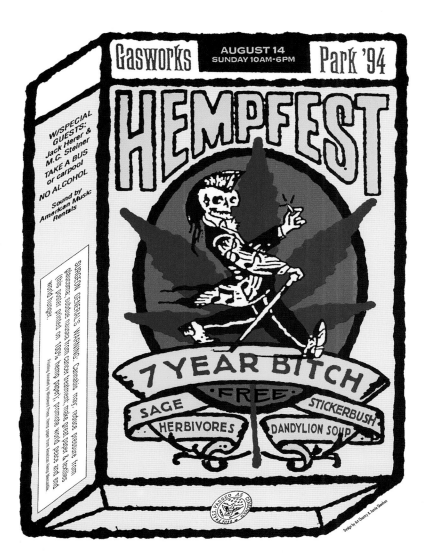

Event Hempfest 1994

Art directors Jamie Sheehan, Art Chantry
Designers Jamie Sheehan, Art Chantry
Studio Sheehan Design
Client Seattle Hempfest
Typefaces Copperplate, Helvetica, hand-rendered
Software traditional mechanical, photocopier
Colors 4/C process
Print run 1,000

Concept "At the time, tobacco companies were under fire for the chemicals put into the manufacturing process of cigarettes. That, combined with the debate over the intentional use of habit-forming additives like nicotine, created an atmosphere of questioning. Therefore, the poster looks like a cigarette pack, touting the positives of all-natural marijuana. The fact that it's printed on hemp paper hammers it all home."

Event MadameX

Art director Hank Trotter
Designer Hank Trotter
Studio Twodot Design
Client Hell's Elevator Productions
Typefaces Stencil, Futura, Split Wide
Software traditional mechanical;
Macromedia FreeHand
Colors 2/C silkscreen
Print run 100

Concept "A potboiler theater production, updated and turned on its side, with cross-dressing performers. I owe a lot of the impact of this poster to the finest exploitation showman ever, Kroger Babb. The lady with the cigarette is lifted from the lobby poster for his 1954 production of *She Should Have Said No!* I did not hesitate to reuse this beautiful drawing, because in Mr. Babb's own words, 'The art of properly exploiting, advertising and selling an attraction is like baking a cake. Two housewives can use the same recipe, yet get entirely different results.' No truer words have ever been spoken!"

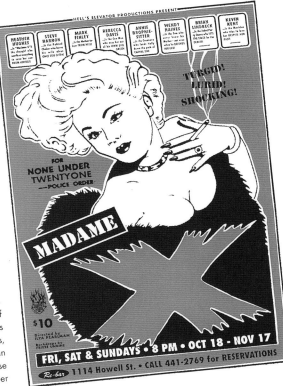

Event King John

Art director Hank Trotter
Designer Hank Trotter
Studio Twodot Design
Client Greek Active
Typefaces Rockwell, Franklin Gothic, Fulton
Script, custom hand-rendered,
Gothic Extended
Software traditional mechanical;
Macromedia FreeHand
Colors 2/C flat, silkscreen
Print run 100

Concept "The border and logo type were
inspired by a poster for the 1930s movie *Skid
Row*. The hard part was drawing the g. The
rest was a no-brainer. 'The street they talked
about in whispers' would now help advertise
a revival of one of Shakespeare's lesser-
known plays."

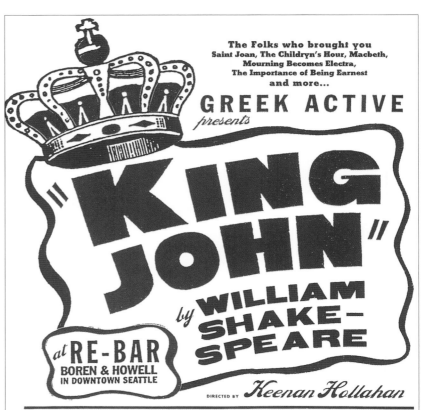

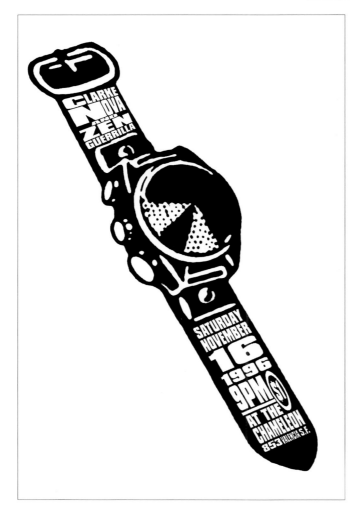

Event Watch

Art director Marcus Durant
Designer Marcus Durant
Illustrator Marcus Durant
Studio Magnetic Spider Design
Client Chameleon
Typeface Impact Condensed Bold
Software Adobe Photoshop;
traditional mechanical
Colors 1/C flat, silkscreen
Print run 50

Concept For this band showcase poster,
Durant "cut out each poster by hand and
wrapped them around telephone poles like
giant wristwatches."

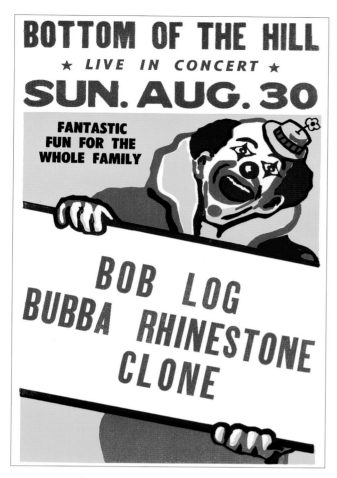

Event Bob Log

Art director Marcus Durant
Designer Marcus Durant
Studio Magnetic Spider Design
Client Bottom of the Hill
Typeface hand-set wood-block type
(identified only by "wide" or "tall")
Software traditional mechanical
Colors 4/C flat, silkscreen
Print run 50

Concept Durant says, "I always think I'm at some kind of 'space circus' whenever I see Mr. Log. So why not a circus poster? Better still, why not craft a 'design' to be done by a poster shop that prints those small community circus posters? This was silkscreened at Trangle Poster."

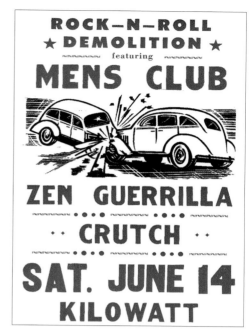

Event Rock-N-Roll Demolition

Art director Marcus Durant
Designer Marcus Durant
Studio Magnetic Spider Design
Client Kilowatt
Typeface hand-set wood-block type
(identified only by "wide" or "tall")
Software traditional mechanical
Colors 2/C flat, silkscreen
Print run 50

Concept "Here's a rock'n'roll crash-up derby." Durant explains that, at the show, "you could pay a dollar to throw a bowling ball at a junked car." As was done with Durant's "Bob Log" poster, this was silk-screened at a traditional community poster shop, Trangle Poster.

Event Hopeless Records Showdown

Art director Lindsey Kuhn
Designer Lindsey Kuhn
Studio Swamp
Client Hopeless Records
Typeface Oldtowne no536D
Software CorelDRAW, Adobe Photoshop; traditional mechanical
Colors 3/C flat, silkscreen
Print run 200

Concept Hopeless Records wanted a Texas theme, so why not a variation on the Wild West "wanted" poster cliché? Kuhn redrew an image from an old 1950s/1960s movie poster book.

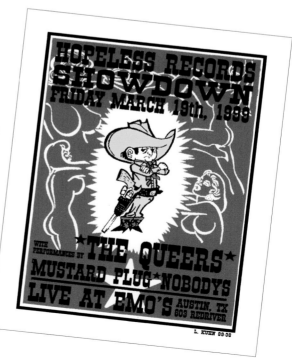

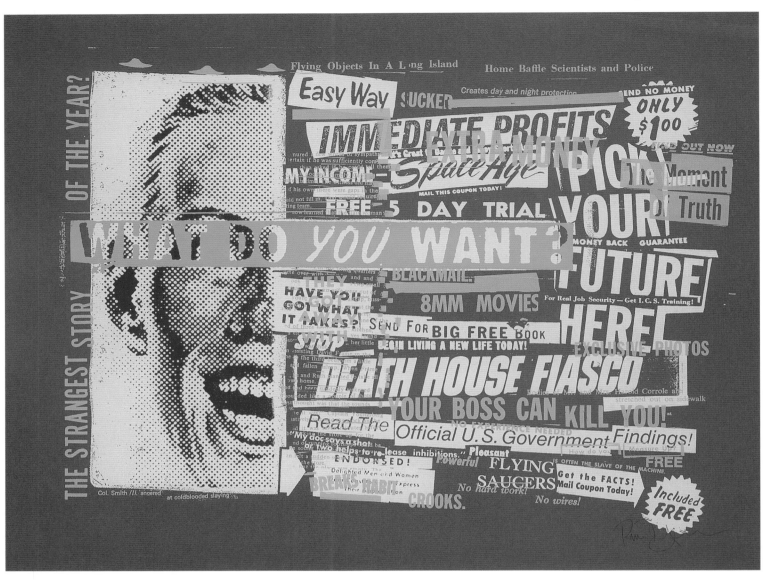

Self-promotion What Do You Want?

Art director Ronnie Garver
Designer Ronnie Garver
Studio Ronnie Garver
Client Ronnie Garver
Typefaces found and manipulated on a photo-
copier from old magazine headlines
and other copy
Software traditional mechanical
Colors 4/C flat (3/C silkscreen, 1/C letter-
pressed)
Print run 30

Concept "A self-promotional piece influenced
by and derived from vintage articles and
ads—in this case mostly 1960s and 1970s
detective or men's magazines. The type was
generated the same way, finding any kind of
headline, ad cop or combinations of type that
I felt were interesting, funny, ridiculous, dumb
or whatever. Kind of a spontaneous piece in
which the details were open to whatever I
could cut and paste into the printable area."

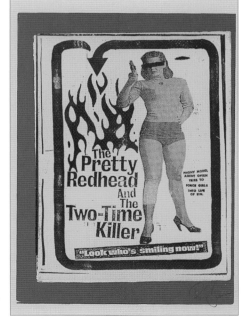

Self-promotion The Pretty Redhead and the Two-Time Killer

Art director Ronnie Garver
Designer Ronnie Garver
Studio Ronnie Garver
Client Ronnie Garver
Typefaces headline type copied out of old
American Detective magazines
Software traditional mechanical
Colors 3/C flat (2/C screenprint, 1/C letterpress)
Print run 25

Concept "A 'freebie' to give away to my favorite clients. No
two of these posters are alike due to so many complications
in the printing (I printed them myself). But I think mistakes
sometimes add to the beauty of the concept. I like that
process. At the time, I was also going through an 'arrow'
phase for whatever reason. A lot of my work was incorporat-
ing arrows as strong graphic elements."

0 968094 POSTERS 9

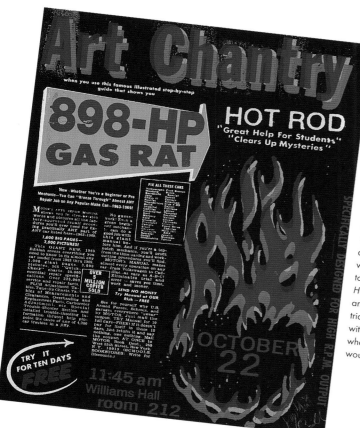

Event Art Chantry lecture

Art directors Ronnie Garver, Chad Ballard
Designer Ronnie Garver
Studio New Mexico State University Department of Art
Client New Mexico State University Department of Art
Typefaces found and manipulated on a photocopier from old magazine headlines and other copy
Software traditional mechanical
Colors 5/C or 7/C flat (depending on what print you pull out of the edition), silkscreen
Print run 70

Concept "We were fortunate to have Art Chantry come for a lecture while I was teaching in the Department of Art at New Mexico State University. When we learned that he was coming, a student and I decided what better way to honor him than with a poster [Chantry is well known for his influential poster designs]. From conceptualization to printed piece: fifteen hours. It started out with a hangover, a box of Hot Rod and Drag World magazines from the 1960s and 1970s, and leftover screen-printing supplies at ten in the morning. Through trial and error, we wound up with many variations due to experiments with color and different papers. It was a compliment, after the fact, when posters were stolen from their postings. I'm guessing that they've wound up as home decor."

Event Ska Fest

Art director Lindsey Kuhn
Designer Lindsey Kuhn
Studio Swamp
Client Emo's
Typefaces Papyrus (altered); hand-rendered
Software CorelDRAW; traditional mechanical
Colors 3/C flat, silkscreen
Print run 225

Concept Ska music has its own distinctive look: You see it, you know it. Kuhn went for a mod/punk attitude with an aggressive scooter/cannon. The scooter is a redrawn army proto-type from World War II.

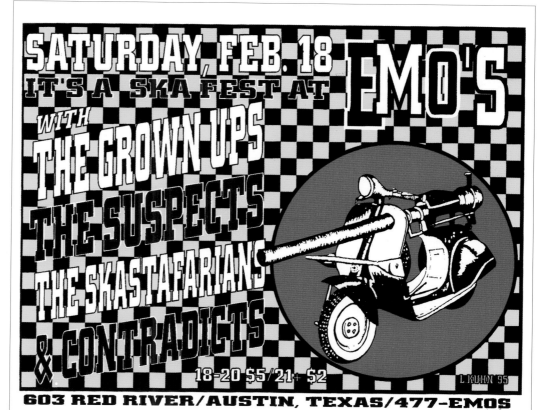

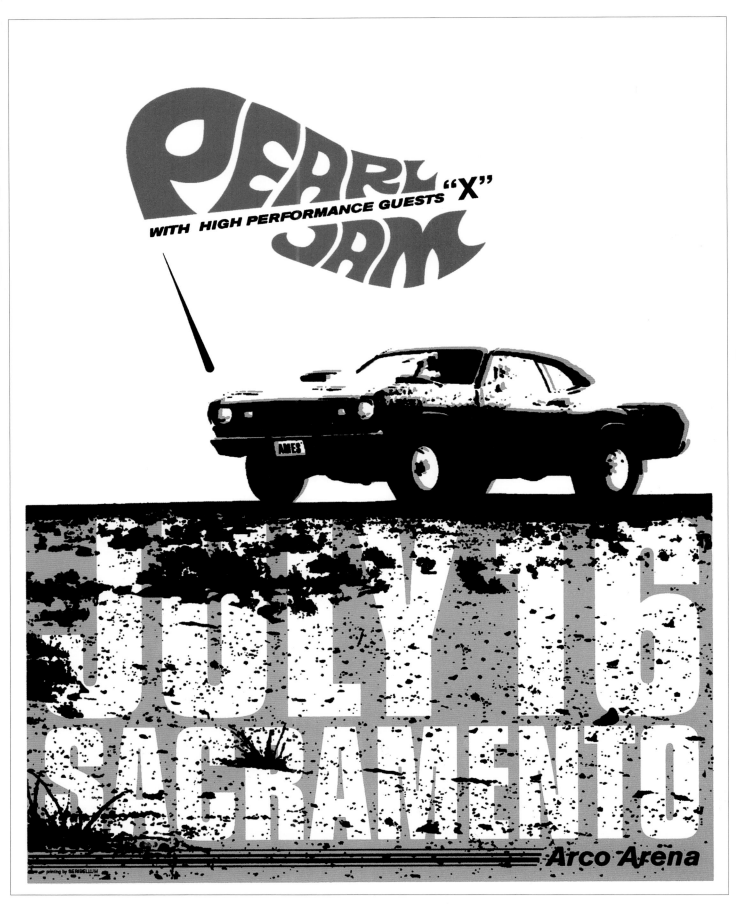

Event Pearl Jam Sacramento

Art director Mark Atherton
Designer Mark Atherton
Illustrator Mark Atherton
Studio Ames
Client Pearl Jam
Typefaces Compacta; hand-styled
Software Adobe Illustrator; traditional mechanical
Colors 2/C flat silkscreen

Print run 250

Concept "Pearl Jam let us do whatever we wanted for each show poster," says Atherton. "I wanted to do something that implied Pearl Jam in the California desert, and I wanted to do something different than the usual illustration-heavy posters that we do for Pearl Jam. I printed the type out of Illustrator, manipulated and pasted it up; then, the films were shot from a traditional mechanical."

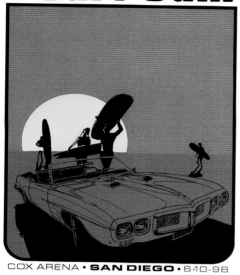

&SPACE HOG
Pearl Jam

COX ARENA · **SAN DIEGO** · 6-10-98

Event Pearl Jam San Diego

Art director Barry Ament
Designer Barry Ament
Illustrator Barry Ament
Studio Ames
Client Pearl Jam
Typefaces hand-rendered; Blister
Software traditional mechanical; Adobe Illustrator
Colors 3/C flat, silkscreen
Print run 400

Concept "Eddie Vedder is a big-time surfer, and San Diego is his hometown," Ament explains. "This was a gimme. The poster for the surf movie *Endless Summer* is one of my all-time faves for its simplicity. I confess, I straight up stole this one and added my own illustration."

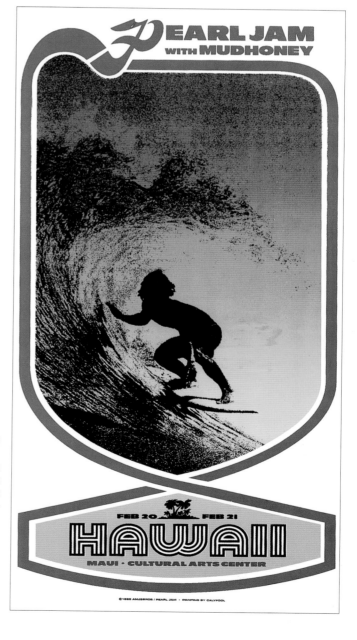

Event Pearl Jam Hawaii

Art director Coby Schultz
Designer Coby Schultz
Illustrator Coby Schultz
Studio Ames
Client Pearl Jam
Typefaces hand-rendered
Software Adobe Illustrator; traditional mechanical
Colors 3/C flat silkscreen (black plus split-fountain)
Print run 500

Concept "Eddie Vedder loves Hawaii, loves to surf, loves good 'surfing style' and colors. I love to make Ed happy."

Agitation propaganda (series of three) "Live Twice the Life in Half the Time" Remover/Installer; "Beatkit Must Die"; "Panic Now"

Art director Shawn Wolfe
Designer Shawn Wolfe
Illustrators Shawn Wolfe; Shawn Wolfe, Ellen Forney ("Live Twice the Life in Half the Time")
Studio Shawn Wolfe Company
Client Beatkit
Typefaces Helvetica Black, Tarzana, Univers Condensed
Software Macromedia FreeHand, Adobe Photoshop
Colors 3/C flat; 2/C flat; 3/C flat
Print run 500 each

Concept "I'd been perpetuating this mock brand, Beatkit, in one form or another since 1984. Intended as a manipulation of consumer media signs and signals, Beatkit was what I'd termed an anti-brand, complete with its own anti-branding strategy presented in paintings, texts and faux ads. Beatkit asserted over and over that it was 'an advertisement for its own future uselessness.' Its slogan, 'The general gloss of falsity is our only product,' attempts to lay bare the false claims, unrealistic visions and empty promises that advertisers and marketers notoriously bombard consumers with. The 'Until 2000' tagline that was part of the logo promised that the brand would discontinue itself, and these posters are part of that general campaign. The "Panic Now" campaign has had a curious sort of crossover appeal here at the end of the millennium, and has been one of Beatkit's biggest breakaway hits to date."

Event Cornelius

Art director Shawn Wolfe
Designer Shawn Wolfe
Illustrator Shawn Wolfe
Studio Shawn Wolfe Company
Client ARO.space
Typeface Pinwheel
Software Macromedia FreeHand, Adobe Photoshop
Colors 2/C flat
Print run 500

Concept "Between Fuct skateboards and Bathing Ape (couture) over in Japan, *Planet of the Apes* has been adopted by a new generation as some kind of late-century, cool, post-human trope worth annexing and exploiting and proliferating. Cornelius is behind the Bathing Ape clothing line and adopted his stage name as a salute to the *Apes* films. His live show is rife with video snippets of various monkeys and other simian weirdness. So, for this poster I featured Cornelius's movie wife Zira prepping, getting dolled up for a night on the town. Of course, an ape lady—like a human lady—is going to shave her legs as part of her pre-clubbing regimen. Suitably, the show was co-sponsored by the Zaius Post Human Archive, a Webzine that I co-edit with Seattle artist Darick Chamberlin. Cornelius himself seemed to really enjoy this poster, recognizing the shaved ape lady as one of his own."

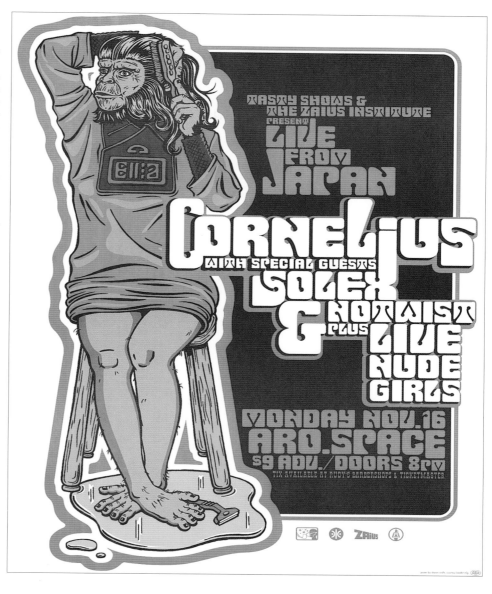

Event Go-Go Go Lounge

Art directors Steve Carsella, Chris Jones, Scott Sugiuchi
Designer Scott Sugiuchi
Illustrator Scott Sugiuchi
Studio Backbone Design
Client Go Lounge
Typefaces Proton, Univers Extended Black
Software Adobe Illustrator, Adobe Photoshop
Colors 4/C Canon laser
Print run 50

Concept "The idea was to portray the go-go girl of tomorrow—a mixture of optimistic 1960s plastic futurism, kitsch painter Keene's doe-eyed waifs and Nancy Sinatra."

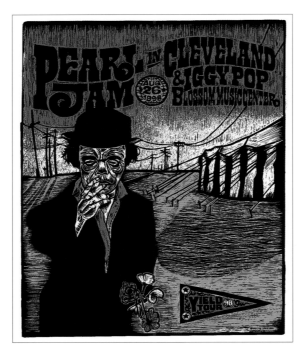

Event Pearl Jam Cleveland

Art director Barry Ament
Designer Barry Ament
Illustrator Barry Ament
Studio Ames
Client Pearl Jam
Typefaces hand-rendered
Software traditional mechanical; hand-crafted linoleum block print
Colors 3/C flat, silkscreen
Print run 400

Concept "Inspired from an old Barnum & Bailey circus program I had from childhood, I tried to capture the contradictions of a circus with happy colors and depressing imagery...like getting sick on cotton candy," explains Ament. "I usually pull out the linoleum after spending weeks on the computer—such was the case here." This piece evokes the poster design of expressionist masters like Käthe Kollwitz and, in particular, Oscar Kokoschka's theater posters.

Event Circus of the Scars

Art director Ashleigh Talbot
Designer Ashleigh Talbot
Illustrator Ashleigh Talbot
Studio Ashleigh Talbot/Parlor XIII
Client Brennan Dalsgard Publishers
Typefaces hand-rendered pen and ink
Software traditional mechanical
Color 1/C (black) offset on glossy white stock
Print run 1,000

Concept The image represents a sideshow, with Talbot adhering to the utilization of black and white to make a "much more powerful statement, rather than using a ton of different colors, which is fine when it's appropriate. The simplicity of the black-and-white poster is made much more effective and powerful by doing the illustration and typography by hand."

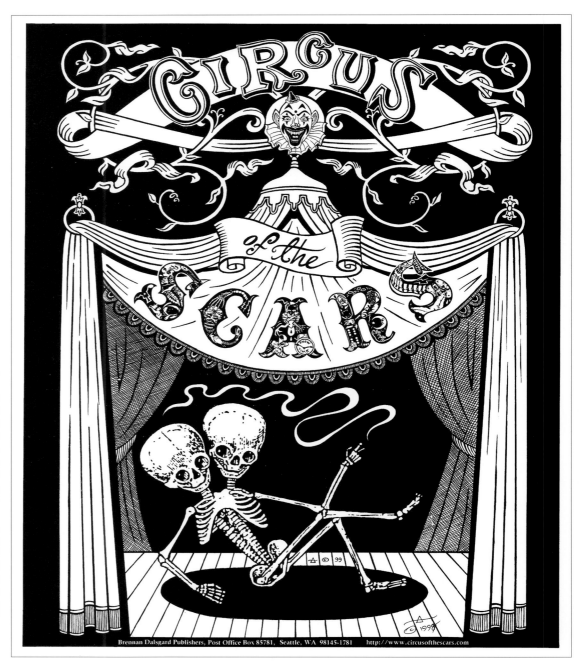

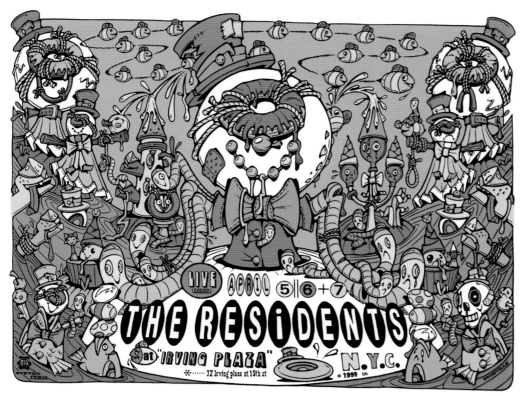

Event The Residents Live at Irving Plaza

Art director Steven Cerio
Designer Steven Cerio
Illustrator Steven Cerio
Studio Steven Cerio's Happy Homeland
Client Noiseville Gallery and The Residents
Typefaces hand-rendered
Software traditional mechanical, Adobe Photoshop
Colors 4/C flat, silkscreen
Print run 500

Concept "Jim Gibson at Noiseville Gallery commissioned me because of the working relationship I have with the band after having contributed to their *Bad Day at the Midway* CD and having helped to create costumes and animation for their film *Disfigured Night* (directed by John Payson of *Joe's Apartment* fame). All of the type was composed in Adobe Photoshop, then printed out and hand-traced so I could add the irregularities I crave. Being under the belief that The Residents are the greatest musical innovators of the last quarter century, I usually spend an inordinate amount of time on our collaborations, and this piece was no exception. I went through more than a hundred sketches before I settled on this image. I also felt obliged to keep with the traditions of their in-house graphics department, Poreknow Graphix, who have been a great influence on both my drawing and design. I feel the finished piece offered a good visual accompaniment to their fantastically cryptic lyrics and bewildering compositions, which are an odd blend of symphonic savantism and psychedelic rationality."

Exhibit The AIGA Colorado Chapter's Literacy Campaign

Art director Dana Collins
Designer Dana Collins
Illustrator Dana Collins
Studio Dana Collins Art for Industry
Client John Bielenberg/American Institute of Graphic Artists, Colorado chapter
Typefaces hand-rendered
Colors hand-rendered
Print run 1

Concept This poster was created as a one-of-a-kind piece only: "A whole bunch of designers were asked by the AIGA to do a one-off poster promoting literacy. This is what I came up with. I couldn't find anyone to print it in kind for me, so I drew it with big chalk sticks onto a large piece of illustration board. A lot of people were 'bent out of shape' because they thought I was making fun of illiterate people."

Event Bauhaus

Art director Lindsey Kuhn
Designer Lindsey Kuhn
Studio Swamp
Client 462 Productions
Typeface Hollyweird
Software Adobe Photoshop, Adobe
Illustrator; traditional mechanical
Colors 3/C flat, silkscreen
Print run 200

Concept This poster has a "sci-fi, arty theme to
go with the band." A group that emerged dur-
ing the 1980s New Wave, Bauhaus is a
David Bowie-influenced conceptual rock
band. Kuhn digitally created the collage of
bodies and faces in the background, and
placed 'Vampira' [from Ed Wood's *Plan 9
from Outer Space*, generally acclaimed as
the worst movie of all time] in the foreground.

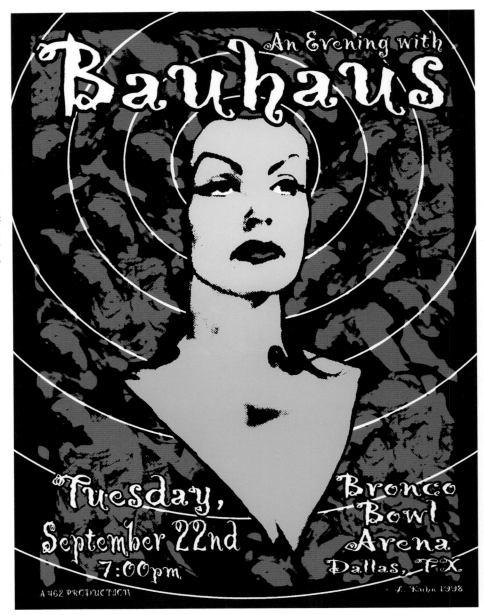

Event Hempfest 1997

Art director Jamie Sheehan
Designer Jamie Sheehan
Studio Sheehan Design
Client Seattle Hempfest
Typefaces Futura Condensed; many cut-and-pasted head-
lines from many sources
Software traditional mechanical; photocopier, Adobe
Photoshop
Colors 4/C process
Print run 1,000

Concept "Since the 1996 Hempfest didn't happen—due to
Seattle Hempfest using the money to develop a voter's
guide and the politics associated with a mayoral election
year—I thought it fitting that the poster be something remi-
niscent of a monster back from the dead. The event the
city hoped wouldn't rear its political head was back!"

Event Hempfest 1995

Art directors Jamie Sheehan, Art Chantry
Designers Jamie Sheehan, Art Chantry
Studio Sheehan Design
Client Seattle Hempfest
Typefaces Futura, Brush Style; many cut-and-pasted headlines from many sources
Software traditional mechanical; photocopier, Adobe Photoshop
Colors 4/C process
Print run 1,000

Concept "The city didn't want to renew the permits for Hempfest because the event was too popular, and the crowds were bigger than the city was comfortable with. The Seattle police didn't like the political rally happening in the newly declared 'drug-free zone.' However, freedom of speech won out. That's when I decided the perfect concept would be a cop telling you to attend the event."

Event Hate Bombs/Thee Phantom 5ive

Art directors Steve Carsella, Chris Jones, Scott Sugiuchi
Designer Scott Sugiuchi
Studio Backbone Design
Client Speed-O-Meter
Typefaces House Gothic Black, Helvetica Extra Compressed
Software Adobe Illustrator, Adobe Photoshop
Colors 4/C process
Print run 50

Concept "This poster is an attempt to reconcile the flavor of the two bands playing—the gear-head garage sound of the Hate Bombs and the landlocked surf tones of Thee Phantom 5ive. The color scheme is a tip of the hat to the classic *Endless Summer* poster."

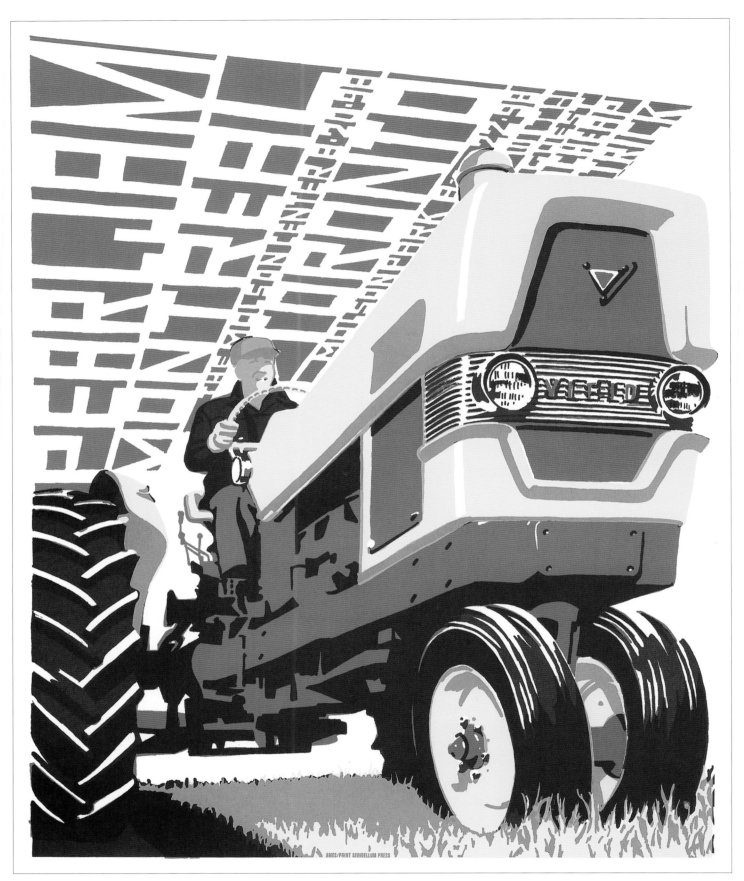

Event Pearl Jam Montreal/Toronto

Art director Coby Schultz
Designer Coby Schultz
Illustrator Coby Schultz
Studio Ames
Client Pearl Jam
Typefaces Hand-rendered
Software traditional mechanical, 100% hand-drawn

Colors 3/C flat, silkscreen
Print run 1,000

Concept Schultz wanted to do "another as-nonrock-as-pos-
sible poster. *Yield,* the title of Pearl Jam's 1998 album,
can take many forms. In this case, a farmer 'yields' a
crop. Do they farm in Montreal or Toronto? Doubt it—did
a tractor anyhow." The poster was printed by Joe Barilla.

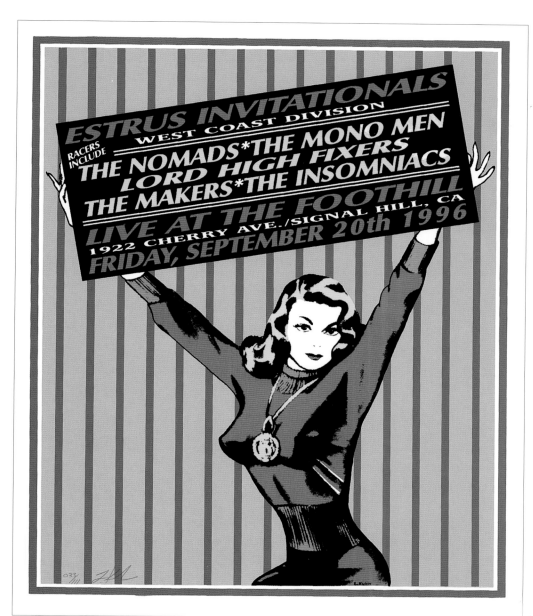

Event Estrus Invitationals

Art director Lindsey Kuhn
Designer Lindsey Kuhn
Studio Swamp
Client Estrus Records
Typeface Photina Casual Black
Software CorelDRAW; traditional mechanical
Colors 3/C flat, silkscreen
Print run 200

Concept Dave Cryder at Estrus wanted a racing theme for this show. Using a pun from the show title and something that's been a "look" for a lot of Estrus record packages—hot rods, smash-ups, you get the idea—Kuhn came up with "this ol' style drag girl." Vrrrooom!

Event The Holiday Show

Art director Hank Trotter
Designer Hank Trotter
Studio Twodot Design
Client Re-bar
Typefaces Gaston Script; an unidentified serif face found in a book, which sometimes has samples without descriptions
Software traditional mechanical; Macromedia FreeHand
Colors 2/C photocopy
Print run 75

Concept "Another fabulous drag show! This one was set against the festive backdrop of snowy holidays. Kinko's no longer has the 17" x 22" copier that produced all these cheap posters. I cry myself to sleep every night because of this loss."

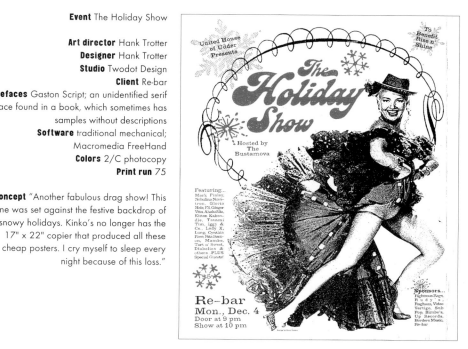

Event Dwarves

Art director Lindsey Kuhn
Designer Lindsey Kuhn
Studio Swamp
Client Emo's and Orbit Room
Typefaces Photina Casual Black,
hand-rendered
Software Microsoft Publisher,
CorelDRAW; traditional
mechanical
Colors 3/C flat silkscreen
Print run 250

Concept "The Dwarves are fun
and crazy (and like to party)!"
Kuhn thought the idea of adapt-
ing the promo ad art from a
1936 anti-drug propaganda
movie, Cocaine, The Thrill That
Kills, "would suit them fine."

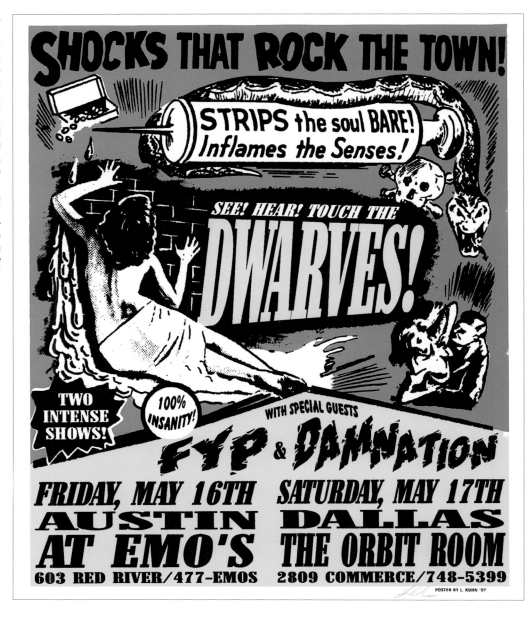

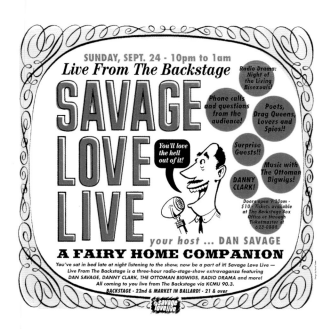

Event Savage Love Live

Art director Hank Trotter
Designer Hank Trotter
Studio Twodot Design
Client Savage Love Live
Typefaces Futura, Century, Modern Outline Condensed,
Cg Davison Americana
Software traditional mechanical; Macromedia FreeHand
Colors 2/C photocopy
Print run 50

Concept "Dan Savage, who had been broadcasting a
radio version of his popular newspaper column (sex
advice), was going to do the show live in front of an audi-
ence. The name 'Savage Love' communicated a lot in
Seattle, so I let that do the talking. I threw in my all-time
favorite border for good luck. I later used this same bor-
der in the Bumbershoot 96 campaign."

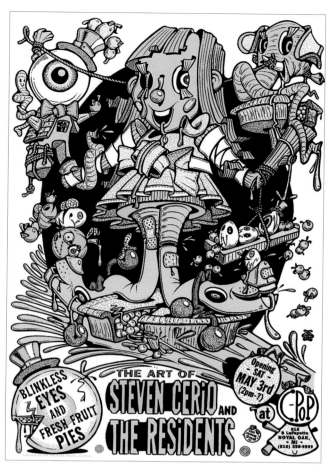

Exhibit "Blinkless Eyes and Fresh Fruit Pies:
The Art of Steven Cerio and The Residents"

Art director Steven Cerio
Designer Steven Cerio
Illustrator Steven Cerio
Studio Steven Cerio's Happy Homeland
Client C-POP Gallery
Typefaces hand-rendered
Software traditional mechanical
Colors 3/C flat, silkscreen
Print run 500

Concept Cerio calls it "a blending of my per-
sonal iconography and the haunting, unblink-
ing, top-hatted eye logo of The Residents, cre-
ated by their in-house graphics team,
Poreknow Graphix, whose influence surfaces
in much of my work. The group and the
gallery gave me complete freedom on the
project. I chose vegetable colors to contrast
the mood set by the overactive composition.
The type was hand-traced and manipulated
from Franklin Gothic."

Event "Have a Hot Time!"

Art director Hank Trotter
Designer Hank Trotter
Studio Twodot Design
Client Re-bar
Typefaces Event Gothic, Type Script Two,
Futura
Software traditional mechanical;
Macromedia FreeHand
Colors 2/C photocopy
Print run 75

Concept "Re-bar is a Seattle institution, a gay
dance club friendly to 'straights.' MC Queen
Lucky is a popular, and pretty, local DJ.
Everyone loves Lucky as much as they love
'evil lady' art. The devil lady came from a
1950s magazine ad and is available to every-
one now in the magazine Craphound #4 ('a
picture book for discussion and activity')."

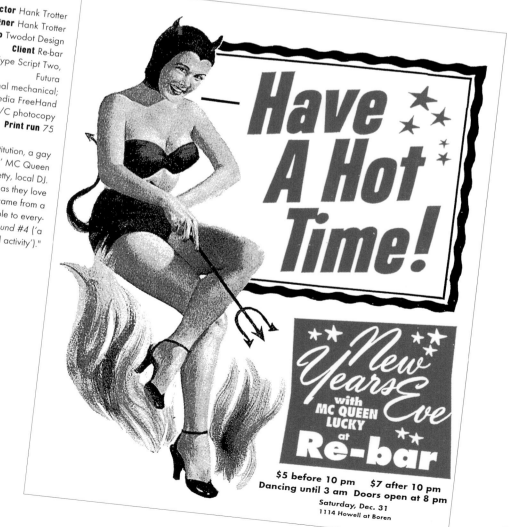

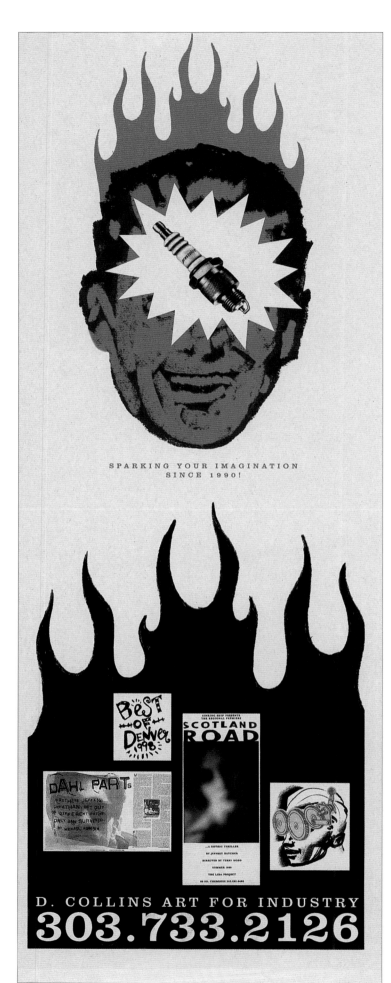

SPARKING YOUR IMAGINATION
SINCE 1990!

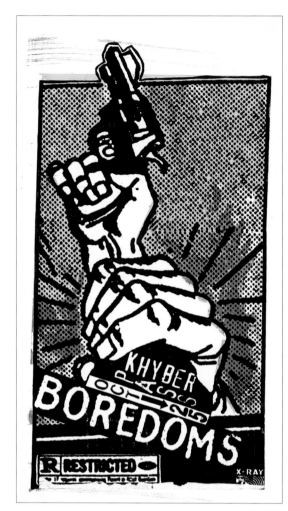

Event Boredoms

Art director Marcus Durant
Designers Marcus Durant, Jeff Prybolsky
Illustrator Marcus Durant
Studio X-Ray Design
Client Khyber Pass
Typefaces Impact (manipulated)
Software traditional mechanical
Colors 3/C flat, silkscreen
Print run 50

Concept "When I first saw the band The Boredoms, it was like watching two winos fighting over a gun. First impressions, first impressions..."

Self-Promotion "Sparky"

Art director Dana Collins
Designer Dana Collins
Illustrator Dana Collins
Studio Dana Collins Art for Industry
Client Dana Collins Art for Industry
Typeface Clarendon Roman
Software QuarkXPress, Adobe Photoshop
Colors 4/C process
Print run About 100 per month

Concept Collins contrived a unique way of generating his promotional piece on a regular basis: "I actually print this out on newsprint from my inkjet printer. This is not only cost-efficient, but it also leaves me the option of making changes on the fly." He further notes, "I wanted to design something wearing all that cool hotrod culture stuff (VonDutch, Ratfink, etc.) on my sleeve. Not only does this speak well of an influence that has ultimately led me toward becoming an imagemaker, it's also just esoteric enough to weed out the creeps."

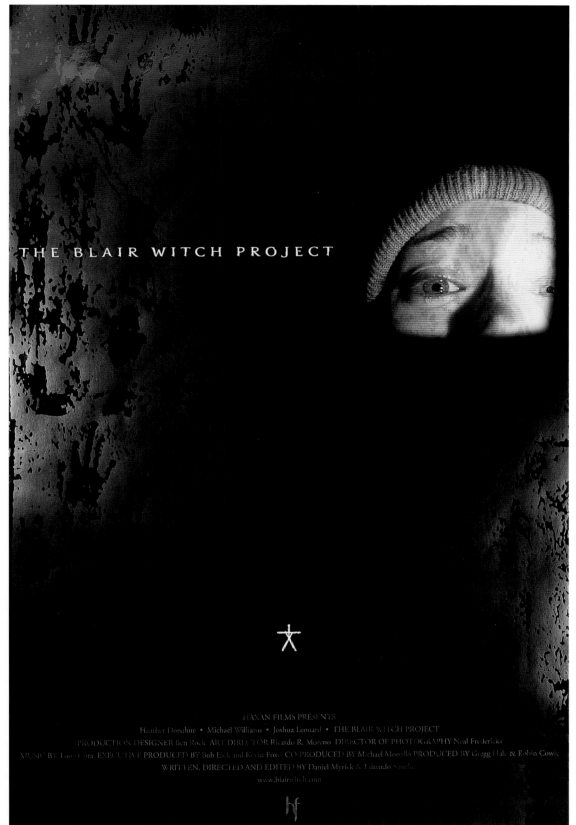

THE BLAIR WITCH PROJECT

HAXAN FILMS PRESENTS
Heather Donahue • Michael Williams • Joshua Leonard • THE BLAIR WITCH PROJECT
PRODUCTION DESIGNER Ben Rock ART DIRECTOR Ricardo R. Moreno DIRECTOR OF PHOTOGRAPHY Neal Fredericks
MUSIC BY Tony Cora EXECUTIVE PRODUCED BY Bob Eick and Kevin Foxe CO-PRODUCED BY Michael Monello PRODUCED BY Gregg Hale & Robin Cowie
WRITTEN, DIRECTED AND EDITED BY Daniel Myrick & Eduardo Sanchez
www.blairwitch.com

Film festival *The Blair Witch Project*
Sundance movie poster

Art directors Steve Carsella, Chris Jones,
Scott Sugiuchi
Designer Steve Carsella
Photography found film footage
Studio Backbone Design
Client Haxan Films
Typefaces Pterra, Garamond
Software Adobe Illustrator
Colors 3/C flat, silkscreen (plus spot varnish)
Print run 500

Concept Carsella went for "creepy, subtle. I
dreamt about an old house from a scene in
the movie, and in my dream this old house
was at one time a snail farm, where one
might breed snails for sale. I guess that is
where the idea for the glistening spot varnish
effect came from."

CDs & MUSIC GRAPHICS

I HAVE SEEN THE FUTURE

Music packaging takes many forms, and other sections of this book have featured work that could be considered music packaging. The dominance of music entertainment in our popular culture makes it difficult to avoid, but for the most part (and for the purposes of this section), the actual packaging of the music is the focus: compact disc covers and vinyl record sleeves. Although CDs have taken over from vinyl records as the preferred commercial medium, vinyl has by no means disappeared. It has, however, become less the province of major music manufacturers than the arena for the independent record label publishing 45 singles and extended play records as an inexpensive (or, more so now, appealing to the collector and having a certain market credibility) alternative to the compact disc. Music subgenres like dance and hip hop have relied upon vinyl, both as a means of conveying its product to its audience and as a creative instrument for its DJs and studio mixmasters.

The challenge in compiling this section was not so much in discerning quality work, since there is a tremendous amount of material from which to choose (also, CD package design is a mostly "young" industry, with designers in their twenties and thirties being relatively common and the industry itself having the appearance of being contemporary, even edgy). Rather, the challenge was in finding those working outside of the record industry mainstream of New York City and Los Angeles (although work in the mainstream was not excluded). Graphics for independent record labels—from such disparate locations as Orlando, the Pacific Northwest and Brooklyn—is much of what is featured here. The often meager budgets of the indies have forced designers to approach problem-solving in a different, often raw and unadorned way. This was especially important to this book, in that ample work from the mainstream (and in particular, the catalog of stellar individual talent like Stefan Sagmeister and Helene

Silverman) is documented in design annuals and survey books on a continual basis.

The benefits of a major label budget, however, can allow for spectacular innovation, with fully realized production values (occasionally accomplished with the patronage of a band with creative control and the good sense to defer to their designers). Otherwise, the quagmire of a corporate bureaucracy can be daunting, not to mention the "the guitarist went to art school" or "the drummer has a girlfriend who went to art school" dilemma. Work done in the industry mainstream, as shown here, has thrived in spite of—or because of—these circumstances.

The conflagration of popular culture influences from the recent past that designers have rediscovered and have consciously, or unconsciously, incorporated into their work is a postmodern conceit of the 1990s. Examples range from Reid Miles' design and art direction of the Blue Note jazz record label in the 1950s, to anonymous periodisms (such as LP records done for garage-surf bands in the 1960s or saccharine teeny-bopper idols in the 1970s), to Jamie Reid's iconic *Never Mind the Bollocks, Here's the Sex Pistols*. More recent influences include Vaughan Oliver's packaging for 4AD Records of England and Bruce Licher's letterpress-driven designs for his Independent Project Press, as well as the not-to-be-underestimated Sub Pop record label—whose use of graphics (and not necessarily their bands) as their brand identity had an enormous influence on how indie labels were to be packaged. All can be perceived as an undercurrent to the work done by the *Next* generation.

In-store poster *Portishead*

Art director Steve Carsella, Chris Jones, Scott Sugiuchi
Designer Scott Sugiuchi
Photography from publicity
Studio Backbone Design
Client Figurehead Promotions
Typefaces Proton, Cyberotica, Helvetica Extra Compressed
Software Adobe Illustrator, Adobe Photoshop
Colors 4/C process (plus spot varnish)
Print run 1,000 limited run

Concept The designer calls it "an experiment with spatial area to content area ratio. The printer stressed over the 'mottled' look of metallic ink on French Butcher paper ('This looks like crap!')."

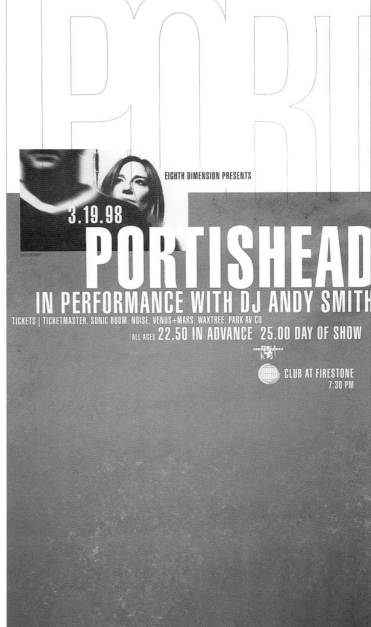

CD package Alan Jones Sextet, *Unsafe*

Art directors Joshua Berger, Niko Courtelis, Pete McCracken
Designer Dylan Nelson
Photographer Lars Topelman
Studio Plazm Design
Client Alan Jones Sextet
Typefaces Trade Gothic, Arial Black
Software Adobe Illustrator
Colors 1/C flat spot color; 4/C process
Print run 1,250

Concept "The packaging and promotions are conceptual extensions of the title of the CD, *Unsafe*. Warning label graphics, safety materials and hazardous material suits are used to convey a sense of danger."

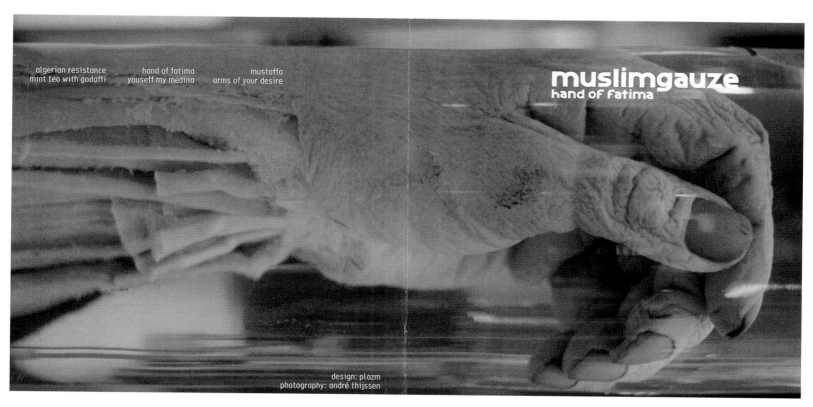

algerian resistance
mint tea with gadaffi

hand of fatima
youseff my medina

mustaffa
arms of your desire

muslimgauze
hand of Fatima

design: plazm
photography: andré thijssen

muslimgauze
hussein mahmood jeeb tehar gass

CD package Muslimgauze, *Hussein Mahmood Jeeb Tehar Gass*

Art directors Joshua Berger, Niko Courtelis, Pete McCracken, Riq Mosqueda
Designer Riq Mosqueda
Photographer Shirin Neshat
Studio Plazm Design
Client Soleilmoon Recordings
Typeface Interface
Software QuarkXPress, Adobe Photoshop
Colors 4/C process
Print run 2,500

CD package Muslimgauze, *Hand of Fatima*

Art directors Joshua Berger, Niko Courtelis, Pete McCracken
Designers Joshua Berger, André Thijssen
Photographer André Thijssen
Studio Plazm Design
Client Soleilmoon Recordings
Typefaces Lilyn Tupelo, Hand of Fatima (Plazm font)
Software QuarkXPress, Adobe Photoshop
Colors 4/C process
Print run limited edition of 1,000

Concept "Fatima, the daughter of Mohammed, is often looked to as an inspirational women's leader. Many women in Islamic societies are required to cover their bodies in public to discourage male temptation. This packaging attempts to question our perception of beauty by juxtaposing natural images of deformity with facsimilies of women."

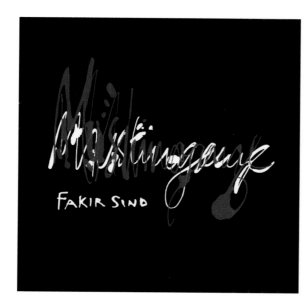

CD package Muslimgauze, *Fakir Sind*

Art directors Joshua Berger, Niko Courtelis, Pete McCracken
Designers Pete McCracken, Jon Steinhorst
Illustration Simona Bortis
Studio Plazm Design
Client Soleilmoon Recordings
Typefaces hand-drawn, Roscent (Plazm font)
Software QuarkXPress, Adobe Illustrator, Adobe Photoshop
Colors 4/C process, plus 1/C flat spot silkscreen
Print run limited edition of 1,000

Concept "Largely an interpretation of the music, this packaging recollects the energy of the tracks and the reoccurring samples of screaming peacocks."

45 single sleeve The Regurgitators
"Nothing to Say"; "I Sucked a Lot of Cock to Get Where I Am"

Art director Hank Trotter
Designer Hank Trotter
Studio Sub Pop Records
Client Sub Pop Records
Typefaces Grant Gothic (a Dan X. Solo face), Futura Extra Bold
Software Macromedia FreeHand
Colors black plus 1/C flat metallic
Print run 3,000

Concept The Regurgitators, an Australian band, wanted a release in the United States to coincide with an American tour. Their previous art could be labeled "early rave flier" with a dash of Japanese pop culture fetishism: bad design, atrocious colors and worse type. Trotter remarks, "Luckily, the release was scheduled late in the tour process and the band would have no time to review art. I decided to use this opportunity to give the band exactly what they didn't want, but which they *should* have—a cowboy and cowgirl to grace their first release in the US of A. The type is cut and pasted from photocopies and then reductions and enlargements are made until it's nice and hideous. I was inspired by the design work of Reid Miles and Art Chantry. Good American graphics to welcome Australians to our country."

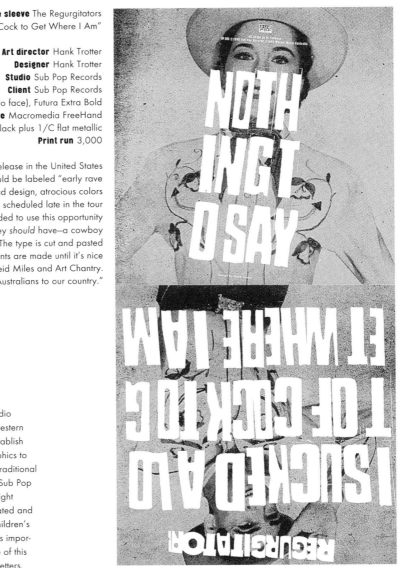

45 single sleeves Friends of Dean Martin, "Con Lo Mejor del Momento"; Dina Martina, "Christmas with Dina Martina"

Art director Hank Trotter
Designer Hank Trotter
Photographer Arthur S. Aubry ("Christmas...")
Studio Sub Pop Records
Client Sub Pop Records; Up Records
Typefaces Event Gothic, Orion Script (both by Dan X. Solo), Roman Compressed No. 2
Software Macromedia FreeHand, Adobe Photoshop
Colors 4/C ("Con Lo Mejor..."); 4/C sleeve, colored vinyl disc with 3/C flat label ("Christmas...")
Print run 3,000

Concept Tucson's instrumental Friends of Dean Martin have an old-time sound, as if their songs were floating in over the radio waves from a dusty, southwestern town. Trotter wanted to "establish that immediately in the graphics to differentiate them from the traditional pop and rock acts that the Sub Pop label was known for. The night desert scene was appropriated and manipulated from an old children's astronomy book. I felt it was important to emphasize the name of this new band—hence big, red letters.

"Dina Martina is a cabaret singer who doesn't get anything quite right, but she gamely pushes on. She directed the photo shoots before I was brought in, and luckily the photographer did a good job. The photos pointed me in the direction of a perfect 1950s era Christmas fantasy. This is Dina's perception of her world. Released by Up Records, I had done much of the label's design since its beginning. The three-color disc label is a master label for all Up singles. Specific release information is overprinted as needed."

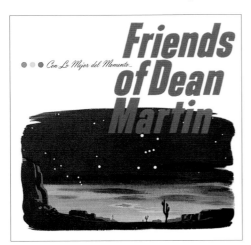

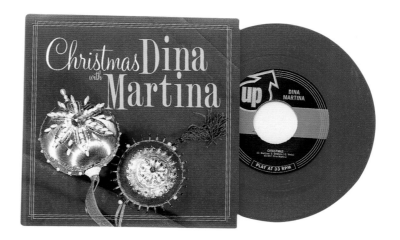

45 single double-sleeve Toilet Boys, "You Got It"; The Donnas, "Get You Alone"

Art director Edward ODowd
Designer Edward ODowd
Photographer Drew Weidemann
Studio Edward ODowd Graphic Design
Client Lookout Records
Typefaces FF Screen Matrix, hand-done logos
Software QuarkXPress, Adobe Photoshop, Adobe Illustrator
Colors 4/C process
Print run 3,000

Concept The idea for the double single emerged as a result of the good experience the two bands had touring together. So to suggest a brother-and-sister act, the mirrored poses and the "pink is for girls, blue is for boys" motifs were used. ODowd comments: "Basically, the idea was to design something hot and sleazy." Unlike most rock band packagers, the label went along with how the bands—and the designer—wanted to be presented. "Once the photographs were matched, they let me do what I wanted, and the label didn't try to second-guess our decisions."

CD digipac Cannonball Adderley, *Quintet in Chicago*

Art director Patricia Lie
Designer Edward ODowd
Studio Edward ODowd Graphic Design, New York, NY
Client Verve Records
Typeface Gates Hellgate Wide (variation)
Software QuarkXPress, Adobe Photoshop, Adobe Illustrator
Colors 4/C plus 3 hits of opaque white on kraft paper
Print run 10,000

Concept Created as part of a series of repackaged classic jazz records from the label's catalog, it was also designed to exist independently. ODowd says, "I wanted something that would be tactile so I selected a kraft stock because it has an organic quality—having a softer, more approachable feel that wouldn't be so brash—to reflect Adderley's image as warm and earthy. He was also an experimental, multilayered musicia. The design suggests this and additionally picks up on qualities of the original album cover art, inset as part of the design."

Tail Removal (Tailecoccusecto...

EXCERPTED ...
The Pathology of Definite Dispro...
EDITED BY DR. M. ...

... not sick are
...rriers can re...
... others with...

... important
...occus, not ...
...red child to ...
...e developm...
...othful behav...
...s are all too...
... in as many
...12 to 15 ye...
...ly treated ta...
...reatment: ...il germ respon...

which will help ...
if your child has this germ.
The tail germ can cause bad man-
ners of different severity in different
individuals. Some manifestations may
be so mild as to be unrecognizable,
while others cause severe discipline
problems, swollen glands in the neck,
scarlet neck lines, and even short at-
tention spans.
The tail germ is highly contagious,
especially among children in the
same family or in the same school-
room. Sometimes we see a family
who has one child who picks his
nose, another with poor table man-
ners, and a third who sasses his el-
ders, yet all have the same tail germ.
To make it even more difficult,
one or both parents may be infected
and have no symptoms whatsoever.
These individuals who have the germ

DR. M. Y. JOHNSON AND PATIENT

Remember, the child will feel ...
ter after few days or hours on peni-
cillin, and it may be tempting to dis-
continue the medication. To be effec-
tive, it must be given for a FULL TEN
DAYS!!! This goes for the corporal
punishment as well!

45 single sleeve Supersuckers,
"Born With a Tail"

Art director Hank Trotter
Designer Hank Trotter
Studio Sub Pop Records
Client Sub Pop Records, Supersuckers
Typefaces Dancer, Century, manual typewriter
Software Macromedia FreeHand, traditional mechanical
Colors 2/C flat (offset)
Print run 2,000

Concept "The Supersuckers are rock 'n' rollers who culti-
vate a 'bad boy' image. Deep down, however, they are
sweet boys who love their mothers. I thought it would be
fun to create a fake illness that has caused these boys to
turn bad. Thus, the 'Born With a Tail' 45 takes the form
of a medical file, complete with a story from a medical
journal and an X ray."

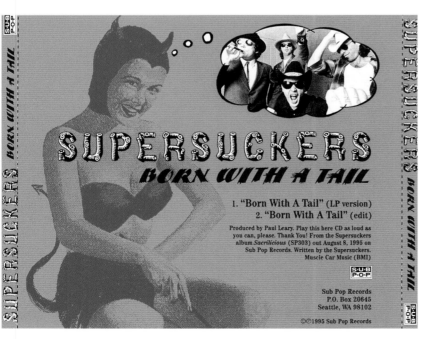

CD package Supersuckers, *Born With a Tail*

Art director Hank Trotter
Designer Hank Trotter
Studio Sub Pop Records
Client Sub Pop Records, Supersuckers
Typefaces Dancer, Log, Century
Software Macromedia FreeHand, traditional mechanical
Colors 2/C offset
Print run 5,000

Concept "Sub Pop was loaded with money when they put
this out. The radio department was new and pushing the
Supersuckers's new album, *Sacrilicious*, really hard. This
CD was sent only to radio stations and other media out-
lets. I used the Log type and cowboy image because the
band, at the time, all wore crumpled cowboy hats on
stage. The thoughts of the cowboy again reflect my idea
of the Supersuckers as rock's nicest bad boys."

45 single cover God Bullies, "Millennium"

Art director Steven Cerio
Designer Steven Cerio
Illustrator Steven Cerio
Studio Steven Cerio's Happy Homeland
Client Radical Records
Typefaces hand-rendered
Software traditional mechanical
Colors 4/C process
Print run 1,000

Concept "The band thought it would be odd to cross-pollinate my overtly friendly style with their overtly sinister one. The band moniker called for something pseudo-religious and cryptic."

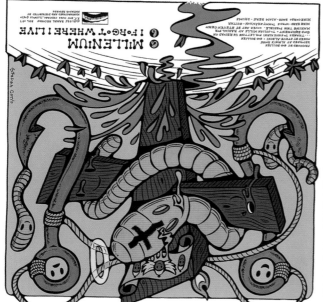

CD package Goobers, A Collection of Kid's Songs

Art director Sheenah Fair
Designer Steven Cerio
Illustrator Steven Cerio
Studio Steven Cerio's Happy Homeland
Client TEC Tones Records
Typefaces hand-rendered
Software traditional mechanical, QuarkXPress
Colors 4/C process
Print run 4,000

Concept "The title type was hand-drawn and vertically stretched on a computer, and then hand-traced once again." The subtitle type led Cerio to design a full matching typeface with four variations for each letterform.

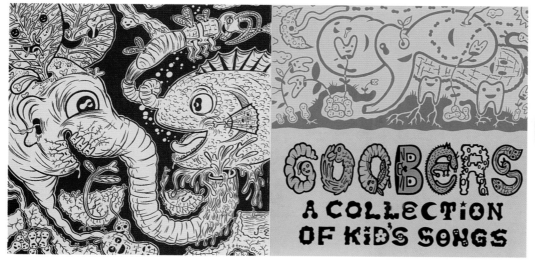

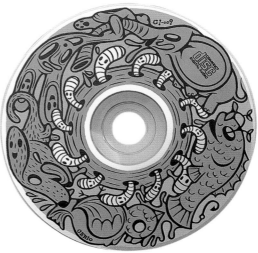

Club promo Snatch! (set of three)

Art director Hank Trotter
Designer Hank Trotter
Studio Twodot Design
Client Snatch!
Typefaces Venus Extrabold Condensed, Century
Software Macromedia FreeHand
Colors 2/C flat offset
Print run 1,000

Concept "I can't remember who brought this project to me, but oh boy, am I ever glad she did. Snatch! was a short-lived lesbian dance night and a perfect opportunity to use sexy images from my old men's magazines. The ladies the promoter of this event wanted to attract all understood these images. I thought it quite punk to use them in a fresh way. My favorite is the one with the woman reaching into the fridge for a piece of pie, the letter A in *Snatch!* covering her bare behind."

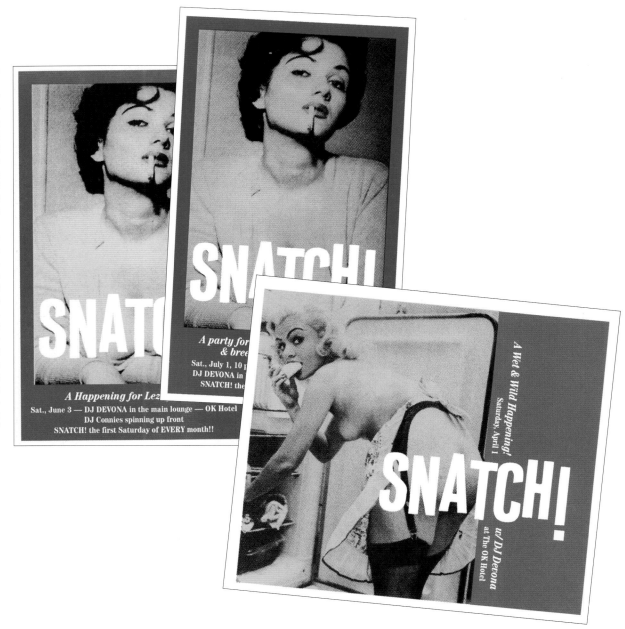

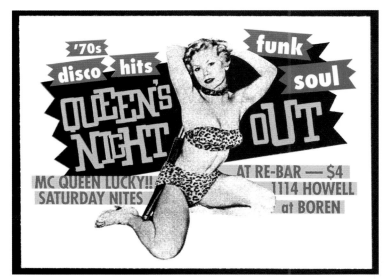

Club promo Queen's Night Out

Art director Hank Trotter
Designer Hank Trotter
Studio Twodot Design
Client Re-bar
Typefaces Futura and an unknown display face
Software Macromedia FreeHand
Colors 4/C process
Print run 1,000

Concept "This is a promotional card for a dance night at Re-bar, where Seattle's smartest gays and straights mix for good music and good dancing. The model, from one of Peter Gowland's how-to pinup photography books, reminded me of MC Queen Lucky. I ran separations on my laser printer and then photocopied them. I wanted to duplicate bad offset printing." The ultimate compliment? "Someone once said it looked like a color Xerox."

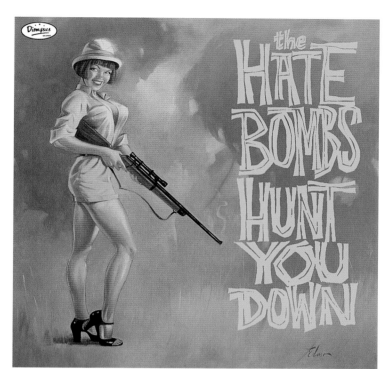

CD package Hate Bombs, *Hunt You Down*

Art directors Steve Carsella, Chris Jones, Scott Sugiuchi
Designer Scott Sugiuchi
Photographer Bob Deck
Studio Backbone Design
Client Dionysus Records
Typefaces hand-rendered, distressed Garamond
Software Adobe Illustrator, Adobe Photoshop
Colors 4/C process
Print run 5,000

Concept "The band wanted to capture the vintage feel of Capitol Records releases, circa 1950. This was achieved by re-creating pin-up art (à la Gil Elvgren) and relying on exotica-inspired hand-lettering, instead of computer-set faces."

45 single sleeve Hate Bombs, "Ghoul Girl" sleeve

Art directors Steve Carsella, Chris Jones, Scott Sugiuchi, Ken Chiodini
Designer Scott Sugiuchi
Studio Backbone Design
Client Baby Doll Records
Typefaces hand-manipulated vintage horror movie typefaces, Helvetica Ultra Compressed
Software Adobe Illustrator, Adobe Photoshop
Colors 2/C flat (black and fluorescent orange)
Print run 500

Concept "Contrary to popular belief, drummers can think! The band's drummer came up with the idea of a split 45 sleeve—one half beautiful ingenue, one half horrific she-devil—that perfectly captures the A-side, 'Ghoul Girl.'"

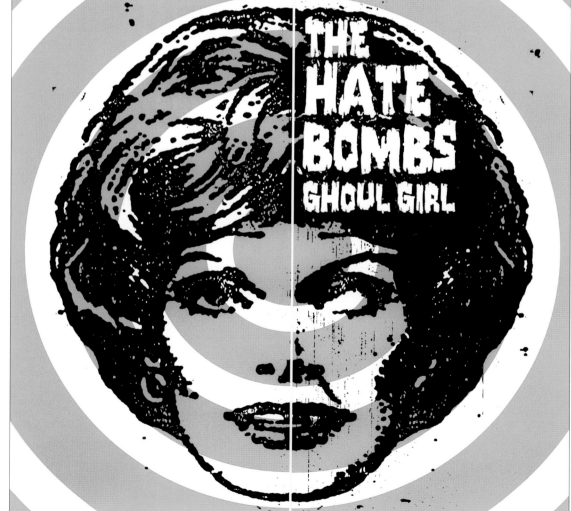

Sackcloth 'n' Ashes

I SEEN WHAT I SAW
BLACK SOUL CHOIR
HAW
SCRAWLED IN SAP
······HORSE HEAD······
RUTHIE LINGLE
HARM'S WAY
BLACK BUSH
HEEL ON THE SHOVEL
AMERICAN WHEEZE
RED NECK REEL
PRISON SHOE ROMP
NECK ON THE NEW BLADE
STRONG MAN

Music by 16 Horsepower, Lyrics by David Eugene Edwards
Published by WB Music Corp./Shame Town Publishing (ASCAP)
Produced by Warren Bruleigh - Co-Produced by 16 Horsepower
Produced, Recorded and Mixed by Michael W. Douglass & Alex Reed at A&M Studios, Hollywood, CA
Recorded by Jeff Powell at Ardent Studios, Memphis, TN
1ST ASSISTANT: JEFFREY S. REED - OTHER ASSISTANTS: SKID MILLS, MATT MARTONE & PETE MATTHEWS
Mixed by Jeff Powell & Warren Bruleigh at Ardent Studios, Memphis, TN ~ Mastered by Alan Yoshida at A&M Mastering Studios, Hollywood, CA
A&R: Jeff Suhy

MUSICIANS: DAVID EUGENE EDWARDS: VOCALS, GUITARS, BANJO, BANDONEON, LAP STEEL
JEAN-YVES TOLA: DRUMS, BACKUP VOCALS
KEVEN SOLL: STAND UP BASS, FLAT TOP ACOUSTIC BASS, CELLO, BACKUP VOCALS
SPECIAL GUEST, GORDON GANO: FIDDLE

Gordon Gano appears courtesy of Interscope Records
Management: Amy Berg for Steve Stewart Management
Thanks to the good people of Denver and to all of our Kin. Slim Cessna and the Auto Club, Jeffrey Paul Norlander and the Denver
gentleman, Leah Samantha and Asher Johanna Edwards, Saret Tola, Laurence Martin Paul, Bob Ferbrache, John Robinson,
Rebecca Blasband, Steve Roberson, Spell, Gordon Gano, Shane Hotle, Marylin and the Mercury Cafe, Deputy Dave Staudte, Stephanie
Dines, Montier family, Rebecca Dickman, Matt Bischoff, Stacy Benedict, Lynne Valencia, Susan Powel, Doug Kaufman, Mary Moses, Tom
Payetta, Jackie Selby, Don Strasborg, Michael Roberts, John Leventhal, Joseph Lujan and family, Michael Mehle, Danielle Faraldo, Kathy
Anaya, Michael Badami, John Fry, Tammy Nestler, Gary Curry, Tim Kae, Sam Gay, Theo Hakola, Patrick Lees and Jeremy Wakefield.
✝ Special thanks to Jeff Suhy and A&M Records, Amy Berg, Stacy Fass, Jamie Friser, Frank Riley, Shari Saba and Steven Stewart. ✝

CONTACT:
16 HORSEPOWER
IDLEDALE BOX 285
DENVER, CO 80453

Art Direction & Design: Sunja Park ✝ Photography: Keith Carter

CD packages Sixteen Horsepower, Sackcloth 'n' Ashes

Art director Sunja Park
Designer Sunja Park
Studio Sunja Park Design
Client A&M Records
Typefaces hand-rendered (primary logotype) and 30 different support faces
Software QuarkXPress, TypeStyler
Colors 4/C process
Print run 50,000

Concept "This was one of the few bands I've worked with that had a very secure identity, and they gave me complete trust and creative control. Their music is very spare and, at the same time, baroque, pretty and aggressive. I tried to convey that in the package. Each lyric was laboriously set line for line. The laser printouts were 'aged' via a clunky, gray copy-machine, then stained with instant coffee powder. Each of the twelve pages took about eight hours to do. The European division of the label wanted a band photo on the cover, so, for them, I made it into a fold-out poster booklet. It's a plastic snake, by the way."

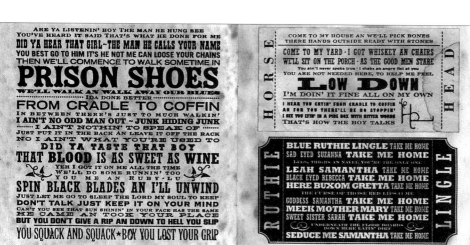

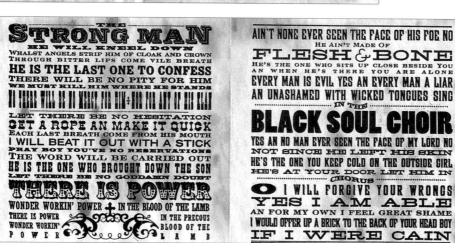

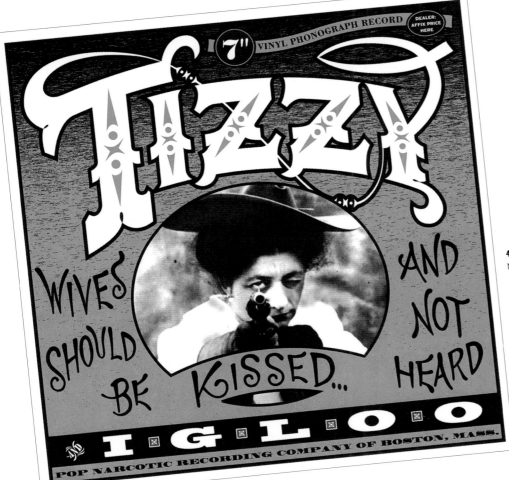

45 single sleeve Tizzy, "Wives Should Be Kissed...and Not Heard"

Art director Thomas Scott
Designer Thomas Scott
Studio Eye Noise
Client Pop Narcotic Records
Typefaces hand-rendered; Blackoak, Madrone, Poplar, Bodoni Poster
Software Adobe Photoshop, Adobe Illustrator
Colors 2/C flat
Print run 1,000

Concept "Although their music is thrashy punk rock, the band suggested a Western look for the cover. The song title inspired this early twentieth-century sheet music look."

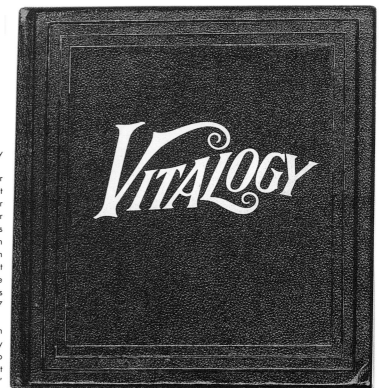

CD package Pearl Jam, *Vitalogy*

Art directors Joel Zimmerman, Eddie Vedder
Designer Barry Ament
Illustrators Barry Ament, Eddie Vedder
Photographers Jeff Ament, Lance Mercer
Studio Ames
Client Epic/Sony Music, Pearl Jam
Typefaces hand-rendered; typewritten
Software Adobe Illustrator, traditional mechanical, typewriter, duct tape, copy machine
Colors 4/C process
Print run 5,351,127

Concept "We basically gutted a medical book from the nineteenth century. After two long days and nights, it was out the door. It's pretty scrappy and rough around the corners, which I think works. We also changed the CD format to vertical to compliment the book feel. Great idea, but not very functional in your CD rack."

10 | IT'S SUMMER HERE

There are 13 headless turtles
Hanging on a line
Their severed heads will snap a stick
And break your finger pretty quick
The blood is draining from their necks
And out into the grass
The flies are buzzing all around
A hatchet sticking in the ground

The river looks like chocolate milk
It's foaming at the banks
The snakes come out to sun themselves
You think you've died and gone to hell
I found one in the yard today
So I gave it to the dog
She barked and got it by the head
And flung it 'round till it was dead
And it's summer here

Out behind the barber shop
The barber's burning hair
He lights it laughing to himself
He knows you can't escape the smell
The smoke is rising from the pile
And out into the town
It stings your eyes and burns your nose
And makes it's way all thru your clothes
And it's summer here

JOHN BOAT 11 | HAGGED 12

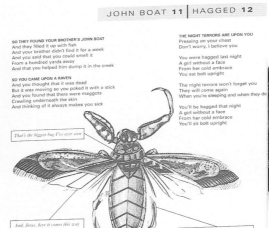

SO THEY FOUND YOUR BROTHER'S JOHN BOAT
And they filled it up with fish
And your brother didn't find it for a week
And you said that you could smell it
From a hundred yards away
And that you helped him dump it in the creek

SO YOU CAME UPON A RAVEN
And you thought that it was dead
But it was moving so you poked it with a stick
And you found that there were maggots
Crawling underneath the skin
And thinking of it always makes you sick

That's the biggest bug I've ever seen

And, Jesus, here it comes this way

THE NIGHT TERRORS ARE UPON YOU
Pressing on your chest
Don't worry, I believe you

You were hagged last night
A girl without a face
From her cold embrace
You sat bolt upright

The night terrors won't forget you
They will come again
When you're sleeping and when they do

You'll be hagged that night
A girl without a face
From her cold embrace
You'll sit bolt upright

I can feel it crawling over me today

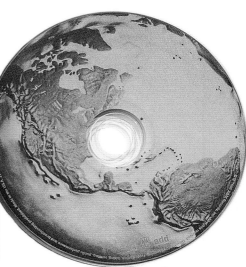

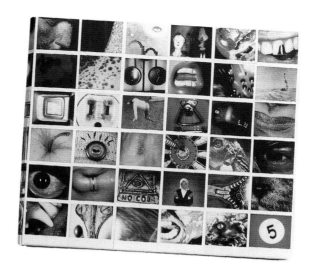

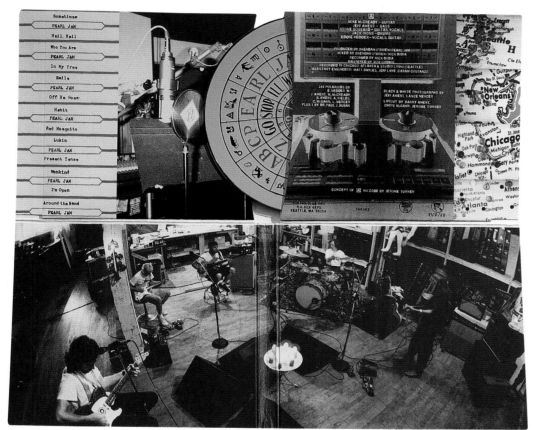

CD package Pearl Jam, No Code

Art director Jerome Turner
Designers Barry Ament, Chris McGann, Jerome Turner
Photographers (black and white) Jeff Ament, Lance Mercer; (Polaroids) Eddie Vedder, Jeff Ament, M. McCready, Barry Ament, A. Fields, Chris McGann, Lance Mercer, P. Bubak
Studio Ames
Client Epic/Sony Music, Pearl Jam
Typefaces children's home printing kit
Software Adobe Illustrator; traditional mechanical elements
Colors 4/C process, matte varnish
Print run 2,205,906

Concept "This was all laid out on the floor of our shop," Jerome Turner explains. "Over several weeks, photos were added and through process of elimination, here's what you got. A bonus for the kids...there's a secret symbol in the photos (stand back and squint). Each CD came with a set of nine cards, out of a possible thirty-six (we were going for the trading card theory). We used high-gloss and matte varnishes on the cards to give them a Polaroid feel. We also use three forensics cameras (Polaroid) and cases of film. My personal fave of all the Pearl Jam CDs, mostly because of the insane amount of work and effort."

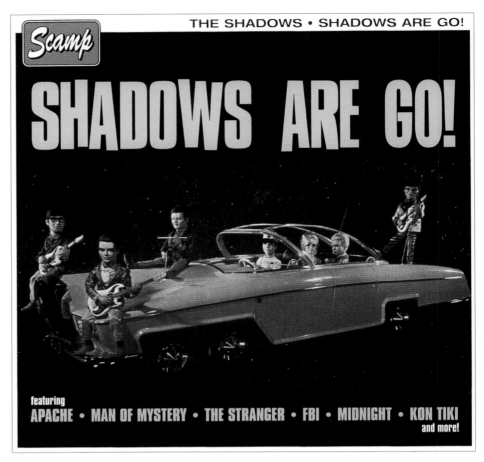

CD package Shadows, *Shadows Are Go!*

Art director Peter Ciccone
Designer Peter Ciccone
Studio Immaculate Concepts
Client Scamp Records
Typeface Compacta
Software QuarkXPress, Adobe Photoshop
Colors 4/C process
Print run 15,000

Concept Ciccone strove for "a 1960s English LP feel, as this was the era of the recordings and when the band was most popular." He tried to achieve an authentic look with the photo of the Shadows as 'Thunderbirds' super-marionettes, from a British science fiction television series for children that combined traditional puppetry with stop-motion animation, instead of cel-animation.

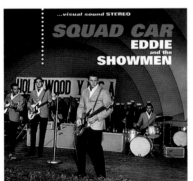

CD package Eddie and the Showmen, *Squad Car*

Art director Peter Ciccone
Designer Peter Ciccone
Studio Immaculate Concepts
Client AVI Records
Typeface Univers
Software QuarkXPress, Adobe Photoshop, Macromedia FreeHand
Colors 4/C process
Print run 6,000

Concept Ciccone used a colorized photo, trying to re-create the feel of an old surf album—by a band who had never released an album during their time together.

CD package Gary Usher, *Greats Volume 1*

Art director Peter Ciccone
Designer Peter Ciccone
Studio Immaculate Concepts
Client AVI Records
Typeface Univers
Software QuarkXPress, Adobe Photoshop, Macromedia FreeHand
Colors 4/C process
Print run 6,000

Concept The designer was "trying to get an updated version of the old Capitol surf album, with no art or band photos other than the original LPs. I kind of remixed the art for the cover, descreening some black-and-white photos from the rear of one album, then applying a coarse screen to it. A lot of the AVI material was done in a style reminiscent of the era when the material was recorded, both to appeal to the collectors and because of my own take on the material."

CD package The Untamed Youth, *Untamed Melodies*

Art director Peter Ciccone
Designer Peter Ciccone
Photographer Stacy Zaferes
Studio Immaculate Concepts
Client Norton Records
Typeface Potomac
Software QuarkXPress, Adobe Photoshop
Colors 4/C process
Print run 2,000

Concept Ciccone formed the design around a hand-tinted photograph from a shoot at Coney Island. "Got some color photos to use as reference and fooled the band. This is a band who sounds like 1960s frat/surf, so I went for something in that style—very much in the Norton style, very straight ahead and clean."

CD package Rare Surf, *Volume 2: The South Bay Bands*

Art director Peter Ciccone
Designer Peter Ciccone
Photographer photos supplied by the bands
Studio Immaculate Concepts
Client AVI Records
Typeface Helvetica Compressed
Software QuarkXPress, Adobe Photoshop
Colors 4/C process
Print run 6,000

Concept "Trying to get a good 1960s feel, I colorized the photo in Adobe Photoshop and tried to use colors reminiscent of the surf era. The band asked how I knew what color their suits were! A very clean design."

CD package The Misfits, *Static Age*

Art director Peter Ciccone
Designer Peter Ciccone
Studio Immaculate Concepts
Client Caroline Records
Typefaces House Monster Fonts, hand-rendered
Software QuarkXPress, Adobe Photoshop
Colors 4/C process
Print run 80,000

Concept Ciccone describes it as "a kind of 1950s Roger Corman movie poster feel, taken from one of the first Misfits fliers. This design is different than the way the band usually presented themselves, but I think it worked nicely, since this was basically their unreleased first album, and gave it a primitive horror-movie look without being too overt."

CD package Peter Thomas Sound Orchestra, *Futuremuzik*

Art director Peter Ciccone
Designer Peter Ciccone
Photograph photo courtesy of Braun AG
Studio Immaculate Concepts
Client Scamp Records
Typeface Univers
Software QuarkXPress
Colors 4/C process
Print run 15,000

Concept Ciccone explains that this is "kind of a 1960s take on the future, with a very clean and minimal design on the cover. There is a little bit of electronica influence, but not enough to distract from what the music is. I found a photo of a futuristic turntable from the 1960s, got the rights, and went from there."

CD package various artists, *Stacked Up*

Art director Hank Trotter
Designer Hank Trotter
Photographer Arthur S. Aubry
Studio Twodot Design
Client Up Records
Typefaces Eddy Gothic, Trade Gothic, Century, Compacta
Software Macromedia FreeHand
Colors 4/C process
Print run 5,000

Concept "I was picturing a Beach Boys hot rod record from the 1960s when I did this design. Up Records is run by a man with an encyclopedic knowledge of pop music, who encouraged this design's reference to a time when albums were either a collection of band's singles, or just a hit or two and the rest filler."

CD package various artists, *Roots Reggae*

Art director Peter Ciccone
Designer Peter Ciccone
Studio Immaculate Concepts
Client Caroline Records
Typefaces Helvetica Compressed, Franklin Gothic, Rosenblum Googlehoffer (variation)
Software QuarkXPress, Adobe Photoshop, Macromedia FreeHand
Colors 4/C process
Print run 15,000

Concept Ciccone explains that it was "another case of no artwork to use, so I pulled what I could from the originals (reworked from original albums) and did a type treatment, trying for a jazzier feel."

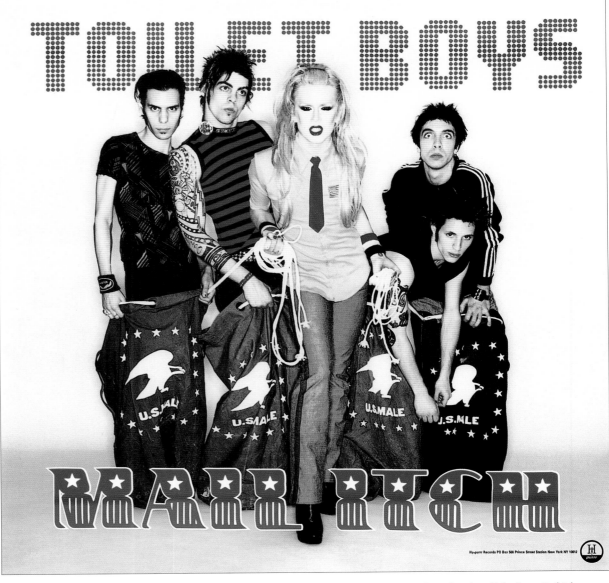

Record package Toilet Boys, *Mail Itch*

Art director Edward ODowd
Designer Edward ODowd
Photographer Eli Hershko
Studio Edward ODowd Graphic Design
Client HyPurrr Records
Typefaces unidentified display face found in a Dover type catalog
Software QuarkXPress, Adobe Photoshop
Colors 4/C process
Print run 1,000

CD package Submarine, *Submarine*

Art director Edward ODowd
Designer Edward ODowd
Illustrator Shasti O'Leary
Studio Edward ODowd Graphic Design

Client The Ultimate Recording Group
Typefaces hand-rendered
Software QuarkXPress, Adobe Photoshop
Colors 4/C process
Print run 10,000

Concept "I first met with Submarine in England. The band and manager took me to a pub, fed me beer after beer and kept on repeating various bits of strange imagery to me. Waking up the next day with a pounding headache, all I could really recall of the previous evening was the band's singer, inches from my face saying, 'Imagine an entire family with their heads on fire....' When I returned to New York a few days later, I sat down with digital illustrator Shasti O'Leary, and it just kind of happened. We sat back from her computer monitor and decided it was the eeriest thing we had ever seen. The band, of course, loved it."

Concept The band approached art director Edward ODowd and said: "We are doing a single called 'Mail Itch.'" According to ODowd, "Most of the work was getting the 'U.S. Male' postal bags and the singer's 'mailperson' costume created. Once the props were in place, we started shooting. The band logo was something we had developed during a previous project (it has since been abandoned for something less campy), and the type for *Mail Itch* was found in an old Dover book. Low-budget projects like these are a huge challenge that I can't resist. They force the creative team to be extremely resourceful in order to make a potential disaster look like a million bucks!"

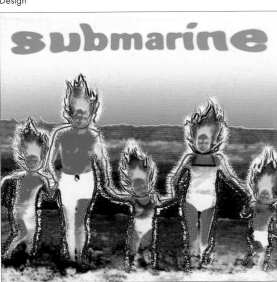

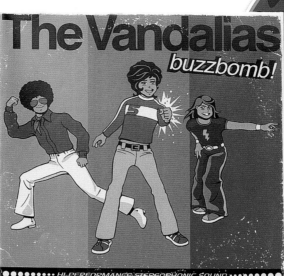

CD package The Vandalias, *Buzzbomb*

Art director Shawn Wolfe
Designer Shawn Wolfe
Studio Shawn Wolfe Company
Client Tenpop Works
Typeface Helvetica
Software QuarkXPress, Adobe Photoshop, Macromedia FreeHand
Colors 4/C process
Print run 20,000

Concept "The Vandalias are a cartoon-concept pop band—a combination of The Archies and *Speed Racer*. This was the band's second CD. I had recently conducted an imaginary interview with the cartoon characters for *Speak* magazine, in which I redrew the characters as *anime* (shorthand for Japanese animation) stars. The band was so excited with the results that they asked me to design the new CD and to redesign the characters in keeping with what I'd done for the *Speak* article. The package is filled with depictions of the fictional characters' Minneapolis stomping grounds, past 'smash hit' sin-

gles of many nations, contests and fan club info in the spirit of classic 1970s teen sensationalism, à la *Tiger Beat*." The designer contrived "scuffling" on the CD cover, akin to an LP record sleeve showing the wear of sitting in a bin for too long, slowly outlining the vinyl record inside.

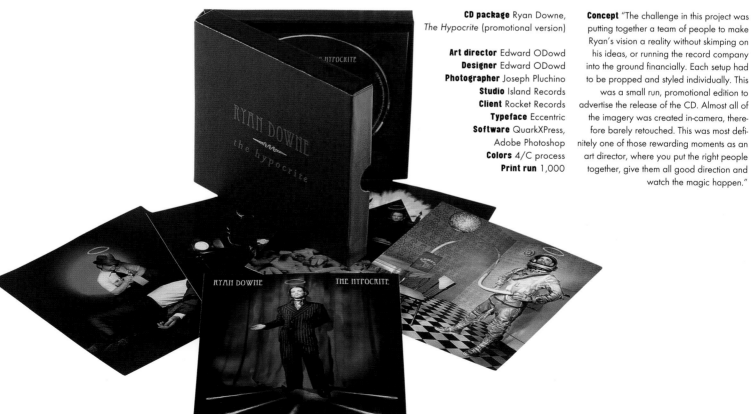

CD package Ryan Downe, *The Hypocrite* (promotional version)

Art director Edward ODowd
Designer Edward ODowd
Photographer Joseph Pluchino
Studio Island Records
Client Rocket Records
Typeface Eccentric
Software QuarkXPress, Adobe Photoshop
Colors 4/C process
Print run 1,000

Concept "The challenge in this project was putting together a team of people to make Ryan's vision a reality without skimping on his ideas, or running the record company into the ground financially. Each setup had to be propped and styled individually. This was a small run, promotional edition to advertise the release of the CD. Almost all of the imagery was created in-camera, therefore barely retouched. This was most definitely one of those rewarding moments as an art director, where you put the right people together, give them all good direction and watch the magic happen."

CD package George Carlin, *The Little David Years*, 7 CD box set

Art director Benjamin Niles
Designer Benjamin Niles
Studio Atlantic Records
Client Atlantic Records
Typefaces Helvetica, Garage
Software Adobe Photoshop, Adobe Illustrator
Colors 4/C process
Print run 10,000

Concept "George sent me a big box of nostalgia and said, 'Go for it.' It was a treat to sift through all the photos and clippings from his heydays in the 1970s. I wanted to make the piece nostalgic, yet contemporary, so I used all the old artwork as it exists today—beat up and well-loved. Then I designed other components to have a similar feel, such as inner sleeves, CD labels and a 32-page booklet. I wanted the cover to be somewhat conceptual and humorous at the same time. I wracked my brain for a hook, but everything seemed trite. Then one day George sent a box of slides of himself simply making faces. Hallelujah. We had the budget to make a seven-step lenticular, but were cautioned not to use more than three photos or the process would turn to mush. It still makes me laugh. This was the best project I've ever worked on. There were no revisions to the design, and George approved everything when he saw it. My favorite class clown."

Promotional Sub Pop holiday card, 1994

Art director Hank Trotter
Designer Hank Trotter
Illustrator Jim Woodring
Studio Sub Pop Records
Client Sub Pop Records
Typefaces Type Script Two, Futura and an unknown display face
Software Macromedia FreeHand
Colors 4/C process
Print run 3,000

Concept "Oh, those crazy, hazy days of the 'cocktail nation!' Sub Pop was loaded with cash at the time as a result of its sale to Warner Bros. Records and had just snapped up Combustible Edison. Presto-chango! In one year Sub Pop goes from a hastily prepared black-only holiday card to this die-cut 4/4 monstrosity with a CD. 'Think of it as a party,' Bruce Pavitt, Sub Pop co-founder, once told me about spending the label's money."

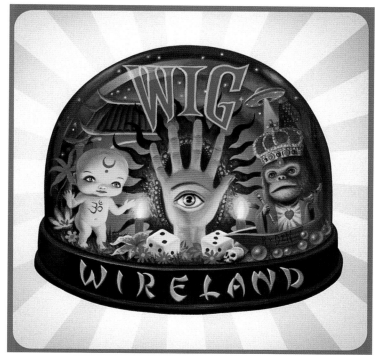

CD package Wig, *Wireland*

Art director Edward ODowd
Designer Edward ODowd
Illustrator Mark Ryden
Studio Edward ODowd Graphic Design
Client Island Records
Typeface Peking
Software QuarkXPress, Adobe Photoshop
Colors 4/C process
Print run 20,000

Concept "*Wireland* is an imaginary place that the band had conjured up some time before our first official meeting. After I was educated, we decided on illustration for the front cover as opposed to photography, as the latter could never do justice to such a surreal scene."

Store promotion Sub Pop Mega Mart card

Art director Hank Trotter
Designer Hank Trotter
Studio Sub Pop Records
Client Sub Pop Records
Typeface Futura
Software Macromedia FreeHand
Colors 2/C flat offset
Print run 1,000

Concept "This piece was my 'A-ha!' moment. It's when everything fell into place for the first time. I was proud of the final product and felt that it was a unique piece that worked well. The Mega Mart is Sub Pop's tiny retail outlet. Thus overselling it, complete with a suave spokesman, provided the necessary cynicism still so popular in today's advertising."

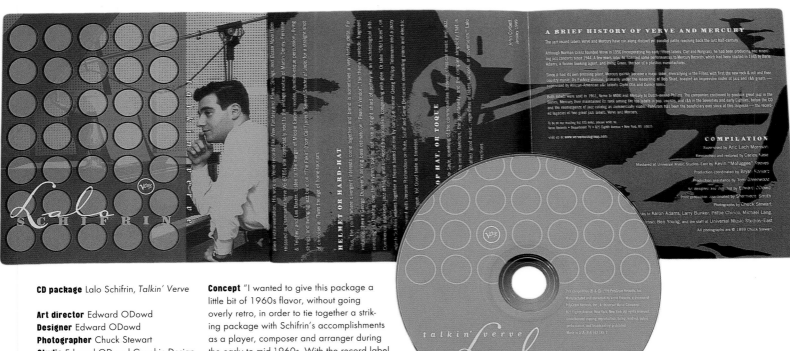

CD package Lalo Schifrin, *Talkin'* Verve

Art director Edward ODowd
Designer Edward ODowd
Photographer Chuck Stewart
Studio Edward ODowd Graphic Design
Client Verve Records
Typefaces Carmella Hand Script, Antique Bold
Software QuarkXPress, Adobe Photoshop, Adobe Illustrator
Colors 4/C process
Print run 10,000

Concept "I wanted to give this package a little bit of 1960s flavor, without going overly retro, in order to tie together a striking package with Schifrin's accomplishments as a player, composer and arranger during the early to mid-1960s. With the record label being insistent on usage of the image portraying 'the man at his piano,' it seemed reasonable to divide the photo into two sections: one for 'the man' and one for 'his piano.' By introducing them separately, this not only allowed me optimum placement for type, which would have otherwise been impossible, but also enabled me to convey his genius by showing how these two parts merge together with color and pattern."

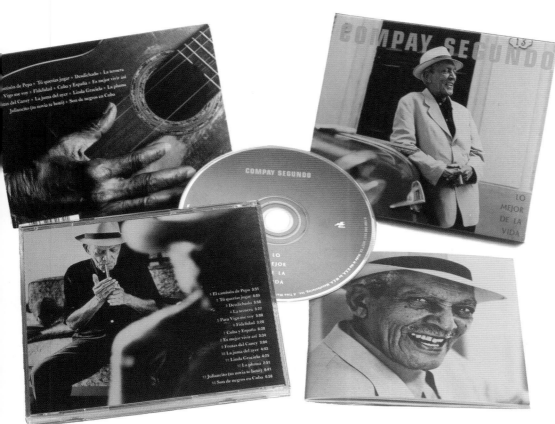

CD package Compay Segundo, *Compay Segundo*

Art director Karina Bezniki
Designer Martin Ogolter
Photographer Javier Salas, Manuel Zambrana
Studio Martin Ogolter/y design
Client Nonesuch Records
Typefaces Eurostile Condensed, Borzoi
Software QuarkXPress, Adobe Photoshop
Colors 4/C process
Print run 10,000

Concept "The client did not want a 'cigar box look,' so I tried to use simple, offbeat colors that seemed appropriate for the classy oldtimer. Compay Segundo is one of the members of the Buena Vista Social Club, and wrote most of the songs on that album. He was rolling cigars for decades, and the music world was oblivious of his accomplishments in the 1940s and 1950s. He wrote many of the classics of Cuban music, and because of the success of Buena Vista is finally reestablished."

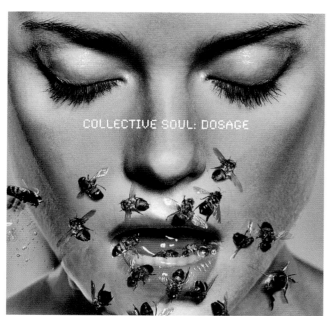

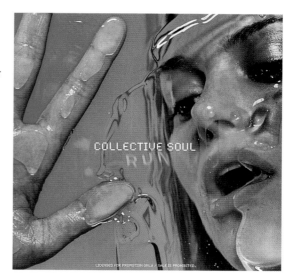

CD package Collective Soul, *Dosage*

Art director Benjamin Niles
Designer Benjamin Niles
Photographer Yves Bottalico
Studio Atlantic Records
Client Atlantic Records
Typeface Synchro
Software Adobe Photoshop, Adobe Illustrator
Colors 4/C process
Print run 750,000

Concept "We shot three concepts for Dosage and the 'bee cover' was chosen. Yes, they're real—but they're dead. The cover was created by compiling five shots, with the bees being moved each time. Diane Murkovich, the model, was terrific, even though she had been covered in honey for most of the day. Actually, everyone was terrific. A blast to work on."

CD single package Collective Soul, *Run*

Art director Benjamin Niles
Designer Benjamin Niles
Photographer Yves Bottalico
Studio Atlantic Records
Client Atlantic Records
Typeface Synchro
Software Adobe Photoshop, Adobe Illustrator
Colors 4/C process
Print run 10,000

Concept "One of the three concepts for the Dosage record—Diane Murkovich in an IV bag—became a cover for one of the singles."

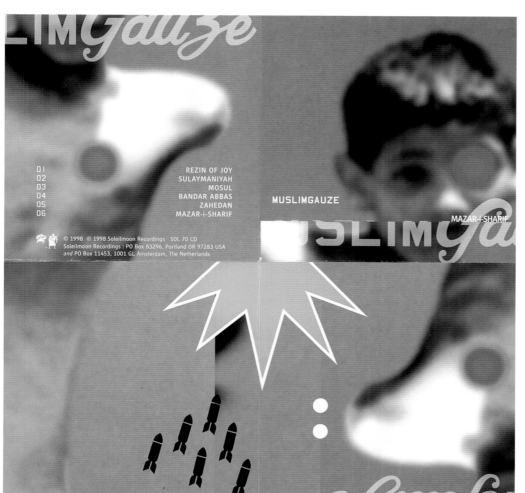

CD package Muslimgauze, *Mazar-i-Sharif*

Art directors Joshua Berger, Niko Courtelis, Pete McCracken
Designer John Kieselhorst
Studio Plazm Design
Client Soleilmoon Recordings
Typefaces Vitrina, Carplates, Roscent (Plazm fonts)
Software QuarkXPress, Adobe Illustrator, Adobe Photoshop
Colors 4/C process
Print run 2,500

Concept "Muslimgauze's music is often described as 'fake-Arab/ethnic/industrial.' He was an interloper from Manchester, England, appropriating Middle Eastern sounds to create a self-styled musical hybrid. This packaging attempts to capture and reveal an outsider's (Western) perspective on the politics of the Middle East."

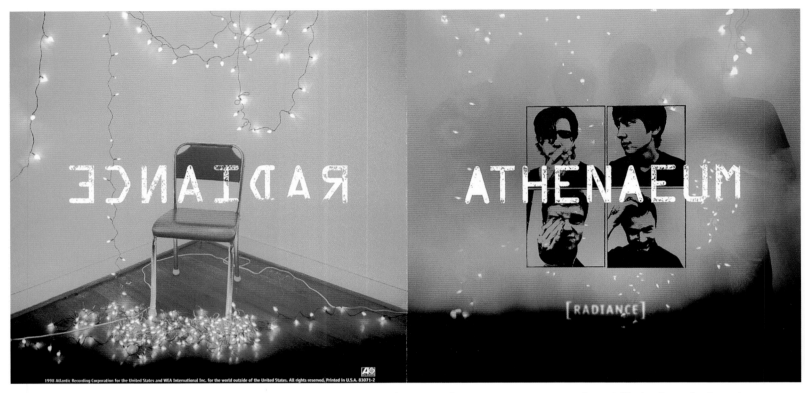

CD package Athenaeum, *Radiance*

Art director Benjamin Niles
Designer Benjamin Niles
Photographer Marina Chavez
Studio Atlantic Records
Client Atlantic Records
Typefaces Officina, Vietnamese wood type stamp
Software Adobe Photoshop, Adobe Illustrator
Colors 4/C process
Print run 40,000

Concept "The band insisted on being shot in their house, which didn't offer much visually. Since the album title was *Radiance*, I thought we'd experiment with various forms of lighting—looking for a chiaroscuro feel. In the end, they killed a shot of the band lit by a refrigerator light. Too bad."

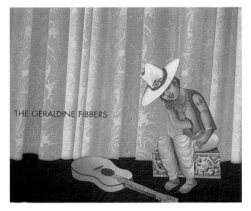

CD package The Geraldine Fibbers, *Get Thee Gone*

Art director Mark Brooks
Designer Mark Brooks
Illustrator Mark Brooks
Studio Mark Brooks
Client Hut Recordings/Virgin Records/Sympathy for the Record Industry
Typefaces unknown
Software hand-made collage, traditional mechanical elements, QuarkXPress
Colors 4/C process
Print run 5,000

Concept "This was originally made as a Sympathy for the Record Industry vinyl EP. Carla Bozulich (Fibbers' singer) took me to dinner in Malibu in exchange for the album art since there was no art budget. Months later, they got signed with Virgin Records. So much for art budgets. They made it up to me on the next record, though."

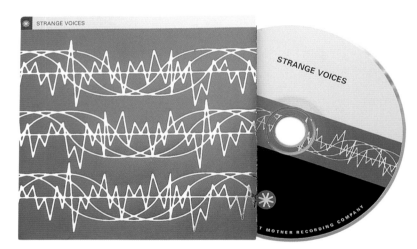

CD package Strange Voices, *Strange Voices*

Art director Shawn Wolfe
Designer Shawn Wolfe
Studio Shawn Wolfe Company
Client Sweet Mother Recordings
Typeface Univers
Software Adobe Photoshop, Macromedia FreeHand
Colors 4/C process, plus silver foil
Print run 1,000

Concept "God, we went around and around on the design of this disc. I had ideas, the band had ideas, the label had ideas—none of which seemed to jive at all. This project dragged out for the better part of a year before we could arrive at a compromise. The band wanted their likenesses to appear on the cover and the label wanted almost anything but that. The least disagreeable solution turned out to be this abstract, waveform, silver foil graphic treatment on the cover, with the appeasing rock star shots included on the inside."

CD package George Carlin, You Are All Diseased

Art director Benjamin Niles
Designer Benjamin Niles
Photographer Benjamin Niles
Studio Atlantic Records
Client Atlantic Records
Typeface Pixymbols
Software Adobe Photoshop, Adobe Illustrator
Colors 4/C process
Print run 50,000

Concept "Not surprisingly, George hates photo shoots, so I just shot his live performance off the television with a digital camera. He said he wanted to look angry. No problem."

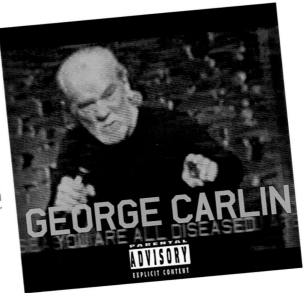

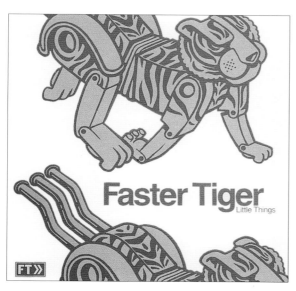

CD package Faster Tiger, *Little Things*

Art director Shawn Wolfe
Designer Shawn Wolfe
Studio Shawn Wolfe Company
Client Faster Tiger
Typeface Helvetica
Software Adobe Photoshop, Macromedia FreeHand
Colors 2/C flat
Print run 1,000

Concept "This was the long-awaited debut (self-released) CD, by Seattle pop-rock trio Faster Tiger. The visual metaphor is pretty literal, I suppose, although that mechanical tiger seems to be trotting along at an almost leisurely pace! We devised our own custom die-cut fold for this paper sleeve. For a low-budget production, it is still sort of elegant." This piece was printed by Girlie Press, Seattle.

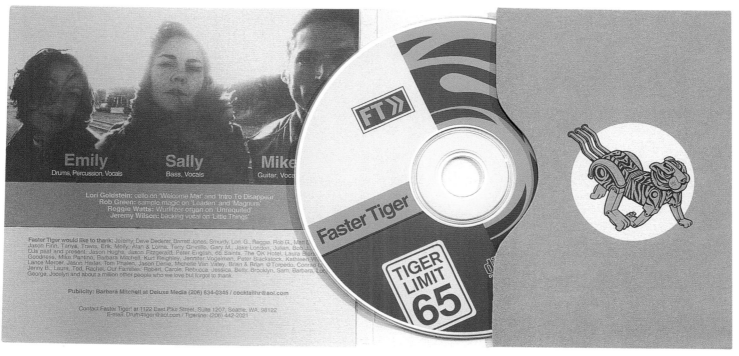

Record package (seven inch) Foreskin 500, *Who's Afraid of the Big Bad Noise?*

Art director Mark Brooks
Designer Mark Brooks
Illustrator Mark Brooks
Studio Mark Brooks
Client Milk Sop Records
Typeface Latin Wide, hand-rendered
Software traditional mechanical
Colors 1/C (black); belly wrap printed red on photocopier onto yellow paper
Print run 1,000

Concept Brooks wanted "to make a comic book with song accompaniment. Side two contains the sound for the read-along story, with all voices done by myself and bandmate Diggie Diamond." The designer is a member of Foreskin 500, and consequently packages all of their releases. In addition to his role in the band, Brooks is an animator and the artist and author of the alternative newspaper comic strip "Mongo Boy."

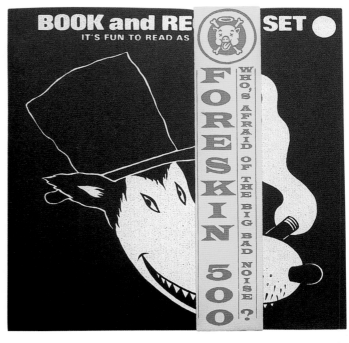

Picture disc (seven inch) Foreskin 500, *More Than a Feeling*

Art director Mark Brooks
Designer Mark Brooks
Illustrator Mark Brooks
Studio Mark Brooks
Client GSL Records
Typeface hand-rendered
Software Adobe Photoshop, QuarkXPress
Colors 4/C process
Print run 1,000

Concept The band aimed "to parody Boston's first album cover. We had to sneak in on the weekends to bandmate John's office to use their computers because they had 64 megabytes (gulp) of RAM (this was 1995)."

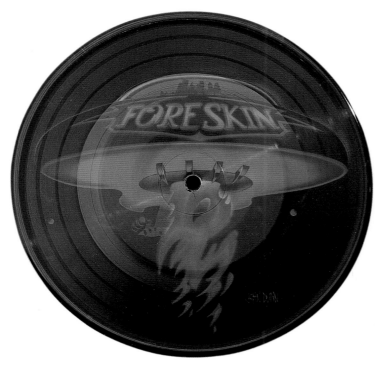

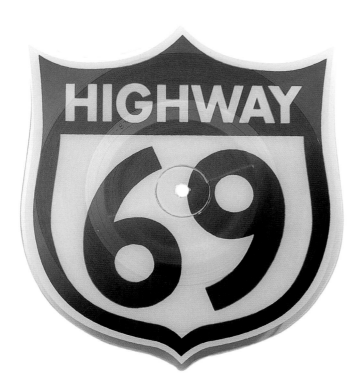

Die-cut picture disc (seven inch) Foreskin 500, *Highway 69*

Art director Mark Brooks
Designer Mark Brooks
Illustrator Mark Brooks
Studio Mark Brooks
Client Basura/Priority Records
Typeface Futura
Software traditional mechanical
Colors white ink screened onto the back of clear vinyl
Print run 3,000

Concept Put simply, the idea was "to create a die-cut highway sign. No matter what direction. Everytime, 69."

CD single package (promotional) Therapy?, "Perversonality"

Art director Sunja Park
Designer Sunja Park
Studio Sunja Park Design
Client A&M Records
Typefaces Eurostyle, Helvetica Rounded
Software Adobe Photoshop, QuarkXPress
Colors 4/C process
Print run 10,000

Concept Appropriating the illustrations from an old children's book, Is a Magnet Sticky?, the designer calls it "a very easy and effective Adobe Photoshop flippy trick. I often imagined this poor kid running into himself thirty years later with three eyes and two mouths, gracing the cover of an Irish hard rock band's CD."

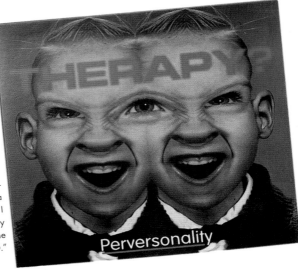

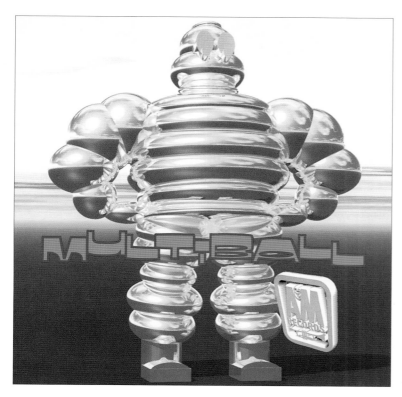

CD package *Multiball*, multi-artist compilation/radio promotion

Art director Sunja Park
Designer Sunja Park
Illustrator Andrew Brandou
Studio Sunja Park Design
Client A&M Records
Typeface Matrix Script
Software Adobe Photoshop, QuarkXPress, Adobe Illustrator
Colors 4/C process
Print run 10,000

Concept "This was a very quick, particularly disposable CD compilation, usually compiled every few months to promote a label's latest releases to college radio. I think the illustration was done in an hour. I put it together in about thirty minutes, but it came out pretty good, I think."

45 single sleeve The Grifters, *Organ Grinder/Wicked Thing*

Art director Hank Trotter
Designer Hank Trotter
Studio Sub Pop Records
Client Sub Pop Records, The Grifters
Typefaces Egyptian Expanded, Hallmark Script
Software Macromedia FreeHand
Colors 4/C process
Print run 2,000

Concept "The Grifters had a member of the band who worked at a screen print shop and knew all about graphic design. He didn't get this design at all, but had to let it slide because the release was late. After this, it was agreed by all parties that The Grifters would work with Sub Pop's other designer."

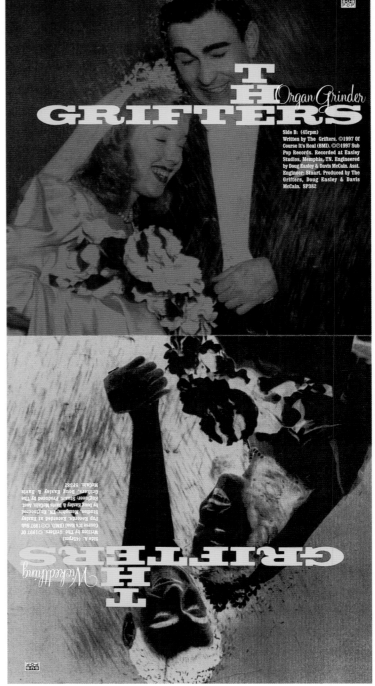

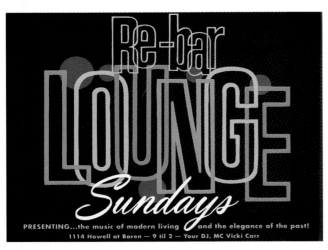

CD package Re-bar, "Lounge Sundays"

Art director Hank Trotter
Designer Hank Trotter
Studio Twodot Design
Client Re-bar
Typefaces Gothic Outline, Type Script Two, Futura
Software Macromedia FreeHand
Colors 4/C process
Print run 500

Concept "More of that damn lounge music all the kids were talking about a few years ago. I was hoping for a neon-light, Vegas feel for this."

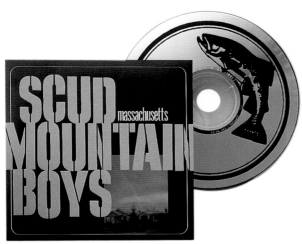

CD package Scud Mountain Boys, *Massachusetts*

Art director Hank Trotter
Designer Hank Trotter
Photographer Bruce Tull
Studio Sub Pop Records
Client Sub Pop Records, Scud Mountain Boys
Typefaces Stencil, Emporia Gothic, Futura
Software Macromedia FreeHand
Colors 4/C process
Print run 5,000

Concept "The Scud Mountain Boys were four guys from Massachusetts with a dark take on traditional American music, yet who sound remotely like the Eagles. They sent in these blurry photos to use (very popular among indie rock musicians at the time). I wanted to create a bold cover for this new band with an unusual name. I believe you can do two things for an unknown band and their CD in the record shop rack: One, grab the buyer's attention somehow; and two, give an indication of what music is inside. Beyond that, it is luck and lots of touring that decide whether anyone ever actually buys the CD."

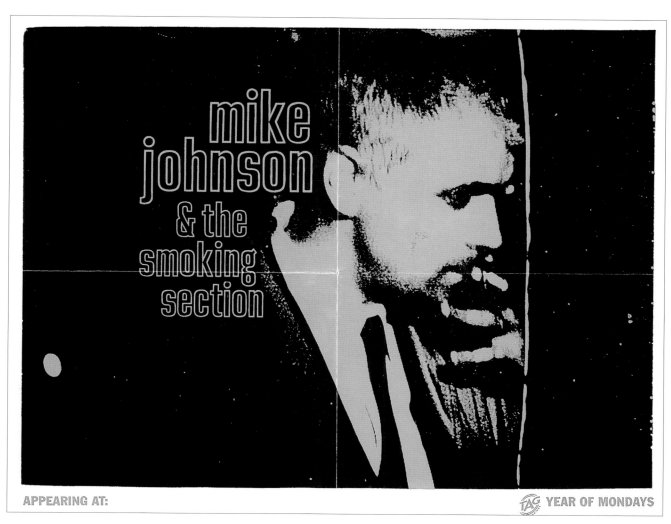

APPEARING AT: TAG YEAR OF MONDAYS

In-store promo sheet Mike Johnson and the Smoking Section

Art director Hank Trotter
Designer Hank Trotter
Studio Twodot Design
Client TAG Recordings
Typeface Gothic Outline
Software traditional mechanical
Colors 2/C flat offset
Print run 2,000

Concept "Mike Johnson played bass in the now defunct alternative rock band Dinosaur Jr. His solo music, however, takes more inspiration from Lee Hazlewood and Charlie Rich. His songs explore sadness, and his voice has a resigned quality. He really does smoke a lot. I thought silver and black in high contrast were best to convey the introspective, quiet and somber music one would encounter at the shows on the tour this poster promoted."

CD package Scud Mountain Boys, *The Early Year (Pine Box)*

Art director Hank Trotter
Designer Hank Trotter
Illustrator Whiting Tennis
Studio Sub Pop Records
Client Sub Pop Records, Scud Mountain Boys
Typefaces Stencil, Clarendon
Software Macromedia FreeHand; traditional mechanical
Colors 4/C process
Print run 5,000

Concept "For this reissue of two of the band's previous vinyl-only albums, I had Whiting Tennis render the photograph from the Scuds' first album in a wood block print. I typeset the song titles, then photocopied them to death and ran them on in one long sentence to convey the band's depressed, stream-of-conscious world view."

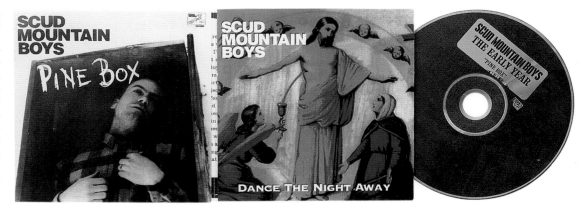

CD package Richard Peterson, *The William Loose Songbook*

Art director Shawn Wolfe
Designer Shawn Wolfe
Studio Shawn Wolfe Company
Client Pop Lama
Typefaces Sign Painter, Akzidenz
Software Adobe Photoshop, Macromedia FreeHand
Colors 4/C process
Print run 1,000

Concept Richard Peterson, a Seattle legend known for years as a street musician, is also a recording artist. His fourth studio release is a collection of work by William Loose (an obscure composer of music for 1950s and 1960s television), rearranged and performed by Peterson, with lyrics written by Peterson and sung and/or rapped by guest vocalists. Wolfe, obviously a fan of this autistic musician, notes, "The CD booklet features photos from Richard's extensive personal collection of 'Personality Buddies' (i.e., famous and not-so-famous entertainers or broadcasters Richard has had his picture taken with). Richard Peterson is an 'outsider artist' in the true sense. The notion of portraying him in front of palm trees for the cover shot was strictly Richard's idea (Loose's most famous TV show music comes from the series 'Sea Hunt'). To fulfill his vision, I worked with the photographer to get a serviceable image of Peterson that we could composite into the fabricated tropical scene. I used Richard's own handwriting, wherever possible, in the liner notes and photo credits."

CD package The Ass Ponys, *The Known Universe*

Art director Sunja Park
Designer Sunja Park
Photographers band photos, Michael Wilson; PhotoDisc, Inc., American Stock Photographer, Curwood, Inc., NASA
Studio Sunja Park Design
Client A&M Records
Typefaces Hefty, Univers
Software QuarkXPress
Colors 4/C process
Print run 50,000

Concept "Most of the songs on this record are about people from the band's home town—probably living and working within about a five-mile radius of the singer's house. There is also an intense longing for the innocence of a childhood never had, so the vernacular of an encyclopedia seemed appropriate for this project."

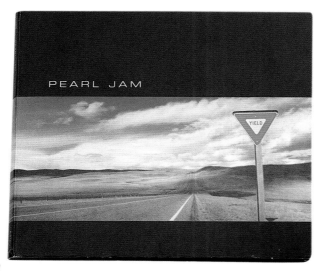

CD package Pearl Jam, *Yield*

Art directors Barry Ament, Coby Schultz, George Estrada
Designers Barry Ament, Coby Schultz, George Estrada
Photographers Jeff Ament, Jerry Gay, Greg Montijo
Studio Ames
Client Epic/Sony Music, Pearl Jam
Typeface Eurostyle
Software Adobe Photoshop, QuarkXPress
Colors 4/C process, matte varnish, high-gloss varnish, die-cut
Print run 1,809,098

Concept "We kept it super simple on the design and tried to drive the great photography."

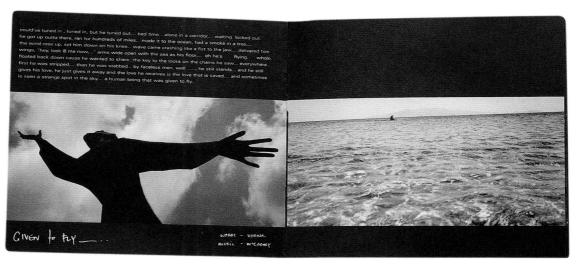

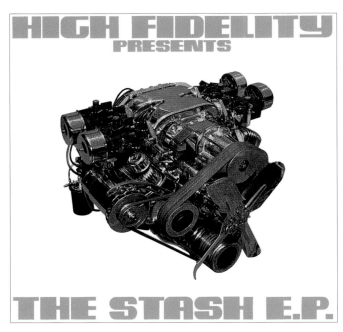

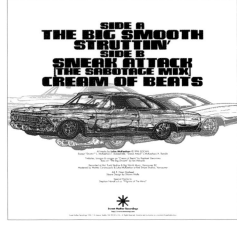

Record package *High Fidelity Presents the Stash EP*

Art director Shawn Wolfe
Designer Shawn Wolfe
Studio Shawn Wolfe Company
Client Sweet Mother Recordings
Typeface Jellybean
Software Adobe Photoshop, Macromedia FreeHand
Colors 4/C process, plus silver foil
Print run 1,000

Concept *"High Fidelity Presents the Stash EP was never explained to me and never made a heck of a lot of sense. In the absence of any direction from the label or the artist, I hauled out this phat image of a chrome-plated car engine. Removed from any context whatsoever, it kind of hovers majestically and provokes, justifying its own presence....hopefully."*

Backstage passes Tasty Shows

Art director Shawn Wolfe
Designer Shawn Wolfe
Studio Shawn Wolfe Company
Client Tasty Shows
Typeface Helvetica
Software Macromedia FreeHand
Colors 2/C flat
Print run 1,000

Concept "This design was recycled from the Meat Beat Manifesto promos I'd done for Tasty Shows. The oxygen mask image (with asphyxiation bubbles added by me) was adopted as the official Tasty logo and was in use for a few years. I always liked seeing these stick-on passes at club events and wished there were an oxygen mask concession around where I could pay to suck up some fresh air from a plastic bag. Maybe. Someday."

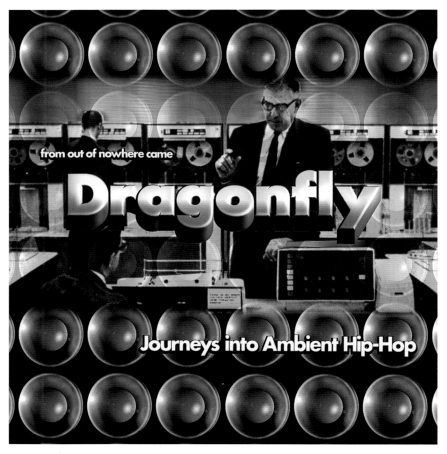

Record package Dragonfly, *Journeys Into Ambient Hip-Hop*

Art director Shawn Wolfe
Designer Shawn Wolfe
Studio Shawn Wolfe Company
Client Sweet Mother Recordings
Typeface Futura
Software Adobe Photoshop, Macromedia FreeHand
Colors 2/C flat
Print run 1,000

Concept "This was Dragonfly's debut twelve-inch single, and was also the first release of the Sweet Mother label in 1996. The two-man band wanted to remain incognito, so I interpreted 'Dragonfly' as a sort of code name for an intelligence spy ring of some kind. The cover image is supposed to suggest the nerve center of the Dragonfly organization, complete with hulking, archaic, mainframe computers and the like."

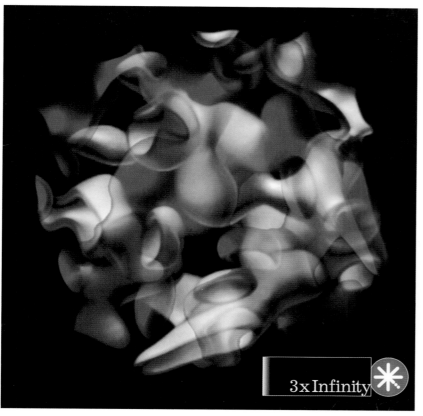

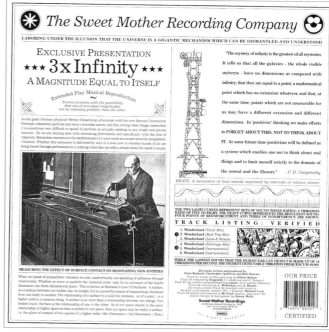

CD package 3xInfinity, *Infinite Possibilities...for Limitless Heads*

Art director Shawn Wolfe
Designer Shawn Wolfe
Studio Shawn Wolfe Company
Client Sweet Mother Recordings
Typeface Bodoni
Software Adobe Photoshop, Macromedia FreeHand
Colors 4/C process
Print run 1,000

Concept "This sleeve was a gas. Nasir Rasheed is the man who started the Sweet Mother label. 3xInfinity is one of DJ Nasir's side projects. The title suggested a metaphysical, head-trip kind of approach to the sleeve design. Nasir had once, not so long ago, worked as a molecular biologist and has a hard science background, so we devised this sleeve as a 'hard science, probing-the-timeslip-mysteries-of-infinity-through-sound' kind of thing....Or something like that. The metaphysical mumbo jumbo on the back was cobbled together from different esoteric sources. I like the juxtaposition of the ultra high-tech mysterioso image on the front cover with the turn-of-the-century, pseudo-science textbook treatment on the backside."

Club event promotion Fat Boy Slim

Art director Shawn Wolfe
Designer Shawn Wolfe
Studio Shawn Wolfe Company
Client Tasty Shows
Typefaces Egyptian, Helvetica
Software Adobe Photoshop, Macromedia FreeHand
Colors 3/C flat
Print run 1,000

Concept "This promo was a huge hit in itself. People love to assemble stuff. This little box hung around people's desks and knick-knack shelves long after the day of the show."

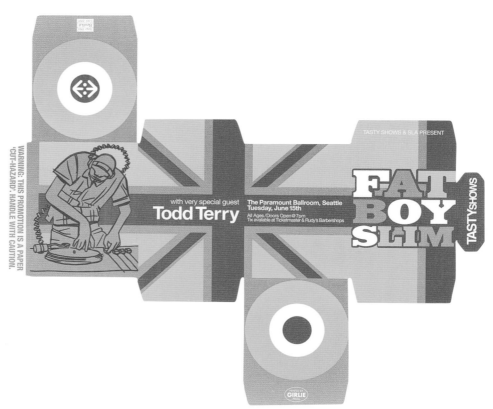

CD package Old Hickory, *Brain Travels Before the Heart Stops*

Art director Sunja Park
Designer Sunja Park
Studio Sunja Park Design
Client Mootron Records
Typefaces Einhorn, hand-lettering
Software QuarkXPress
Colors 4/C process
Print run 3,000

Concept For Los Angeles pop band Old Hickory's second release, "All the illustrations were culled from Golden Book encyclopedias. Each page of the booklet referred to the lyrical content of the song it illustrated. They really wanted a nice package. I think more was spent on printing (even though it was printed digitally to save money), than recording and pressing the CDs!"

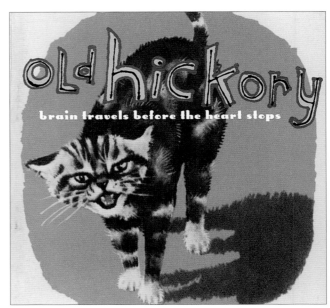

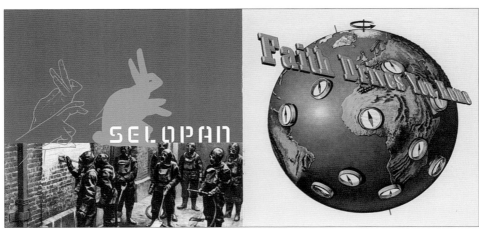

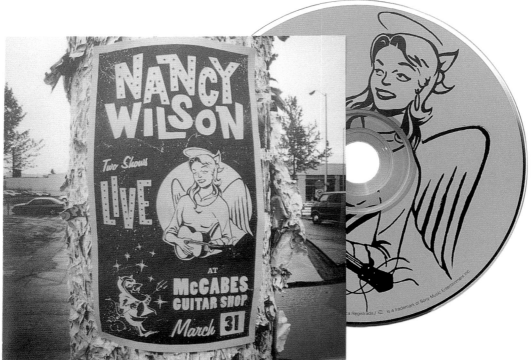

CD package Nancy Wilson, *Nancy Wilson Live @ McCabes Guitar Shop*

Art directors Coby Schultz, Nancy Wilson
Designer Coby Schultz
Illustrator Coby Schultz
Photographer John E. Hillingsworth
Studio Ames
Client Epic/Sony Music, Nancy Wilson
Typeface hand-rendered
Software Adobe Illustrator; traditional mechanical elements
Colors 4/C process
Print run 10,000

Concept The designer intended to "bring back the flyer on the telephone pole–place poster in a generic, everyday scene. The photo was taken in rainy Seattle, but the show was actually in sunny Los Angeles. Nancy was happy; we were happy. She was, to date, the easiest client to please."

god Lives Underwater
Life in the So-Called Space Age

CD package (gatefold) God Lives Underwater, *Life in the So-Called Space Age*

Art director Sunja Park
Designer Sunja Park
Photographer John Eder
Studio Sunja Park Design

Client 1500 Records
Typefaces Euphoria, Gill Sans
Software Adobe Photoshop, QuarkXPress
Colors 4/C process
Print run 50,000

Concept "The package needed to reflect the dense, surreal, urban environment that spawned the band (a Los Angeles-based DJ duo) and their music. John Eder had just gotten back from Bangkok with photos of crazy buildings. We got him in a helicopter weaving through downtown Los Angeles skyscrapers for the rest."

STUDIO

96819

This section refers to, generically, the design studio and the variety of materials generated by the freelance designer or independent design firm. Unlike previous sections, this one includes work as diverse as advertising, logo identities, stationery, business cards, wedding and birth announcements, self-promotion, audio box packaging, digital tape cassette covers, sale fliers, calendar cards, clothing labels and hang tags, publications and even parody, among other ephemera.

Indeed, like previous sections, this one benefits from a kind of aggressive resourcefulness, whether it is getting the best results out of a low, nearly nonexistent budget (see Heidi Kearsley's and Steven Cerio's self-promotional materials using rubber stamping), or maximizing the possibilities of an identity program (examine Plazm Design's solution for the Campaign for PICA). Here, also, we see logo identities executed by designers who are, in general, more conversant in rock 'n' roll and popular culture than corporate structures, yet who have created logos that are strikingly purist while retaining a counterintuitive originality. Ames's logos for K2 and Ride Snowboards, Me Music and Chemistry illustrate this interpretation. Much of their work, and the work of others in this section, also calls to mind the concept of "culture jamming," which is a form of parody that takes corporate symbols or advertising imagery (or its style) and changes the signature or copy to reflect a humorous or political message and may even be used to mock the qualities of the original corporate or advertising source. By adapting a formal, almost intimidating, corporate language for designs intended for an entertainment-oriented, multimedia company or a small, independent filmmaker, these designers are, like culture jammers, turning on its head our notions of perceiving visual language.

Also of special interest is the concept of the design studio as publisher—individuals who, for completely different, idiosyncratic purposes have generated their own magazines as vehicles for design. For example, Hank Trotter produces *Kutie*, an homage to men's magazines of the 1950s and early 1960s—not pornography, per se, but an anachronistic magazine concept using the structure and format of out-of-print publications such as *Ace*—with "manly" writing, offbeat humor and racy pictures. Stop to consider the re-emergence of "cocktail culture," the post-WWII, Sinatra-influenced era in fashion, music and lifestyle. Could purely graphic media have been far behind? Mark Dancey publishes *Motorbooty* as an extension of his own abilities as an art director, designer, cartoonist, illustrator and typographer, but also, significantly, as a showcase for artists who had formerly worked outside of the publishing mainstream. The energy and irreverence of the best of *Motorbooty* evokes *Mad* magazine during its heyday under William M. Gaines and Harvey Kurtzman. Plazm Design began as *Plazm*, in a sort of odd role reversal—a publication becoming a design studio. Given that, *Plazm* is a comprehensive, free-form, high design "bulletin board" for the creative community, which not only features guest design talent, but also generates and promotes new font designs. Like vigilantes, these designers have taken matters into their own hands.

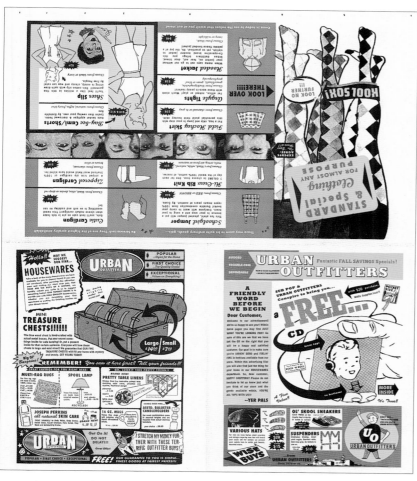

Advertising Urban Outfitters Fall 1994 Sale Flier

Art director Art Chantry
Text Art Chantry, Hank Trotter
Studio Art Chantry Design
Client Urban Outfitters
Typefaces Futura, Franklin Gothic, Trade Gothic, Rockwell
Software traditional mechanical; Macromedia FreeHand
Colors 4/C process
Print run 1,000,000

Concept "Art Chantry got this job and brought me in to help get it done," Hank Trotter explains. "Most of the design is his. Can you tell which page is all mine? I hope not. My main job here was to do all the typesetting and write the bonehead copy: 'Welcome to our advertisement! We're so happy to see you!' and 'HOT DANG! IT'S...PANTS!' I learned a ton working with Art on this and doubt anyone could, or would, want to duplicate an effort like this."

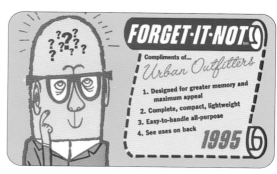

Ephemera Urban Outfitters Calendar Card

Art director Howard Brown
Designer Hank Trotter
Studio Twodot Design
Client Urban Outfitters
Typefaces Eddy Gothic, Franklin Gothic, Personality Script
Software traditional mechanical; Macromedia FreeHand
Colors 4/C process
Print run 5,000

Concept "I love wallet calendars. They used to be really popular. Now, they're pretty much the domain of insurance agents. But Urban Outfitters came up with the idea of doing a card calendar in 1994, and I was honored to design it. The clip art was found in old magazines."

Ephemera Uni-Card

Art directors Howard Brown
Designer Coby Schultz
Illustrator Coby Schultz
Studio Ames
Client Urban Outfitters
Typefaces Chatten, Akzidenz Grotesk
Software Adobe Illustrator
Colors 3/C process
Print run 20,000

Concept The design was based on a credit card. Says Coby Schultz, "If you were to have one card in your wallet, this is it—the Uni-Card. It's just a cool-looking wallet-sized calendar that looks like it'd be useful at all international airports. Printed with metallic inks. Looked so good you could almost buy gas with it."

Ephemera Holiday Greeting air freshener

Art director Jamie Sheehan
Designer Jamie Sheehan
Studio Sheehan Design
Client Sheehan Design
Typefaces Futura found and compiled
(cut and paste) headlines
Software Adobe Photoshop, QuarkXPress
Colors 3/C flat
Print run 1,000

Concept The idea was to create "something
from an everyday object, which would be
cheap to produce. Waiting in line at the gas
station, I noticed these 'green trees'—some-
thing you see every day. The trees looked like
a holiday ornament if taken out of its usual
context and, voila, a greeting card is obvious.
Best part: the die-cut is already done!" As the
old cliché goes, "Great minds think alike."
Sheehan and Ames were unaware of each
other's work in this case, but share some simi-
lar influences.

Party invitation Feliz Navidad air freshener

Art directors Mark Van S., Barry Ament, Coby Schultz,
George Estrada
Designer Barry Ament
Illustrator Barry Ament
Studio Ames
Client Mark Van S., Ames
Typefaces Havana, Jellybean
Software Adobe Illustrator
Colors 3/C
Print run 500

Concept "Doing your own stuff is always the most fun. The
design work took only a few hours and was pretty simple.
The real work was with the stapler and hole punch. We
were on a two-hundred dollar budget, but we still wanted
to produce a memorable invite. The air freshener was a
cheap solution and a perfect fit (the tree being the ulti-
mate symbol of holiday festivities). That party ruled!"

Ephemera Buhner Halloween invitation

Art directors Jamie Sheehan, Art Chantry
Designers Jamie Sheehan, Art Chantry
Studio Two Downtown, Inc.
Client Jay and Leah Buhner
Typeface Manson
Software QuarkXPress, Macromedia FreeHand
Color 1/C black
Print run 50

Concept The goal was to fabricate a fanciful invitation to
a family-style country Halloween party, complete with hay
rides and other activities for friends with children. Meant
to encourage the whole family to come for the fun, the
invitation includes a bendable plastic skeleton clutching a
"tombstone" full of gummy worms.

Ephemera Linda's Tavern matchbook

Art director Hank Trotter
Designer Hank Trotter
Studio Twodot Design
Client Linda's Tavern
Typefaces Futura, Linoscript
Software Macromedia FreeHand
Colors 3/C process
Print run 10,000

Concept "The matchbook was part of a whole campaign for a new tavern with a Northwest timber-town theme. I am particularly proud of my copywriting on this. 'A Nice Place for Nice People' was inspired by a local radio station that plays Frank Sinatra. One time, the announcer came on after a particularly soothing song and said 'KIXI, nice music for nice people.' I added the word 'friendly' on the back because, until Linda's opened, most taverns in Seattle were rock joints with surly wait staff. Also, Linda's is located in Seattle's gay neighborhood, and the proprietor wanted to make sure everyone was welcome."

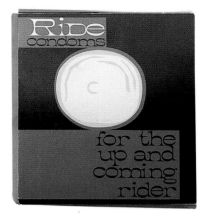

Ephemera/giveaway Ride condoms, "For the Up and Coming Rider"

Art directors Mike Styskal, Chris Franc
Designer Chris Franc
Studio Ride Snowboards
Client Ride Snowboards
Typeface hand-rendered
Software Macromedia FreeHand
Colors 4/C offset
Print run 1,000

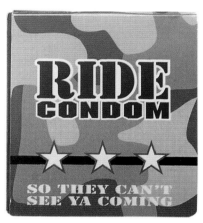

Ephemera/giveaway Ride condoms, "So They Can't See Ya Coming"

Art director Mike Styskal
Designer Mike Styskal
Illustrator Mike Styskal
Studio Ride Snowboards
Client Ride Snowboards
Typeface Stencil
Software Macromedia FreeHand
Colors 4/C offset
Print run 1,000

Concept "'For the Up and Coming Rider' was a trade show giveaway for Ride. Since the trade show giveaway had always been condoms, 'So They Can't See You Coming' was a reinforcement piece to establish Ride in consumers' minds."

Ephemera Breithaupt wedding invitation

Art director Jamie Sheehan
Designer Jamie Sheehan
Studio Sheehan Design
Client Michele Niewiadomski
Typefaces Adobe Garamond for body; hand-rendered Shelley Allegro for date; unidentified Art Nouveau type for headline (from a Dover book)
Software traditional mechanical; QuarkXPress
Colors 3/C flat
Print run 1,000

Concept The client and her fiancé already had children together, and they were constantly pestered about when they were to be married. "Since they had 'already sown their seed,' the concept was a package of scattered garden seeds, so people could now sow their own. Thus the family-in-a-pea-pod collage."

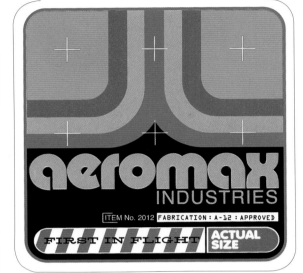

Hang tag/Pocket flasher Aeromax Industries

Art director Shawn Wolfe
Designer Shawn Wolfe
Studio Shawn Wolfe Design
Client Aeromax Industries
Typeface Spaceage
Software Adobe Pagemaker
Colors 5/C flat, brand type, embossed
Print run 50,000

Concept Says Estrada, "I used two colors the best I could—with knockouts and overprints. I wanted a jazzy, street-feel (like 'Paul Rand-in-the-hood')."

opposite page

Ephemera Fan Club Newsletter

Art directors Barry Ament, Coby Schultz, George Estrada, Mark Atherton
Designers Barry Ament, Coby Schultz, George Estrada, Mark Atherton
Illustrators Barry Ament, Coby Schultz, George Estrada, Mark Atherton
Studio Ames
Client Pearl Jam
Typefaces hand-rendered
Software traditional mechanical
Colors 2/C flat, silkscreen
Print run 25,000

Concept "Not a computer in sight...all hand-crafted down to the smallest type. We all took a chunk and met in the middle. Trick or treat!"

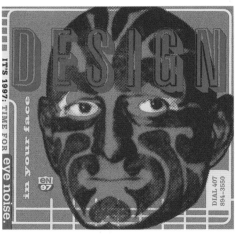

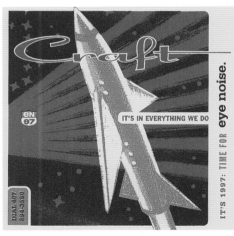

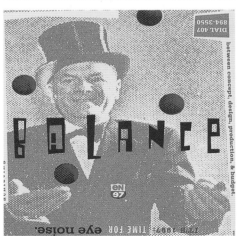

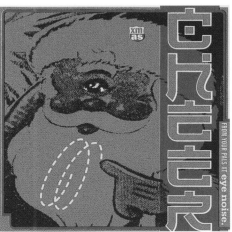

Self-promotion Eye Noise flash cards

Art director Thomas Scott
Designer Thomas Scott
Studio Eye Noise
Client Eye Noise
Typefaces hand-rendered
Software traditional mechanical; QuarkXPress
Colors 2/C flat on cream stock
Print run 500

Concept: Corral explains that the author's characters are rock-climbing enthusiasts and "Deadheads" (fans of the psychedelic band, The Grateful Dead). "I juxtaposed the repeated images of the rock climber, along with the radical arrangement of the type forms, in an attempt at reflecting the hallucinogenic nature of the story. Although the title type is fragmented, broken apart, and dressed up, it remains remarkably easy to read."

TEN CLUB
CHECK OUT THE ALL NEW #13 NEWS-LETTER...

...WE DARE YOU!
INSIDE
ASK GEORGE · TOUR INFO
NEW VIDEOS · CONTESTS
BOOK OFFER · & MORE!

P.O. BOX 4570 SEATTLE WA 98104

TEN CLUB

THE BARE! HIDEOUS! DANGEROUS!
FLESH OF STONE

FOR THOSE OF YOU WITH AN EYE FOR THE STRANGE AND FASHIONABLE, TAKE OUR STONE CLONE AND TRANSFORM HIM AND HIS AXE INTO YOUR OWN AMAZING CREATION. DON'T HOLD BACK! THE WINNER WILL RECIEVE A TENNIS RACQUET SIGNED BY THE LIVING STONE. ENTER AT YOUR OWN RISK!

HINT: Have your Stone figure laser copied onto a heavy paper stock (KINKOS). This will give you a more durable Stone to work with and you won't have to cut up your news letter.

#12 CONTEST
THANKS TO ALL OF THOSE THAT ENTERED. THERE WERE SOME INCREDIBLE PIECES. KEEP UP THE GOOD WORK AND KEEP READING.
GRAND PRIZE
REATHA KEMME
Huntington Beach, CA
RUNNERS UP
JULIE JENKINS
Seattle, WA U.S.
DAN KASSIONES
Vancouver, B.C., Canada
DIANE LEA
Albuquerque, NM, U.S.
JEZALL IUNGEM
Sydney, Australia
ROXANA ZEGAN
Charlesbourg, Quebec, Canada

8 TOUR

WHEW, HOME AT [LAST]. IT'S TIME TO TAKE A QUICK BREAK AFTER A BUSY YEAR. TOUR-[ED] MAUI, NEW ZEALAND, & AUSTRALIA THIS SPRING, THEN [HI]TTING THE U.S. WITH OVER 40 SHOWS FROM MISSOULA, MONTANA TO WEST PALM BEACH, FLORIDA. THE TOUR [C]OULD'NT HAVE GONE ANY BETTER (WITH THE EXCEPTION [OF] THE OCCASIONAL THREAT OF HURRICANES). IT'S BEEN [A]MAZING SEEING ALL OF YOU & YOUR FRIENDS IN THE [FR]ONT ROWS. THANKS FOR COMING OUT, AND THANKS [FO]R ALL OF THE LETTERS & E-MAILS REGARDING YOUR [FA]N CLUB TICKETS. IT'S OUR PLEASURE TO GIVE YOU THE [BE]ST SEATS IN THE HOUSE.

CHANGES
SO, WE HAVE [MA]DE A FEW PERSONNEL CHANGES [ARO]UND THE OLD FANCLUB FACT-[ORY]. CHANGE IS GOOD, BUT IT [AL]SO TAKES TIME, SO CUT US [SO]ME SLACK IF THE NEWS-[LE]TTER IS A BIT LATE. HOW-[EV]ER, WE'RE REJUVENATED, [IN]SPIRED AND READY TO GET [BA]CK TO THE BUSINESS @ HAND, [W]HICH IS TAKING CARE OF [YO]U IN THE BEST WAY POSS-[IB]LE!

FRIENDS LIKE THESE
[ON]E OF [OU]R FAVORITE [TH]INGS ABOUT TOURING IS GETTING TO PLAY WITH SUCH [GR]EAT SUPPORT ACTS. LEGENDS LIKE X, CHEAP TRICK, [FR]ANK BLACK, & IGGY POP, OLD FRIENDS LIKE MUDHONEY, [G]OODNESS, & BEN HARPER + NEW FRIENDS RANCID, SEAN [LE]NNON, MURDER CITY DEVILS, ZEKE, SPACEHOG, & THE [W]ALLFLOWERS. IT WAS A PLEASURE, THANKS TO ALL!

NOW THAT THE TOUR IS OVER, IT'S TIME FOR US TO GET READY FOR THE HOLIDAYS, BECAUSE WE MAKE ALL OF OUR OWN GIFTS, WE'VE GOT ALOT OF WORK TO DO. BRETT HAS BEEN BUSY REVIEWING ALL OF THE TAPES FROM THE TOUR, TRYING TO SORT OUT SOME GOODIES FOR THE HOLIDAY SINGLE. IT'S GOING TO BE TOUGH TO NARROW IT DOWN TO JUST TWO OR THREE SONGS...
[STAY TUNED]
*BRETT'S OUR SOUND GUY

KILLER KRISTMAS

TOP 13

STONES

PEARL JAM TRIBUTE BANDS/SONGS
1. THE JAM 2. HEAVY INTO JEFF 3. MINDY MCCREADY
4. IRON MAIDEN (EDDIE & EM'S) 5. CREED 6. ABBA (GAVE ABBRUZZESE)
TRIBUTE BANDS 7. GOING TO CALIFORNIA (CIVIL REPORT OF GIVEN TO FLY)
8. TEST AMENT 9. VEDDER THAN EZRA 10. CARPENTERS
(OBSCURE STONE TRIBUTE BAND) 11. JEFFERSON AIRPLANE
12. EDDIE & THE KOUSENS 13. IRON MAN

STONE TRIBUTE BANDS/SONGS
1. ROLLING STONES 2. STONE ROSES 3. STONE PONIES
4. STONE TEMPLE PILOTS 5. BOB DYLAN (RAINY DAY WOMAN
#1 & #13/STONE MUST GET STONED) 6. SLY & THE FAMILY
STONE 7. AND IT STONED ME (VAN MORRISON) 8. PAPA
WAS A ROLLING STONE 9. MARY CHAPIN
CARPENTER 10. STONE FREE 11. JOHNNY
CASH (I HEAR A CARPENTER) 12. CAR-
PENTERS 13. BLOODSTONE

@VHC TEN CLUB PEARL JAM NEWS-LETTER 13

STRANGE THINGS HAPPEN HERE!!!

VIDEO THE KILLED THE RADIO STAR

THERE HAVE BEEN A COUPLE OF VIDEOS RELEASED FROM OUR CAMP THIS YEAR WHICH MAY HAVE CAUGHT A FEW OF YOU OFF GUARD. IT SEEMS LIKE IT'S BEEN A PLEASANT SURPRISE. SINGLE VIDEO THEORY GAVE US A CHANCE TO LET OUR FANS INTO OUR CLUBHOUSE AND GIVE YOU ALL A LOOK AT SOME OF OUR SONGS FROM YIELD IN THEIR RAW AND UNPOLISHED STATE.

THE FULLY ANIMATED VIDEO CLIP FOR "DO THE EVOLUTION" WAS RECENTLY RELEASED, ENDING A SIX YEAR HIATUS FROM MUSIC VIDEOS. IT FEATURES ANIM-ATION FROM TODD MCFARLANE, THE CREATOR OF SPAWN. MCFARLANE WORKED CLOSE-LY WITH THE BAND AND ADMITTED THAT TRYING TO CRAM THE ENTIRE EVOLUTION OF MAN-KIND INTO 3 MINUTES AND 55 SECONDS WAS RATHER DAUNTING. HE HOPES THE VIDEO WILL INSPIRE VIEWERS TO QUESTION MAN'S ROLE.

CABFARE
YOU CAN FIND THE NEW PEARL JAM TRACK ALONG WITH PREVIOUSLY UN-RELEASED SONGS FROM SUPER-GRASS AND FUMANCHU ON THE SOUNDTRACK TO THE NEW FILM CHICAGO CAB AVAILABLE ON LOOSE & GROOVE RECORDS. ALSO ON THE SOUNDTRACK IS GREAT MUSIC FROM BRAD, THE HIP! KILLERS, AND SPARKLE HORSE. VISIT www.loosegroove.com

WHAT'S IN A NUMBER?
When I was a small boy, growing up on the northern plains of Montana, (7 miles in the snow every day...ha,ha, my mom told me all kinds of stories about superstition, particularly ones surrounding the number 13. Mostly, I sided with my dad. "Hogwash!"

Until one chilly afternoon in October of 1972. I was 4 weeks into my job, delivering the "Grit", a national weekly newspaper. I made a nickel profit per newspaper from each of my 34 customers. That allowed me about 10 packs of baseball cards, 4 Orange Crush sodas, 2 Spiderman comic book and a sack of Jolly Rancher candies. I was living the high life.

Just a few delivered papers into my fifth week out, I crossed one of the 3 paved streets in Big Sandy, near the butcher shop; when a small twister hit me, and knocked me off my homemad metallic green faux-Schwinn 3-speed and spilled 28 newspapers into the win creating a 15 foot high paper funnel.

I cleaned myself off, proud of my soon to be huge scabs on my elbows and hand, partly happy that I was done with my route.

Until my dad told me I would have to deliver papers for the next 4 weeks for no salary to pay for the lost papers. Harsh reality for a 9 year old. Oh, yeah, it was Friday the 13th.

JEFF AMENT

13 HMMM. WHY ARE THEIR NO 13TH FLOORS IN BUILDINGS? 13 PRIESTS CHARGED WITH 13 COUNTS OF DEPAVITY HAD 13 LAW-[YE]RS DEFENDING AGAINST 13 LAWYERS PROSECUTING EACH [OF] 13 YEARS IN PRISON TO ATONE FOR THEIR SINS. A 13 YEAR OLD BOY & 13 YEAR OLD GIRL EXCHANGED GLANCES [&] SMILES IN THEIR HOMEROOM 13. A 13 YEAR OLD CHILD DIED FR M AN OVERDOSE OF HEROIN IN THE BLEAK HOTEL ALLEY FOR NO REASON. THIRTEEN IS THE MAJESTIC NUMBER, SOMETIMES I NO ODER WHY. PERHAPS IN A REVERSE UNIVERSE IT BRINGS PRIMATES GOOD LUCK. IS THERE A 13TH DIMENSION WHERE PE[R]SPECTIVE IS LOST & FOUND ETERNALLY.

13 HMMM. 13 MASKS TO HIDE THE TRUTH FROM FICTICIOUS DEVILS. THE FALL TO THE FLOOR AT MY FEET.... 13 COMMUNISTS + 13 CAPITALISTS EQUALS THE SAME THING. OR NOT? 13 LOVERS LIE IN 13 FIELDS OF PEACE & SERENITY. POL POT WANTED TO ERASE THE HISTORY OF CAM-BODIA BY KILLING ALL DOCTORS, LAWYERS, TEACHERS, & EDUCATED PEOPLE - HE WANTED TO START YEAR ZERO! THAT'S 13 - 13.

13 HERMAPHRODITES WALKED HAND IN HAND WITH 13 STOCK-BROKERS DISCUSSING 13 TOP-ICS, FOOTBALL, PETS, FASHION, CACTUS, THE HOTEL NEW HAMPSHIRE BY JOHN IRVING, RACISM IN SEATTLE, THE PRICE OF FISH, HOLIDAY ACTIVITIES, MILITARY STRATEGIES, COMEDY & TRAGEDIES, DISEASES PHARM-CEUDICAL COMPANIES REFUSE TO STUDY BECAUSE THEY CAN'T MAKE A PROFIT FROM THEM, RAPACIOUS EVANGELISTS LIVING THRU WOODEN TEETH AND 10 TOP UTTI ACTUALLY TASTES LIKE ICE CREAM!! *MIKE M.*

ASK GEORGE

AS AN AVID SUGAR EATER, I BELIEVE CHOCOLATE AND CANDY ARE NOT THE SAME THING. THEY SHOULD BE CALLED CHOCOLATE, NOT CANDY, CANDY, ON THE OTHER HAND, ARE ALL SWEETS NOT CONTAINING CHOCOLATE (CLOGHLIE, JELLY BEANS, JOT TAMALES) CHOCOLATE IS NOT CANDY, AND CANDY IS NOT CHOCOLATE.

ASK GEORGE WANTS TO ASK YOU... IS CHOCOLATE CONSIDERED CANDY???

AGREE OR DISAGREE?

Special thanks to Mary Margaret, of Calmont, PA for the thoughtful Pittsburgh Pirates LP and her recollections of Pirate great, Roberto Clemente.

GEORGE, MY FRIEND AND I ARE HAVING A BIT OF A DISAGREEMENT. SHE DOESN'T BELIEVE THAT STONE GOSSARD'S REAL NAME IS "STONE", THAT IT'S JUST A STAGE NAME THAT HE USES BECAUSE HE DOESN'T LIKE HIS ACTUAL NAME, BUT I KEEP TELLING HER THAT IT IS HIS REAL NAME. WHO'S RIGHT HERE?? Brooke M. Gilbert

IT'S TRUE, STONE ISN'T HIS REAL NAME. IN MANY WAYS HE IS THE SAME SCENARIO AS JUDAS PRIEST VOCALIST, "RIPPER" OWENS, FOUND HIMSELF IN. THEIR REAL NAMES JUST WEREN'T "STAGE SAVVY ENOUGH. HOW COULD LONG-TIME PRIEST FANS RESPOND TO REPLACING LEGENDARY SINGER, ROB HALFORD, WITH A GUY NAMED TIM, INNOCENT NAME LIKE TIM OWENS? NO, IT JUST WOULDN'T WORK. SIMILARLY, STONE'S STORY DATES BACK TO HIS DAYS IN THE THEN-PIONEERING SUB POP BAND, GREEN RIVER, WHEN HIS REAL NAME, LARRY, JUST WOULDN'T HAVE BEEN GRINGY ENOUGH FOR THE TIMES. SOME-THING HAD TO BE DONE & IT WAS SUGGESTED BY HIS THEN-PEARL JAM MANAGER, KELLY CURTIS THAT HE CHANGE HIS NAME TO "STONE"- A NAME HE FELT REALLY GAVE THE GUITARIST AN OVER-THE-TOP EDGE HE WAS LOOKING FOR. + NOW THAT PEARL JAM IS FAMOUS, STONE WILL CERTAINLY BE REMEMBERED WITHIN HISTORY AS HAVING ONE OF THE HEAVIEST NAMES IN ROCK.

HEY GEORGE, I READ IN THE LAST NEWSLETTER THAT YOU AND THE GUYS GET TOGETHER AT SOMEONE'S HOUSE & DRINK WHINE WHILE DISCUSSING LETTERS. WHAT IS THE BAND'S FAVORITE WHINE? Rob & Mackenzie Tempe, AZ.

FIRSTLY, JOHN, THE BAND'S FAVORITE "WHINE" WOULD BE ABOUT MISSPELLED WORDS IN LETTERS FROM THEIR ENGLISH SPEAKING FANS.

WHAT'S UP GEORGE? WE HEARD A RUMOR THAT IF YOU PLAY THE SONG "PRY" BACKWARDS, IT SAYS "THINK YOU PETE TOWNSEND". IF THAT'S TRUE, ARE OTHER SONGS BY PJ SUBLIMINAL? Rob & Mackenzie Tempe, AZ.

IT'S TRUE, IT IS PURELY COINCIDENTAL. HMMM. ARE THERE MORE? TWO DHIF DNA LYVIY EHT YUB. YUO DOOF DNA LYVIV EHT YUB. TWO MAP DHA LYMK EHT YUB !SUOROS | SUOROS

GEORGE, I REALLY WANT TO GET INTO THE CAREER OF BEING A ROADIE. HOW DO YOU GET INTO THIS? I'M A GIRL & HAVE NEVER REALLY HEARD OF ANY GIRL ROADIES. IS IT HARDER TO BE A ROADIE FOR A GIRL? DOES OR HAS PEARL JAM EVER HAD A GIRL ROADIE? Jenn P. Greenwich, CT.

PEARL JAM DOES, IN FACT, HAVE GIRL ROADIES- ALTHOUGH I'M NOT SURE THAT ANY COULD DESCRIBE EACH ONE OF THEM AS A TRUE-BL 'ROADIE'. LET ME PUT IT THIS WAY.... THE REASON WE HAVE SIX WOMEN TRAVELING ON TOUR WITH US, HOWEVER, YOU CAN INFER BAND IS NOT THE FULL-TIME OCCUPATION FO A COUPLE OF THEM. @ THE CURRENT COUP OF WOMEN ON TOUR WITH US, JOB DESCRIPTIONS RANGE FROM ACCOUNTANT, PUBLIST, MANAGERIAL ASSISTANT / FESTING, MERCHAN ISER, AND THE BAND'S ON-STAGE MONITOR ENGINEER. IS IT HARDER TO BE A GIRL? YOU BET... IF IN GENERAL, IT'S NOT ANY MORE DIFFICULT FOR A WOMAN - UNLESS, PERHAPS, YOU'RE TALKING ABOUT PHYSICAL LIFTING - BUT ITS A MALE DOMINATED INDUSTRY & SOMETIMES BEING A WOMAN IT IS DIFFICULT FOR SOME PEOPLE IT IS HARD TO GET MORE DESERVE FOR SOME WOMEN WHO ARE IMMERSED IN THIS TYPE OF WORK TO ASPIRE TO A POSITION HIGHER MORE PRODUCTION OR JUDGMENTIAL CREDEN-TIATED, & LESS DEMANDING PHYSICALLY."

DEAR GEORGE, BECAUSE I AM AN OLDER FAN, I WOULD LIKE TO KNOW. ...DO ANY OF THE MEMBERS OF PEARL JAM LIKE GARDENING? I SEE JACK IRONS MOWS THE LAWN, BUT I'M INTERESTED IN KNOWING THEIR FAVORITE CULTIVATION ACTIVITIES. NOTHING LIKE A FRESH SALAD FROM THE BACKYARD. Gerry M. Bubbleton Beach, B.C., Canada

TO FIND THE ANSWER TO THIS QUESTION LOOK NO FURTHER THAN THE SONG "GARDEN" APPEAR ON THE BAND'S FIRST RECORDING, TEN. FORMALLY, THE SONG IS ACTUALLY TITLED "GARDEN OF STONE" BECAUSE OF WHAT ELSE - STONE'S PASSION FOR CULTIVATING THE SOIL. INITIALLY, STONE LOVED GROWING THE NORMAL STUFF; TOMATOES, CARROTS, LETTUCE, ETC. BUT IN THE PAST 4 OR 5 YRS, HIS FOCUS HAS CHANGED TO ONLY ONE THING IN PARTICULAR... PUMPKINS. YES, STONE HAS BEEN STRIVING THIS YEAR TO ENTER & WIN THE GREATER SEATTLE BIG-ASS PUMPKIN CONTEST HELD JUST BEFORE HALLOWEEN. IF HE WINS, HE & HIS PUMPKIN PATCH WILL RECEIVE A VISIT FROM THE GREAT PUMPKIN HIMSELF!

TO WHOM IT MAY CONCERN, I JUST BECAME A MEMBER OF THE VHC FAN CLUB! I RECENTLY RECIEVED NEWSLETTER #12. AND THERE'S A SECTION CALLED "ASK GEORGE"? WHO'S GEORGE? AND WHAT OTHER THINGS DON'T I KNOW ABOUT? Nancy C. Los Angeles, CA!

WHO IS GEORGE? GEORGE IS A FIGMENT OF YOUR IMAGINATION. HE DOES NOT TRULY EXIST. BE IS THERE FOR THE PEARL JAM FAN, YET NOT REALLY THERE AT ALL. HE IS EVERYTHING YOU WANT HIM TO BE, & EVERYTHING YOU DON'T WANT HIM TO BE TOO. IT IS BEST NOT TO DWELL TOO HARD ON WHO IS GEORGE? MANY A PEARL JAM FAN HAVE CEASED TO LIVE NORMAL, HAPPY, PREVIOUSLY FULFILLING LIVES BECAUSE THEY'VE TRIED TOO HARD TO UNDERSTAND WHO IS GEORGE? IS IT NOT ENOUGH THAT HE GRACIOUSLY ANSWERS YOUR QUESTIONS? MUST HE BE ENLIGHTENED TOO? IF KNOWLEDGE IS KNOWING, THEN WISDOM WOULD BE KNOWING WHEN YOU KNOW TOO MUCH.

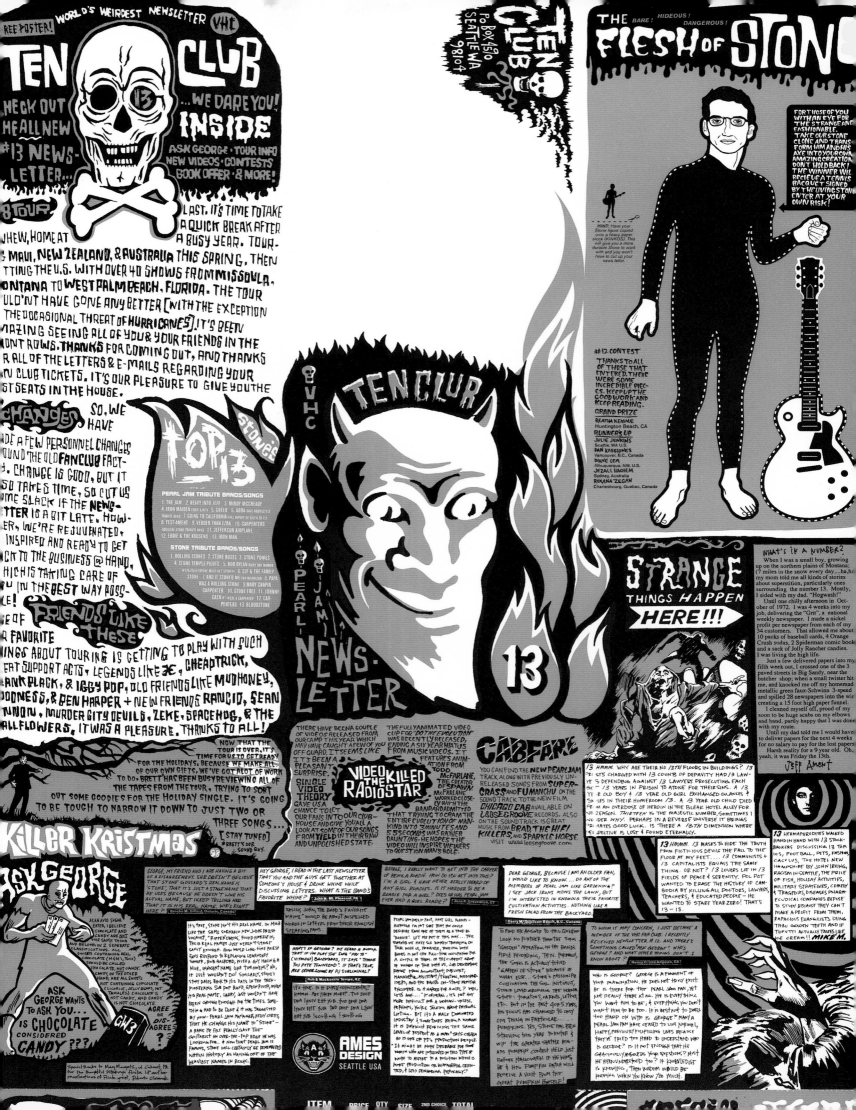

AMES DESIGN
SEATTLE USA

Advertising campaign Harold & Maude's
Espresso Bar

Art director Thomas Scott
Designer Thomas Scott
Illustrator Thomas Scott
Writer Ernie Kelly
Studio Eye Noise
Client Yab Yum
Typefaces Brush Script, Eagle Bold,
Franklin Gothic, Akzidenz Grotesk, hand-
rendered lettering
Software Adobe Photoshop, Adobe Illustrator
Colors 1/C (black) on newsprint

Concept "These ads ran in the local free 'alter-
native' newspaper. Yab Yum has three busi-
nesses side by side: billiards room, bar and
coffee house. The primary goal was to get the
ads to stand out in a crowded publication. We
accomplished that with a cheesy, unslick look.
These ads were very memorable to customers."

Concept Cerio comments on the
business card he designed to pro-
mote his illustration work: "I
thought I'd use a subdued card
stock for once. I think it gave an
honest working man's vibe (a
touch, anyway)." He says about
the alternate card, "I don't care
what anyone says, I think ther-
mography can be cool if its
nausea potential is utilized cor-
rectly." Designers often use very
inventive means to express their
work in self-promotion—printing
with one color or manufacturing
by hand—proving that limited
resources are no barrier and are
often a catalyst for creativity.

Business cards/self-promotion
Steven Cerio's Happy Homeland

Art director Steven Cerio
Designer Steven Cerio
Illustrator Steven Cerio
Studio Steven Cerio's Happy Homeland
Client Steven Cerio's Happy Homeland
Typefaces hand-rendered
Software traditional mechanical
Color 1/C offset on kraft paper stock;
1/C thermography
Print run 1,000 each

Logo identity/self-promotion Steven Cerio's Happy Homeland

Art director Steven Cerio
Designer Steven Cerio
Illustrator Steven Cerio
Studio Steven Cerio's Happy Homeland
Client Steven Cerio's Happy Homeland
Typeface hand-rendered
Software traditional mechanical
Color 1/C rubber stamp using a rocker handle
Print run variable as needed

Concept "The plan was to design a rubber stamp for correspondence
that was big and unwieldy enough to hand-color when the urge hit me."

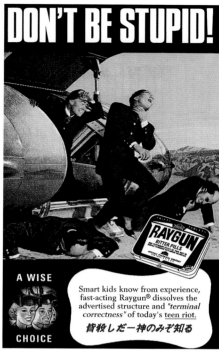

DON'T BE STUPID!

A WISE
CHOICE

RAYGUN
BITTER PILLS

Smart kids know from experience,
fast-acting Raygun® dissolves the
advertised structure and *"terminal
correctness"* of today's <u>teen riot</u>.

皆殺しだ一神のみぞ知る

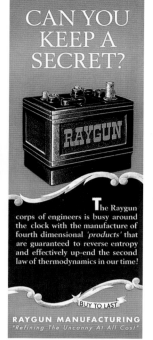

CAN YOU KEEP A SECRET?

RAYGUN

The Raygun
corps of engineers is busy around
the clock with the manufacture of
fourth dimensional *'products'* that
are guaranteed to reverse entropy
and effectively up-end the second
law of thermodynamics in our time!

BUY TO LAST

RAYGUN MANUFACTURING
"Refining The Uncanny At All Cost"

Concept "I worked with David Carson on *Ray Gun* for a lit-
tle more than two years. I was left to my own devices to
make something interesting out of the review section at the
back of the magazine. These sections are typically a ghetto
of half-pages and quarter-pages strewn with beer ads,
record reviews and other poorly fitting, incongruous ele-
ments. I took the opportunity to interrupt those pages even
further with the insertion of these awkward 'mock ads' for
'Ray Gun Engineering.' This was an extension of my own
'Beatkit,' absurdist advertisements in a way, and was an
opportunity to carve a fun niche for myself out of what was,
at the time, a true free-for-all anyway. I never got Carson's
reaction to this stuff until after the magazine hit newsstands,
typically. But I think he was amused all the same."

Advertising/culture jamming
Ray Gun "Don't Be Stupid!" mock ad

Art director David Carson
Designer Shawn Wolfe
Illustrator Shawn Wolfe
Studio Shawn Wolfe Company
Client *Ray Gun* magazine
Typeface Helvetica Condensed
Software Adobe Photoshop
Colors 4/C process

Advertising/culture jamming
Ray Gun "Can You Keep a
Secret?" mock ad

Art director David Carson
Designer Shawn Wolfe
Illustrator Shawn Wolfe
Studio Shawn Wolfe Company
Client *Ray Gun* magazine
Typefaces Excelsior, Futura
Software Adobe Photoshop
Colors 4/C process

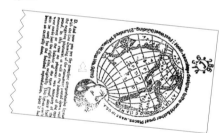

Business cards/self-promotion Kearsley
Group (1988, 1993)

Art director Heidi Kearsley
Designer Heidi Kearsley
Studio Kearsley Group
Client Kearsley Group
Typefaces Futura, Garamond 3
Software traditional mechanical
Color 1/C rubber stamp
Print run variable as needed

Concept "I found a bunch of existing tags at a
'mom and pop' stationery store. I wanted to
play off the fact that I was designing so many
hang tags for the fashion industry. Rubber
stamping is such a low-tech, highly inconsis-
tent and sometimes hard-to-read way of
reproducing an image or text. That's what I
like about it." In the latter version, the design-
er employed much the same methods, as well
as pinking shears and a hand die cut.

Ephemera Annie Sprinkle's post-modern
pin-ups picture playing card (back)

Art directors Annie Sprinkle, Katherine Gates
Designer Steven Cerio
Illustrator Steven Cerio
Studio Steven Cerio's Happy Homeland
Client Gates of Heck Publications
Typefaces hand-rendered, Copperplate
Software traditional mechanical
Color 1/C flat
Print run 500

Concept "This was the second draft that
ended up in print. Annie dug her facial like-
ness and the vulva-esque card suits, but need-
ed her breasts to be enlarged to be closer to
their true proportions. This change ended up
filling the composition nicely (pun intended)."

Logo identity Atomic Joe

Art directors Steve Carsella, Chris Jones, Scott Sugiuchi
Designer Scott Sugiuchi
Studio Backbone
Client Atomic Joe
Typeface Portrzebie
Software Adobe Illustrator

Concept "This logo is for an Internet-based, antique/novelties dealer who specializes in 1950s kitsch. The client requested a logo based on a character who 'travels through time and brings collectibles to the future (our present) for general consumption.' The design is based on a mixture of 1950s character trademarks and the modernist UPA cartoons of John Hubley."

Logo identity Zinc Bar

Art directors Steve Carsella, Chris Jones, Scott Sugiuchi
Designer Chris Jones
Studio Backbone
Client Icon Nightclub
Typeface Futura
Software Adobe Illustrator

Concept "After we'd already finished this logo for the client, he wanted to change the name of his bar to Lithium, because he couldn't get these huge silver, metal panels that he wanted for the V.I.P. area. We basically told him what a stupid idea it was, and that nobody really cares what color zinc is, blah, blah, blah. As you can tell, the name still stands as Zinc Bar."

Logo identity Backbone

Art directors Steve Carsella, Chris Jones, Scott Sugiuchi
Designer Steve Carsella
Studio Backbone
Client Backbone
Typeface Futura
Software Adobe Illustrator

Concept "I wanted to avoid the obvious (spines, vertabrae, X rays). It's just fun typography." For the secondary logo, "It's the restroom guy...but with three heads. It's very us."

Logo identity Haxan Films

Art directors Steve Carsella, Chris Jones, Scott Sugiuchi
Designer Steve Carsella
Studio Backbone
Client Haxan Films
Typeface Cirrus
Software Adobe Illustrator

Concept "The word 'haxan' is Swedish for witch, so I tried to create something that looked like a rune or glyph; something a witch might scribe onto stone or paper. Ligatures to me always seemed 'other worldly,' and I wanted that."

Logo identity Seattle Thunderbirds ("T-Birds")

Art director Jamie Sheehan
Designer Jamie Sheehan
Illustrator Todd Lovering
Studio Sheehan Design
Client Seattle Thunderbirds Hockey Club
Typeface hand-rendered
Software traditional mechanical; QuarkXPress
Colors 2/C flat

Concept "The T-Birds already had a mascot named (of all things) 'Cool Bird.' They were interested in developing a logo of the 'Cool Bird' for the jersey in a 1990s fashion." This jersey is now worn for home games and special events, such as the playoffs.

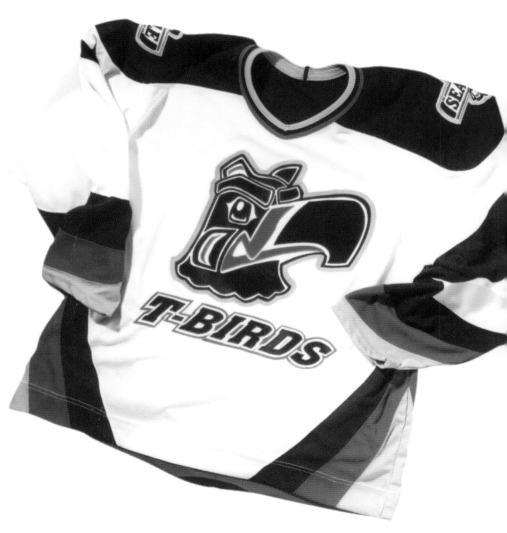

THE BLAIR WITCH PROJECT™

Logo identity *The Blair Witch Project* (film)

Art directors Steve Carsella, Chris Jones, Scott Sugiuchi
Designer Steve Carsella
Studio Backbone
Client Haxan Films
Typeface Pterra
Software Adobe Illustrator

Concept It's "based upon the totems featured in the film. After screening the film, it was the obvious choice for an icon. It was just a matter of execution."

Logo identity Knock-Knock

Art directors Steve Carsella, Chris Jones, Scott Sugiuchi
Designer Steve Carsella
Studio Backbone
Client William Dell
Typeface Toreador
Software Adobe Illustrator; photocopier

Concept "The owner hung a clear, acrylic sign with the logo on it- upside-down and backwards. It still read correctly, for the most part."

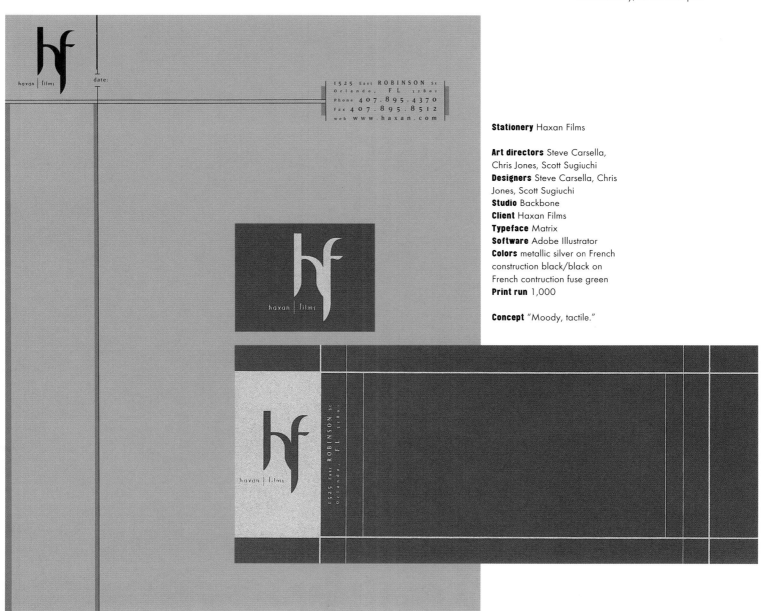

Stationery Haxan Films

Art directors Steve Carsella, Chris Jones, Scott Sugiuchi
Designers Steve Carsella, Chris Jones, Scott Sugiuchi
Studio Backbone
Client Haxan Films
Typeface Matrix
Software Adobe Illustrator
Colors metallic silver on French construction black/black on French contruction fuse green
Print run 1,000

Concept "Moody, tactile."

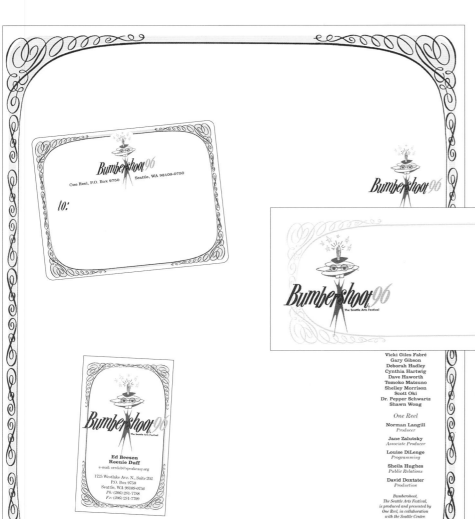

Collateral Bumbershoot '96

Art director Hank Trotter
Designer Hank Trotter
Illustrator Ed Fotheringham
Studio Twodot Design
Client One Reel
Typefaces Treasure Island, Clarendon, Futura
Software Macromedia FreeHand
Colors 4/C process
Print run various, depending upon item

Concept "I'm not sure if anyone has ever anthropomorphized the Space Needle [Seattle architectural landmark] before, but I thought it was a good idea for Bumbershoot. I wanted to play up the fun aspect of this four-day arts festival at the Seattle Center. I was on a big border binge at the time. I was also in love with type made out of wood planks. The two make no sense together, which I thought was perfect for an arts festival where Sonic Youth can be on one stage at the same time Tuvan throat singers are playing on another stage. I don't think the client ever quite got this design, but they were game enough to go along with it, for which I am grateful."

0 968094 STUDIO 9

Business card Shawn Wolfe

Art director Shawn Wolfe
Designer Shawn Wolfe
Studio Shawn Wolfe Company
Client Shawn Wolfe Company
Typeface Helvetica
Software Macromedia FreeHand, Adobe Photoshop
Colors 4/C process
Print run 500

Concept "I find the photo image profoundly disturbing
and amusing and charming. Definitely difficult to disre-
gard without a second thought. This antique, plaster baby-
head thing used to hang in my grandmother's kitchen,
until she gave it to me a few years ago. The fact that he's
a baby, dressed up like a cherubic Beau Brummel and
smoking what looks like a little crack pipe is completely
weird. Reason enough to use it on my business card, I
guess. He probably looks a little like me too."

Stationery/identity Brennan Dalsgard Publishers

Art director Ashleigh Talbot
Designer Ashleigh Talbot
Illustrator Ashleigh Talbot
Studio Ashleigh Talbot/Parlor XIII
Client Brennan Dalsgard Publishers
Typefaces hand-rendered pen-and-ink; Calisto MT
Software traditional mechanical
Colors 2/C (red and black) and gold embossed on ivory linen
Print run 2,500 each

Concept A publisher of books on historical and modern sideshow, the
client wanted a design that illustrated their milieu. Talbot explains, "I
was inspired by beautiful old letterheads I had seen in some circus
magazines and thought that something old and elegant, yet bold and
colorful—much like circus and sideshow banners used to be at the turn
of the century—would fit perfectly. All of it was drawn by hand—a nod
to my true circus artist inspiration, Roland Butler."

SEATTLE PORTLAND SAN FRANCISCO

Logo identity Lunar Systems (museum software developer)

Art director Heidi Kearsley
Designer Heidi Kearsley
Studio Kearsley Group
Client Linda Cannon Gallery
Typefaces hand-rendered
Software traditional mechanical

Concept "The client wanted the logo to be down-to-earth—hence the hand-drawn lettering—with a spacy twist. I used a (at the time) cutting-edge font and 'spaced' it a little off-beat."

Logo identity Way 2 Go (clothing packaging)

Art director Heidi Kearsley
Designer Heidi Kearsley
Illustrator Heidi Kearsley
Copywriter John Koval
Studio Kearsley Group
Client Seattle Blues
Typefaces hand-rendered adaptation of Bassuto and Armada 3 Compressed
Software photocopy (Canon 90/30), manipulated; traditional mechanical
Color 1/C flat (black)
Print run 4,500

Concept "Dude...way to go...John [the copywriter] and I worked on names. We wanted to come up with something fun. This is a junior girls' clothing line that was distributed mostly to JCPenney's stores."

Logo identity Dale W. Windham (photo studio)

Art director Heidi Kearsley
Designer Heidi Kearsley
Illustrator Heidi Kearsley
Studio Kearsley Group
Client Dale Windham
Typefaces hand-rendered adaptation of American Typewriter and Bernhard Cursive
Software traditional mechanical

Concept "W is a nice letter to work with. This logo was embroidered (black and gold) on a bathrobe, a ball cap and a golf bag—and tattooed onto Mr. Windham's neck. Ouch! I think he liked it."

Logo identitiy Orbit (jewelry store)

Art director Heidi Kearsley
Designer Heidi Kearsley
Studio Kearsley Group
Client Diane Graves
Typefaces Bordeaux Roman, David Quay
Software traditional mechanical

Concept "Orbit was a store that sold many local designers' work. I wanted to play off looking ornamental, like a brooch or something you would wear on your lapel." Not to mention, "Diane [Graves] had an unbelievable globe collection."

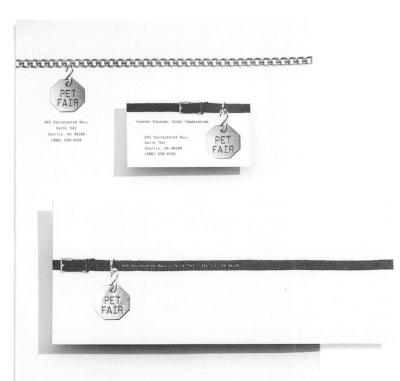

Stationery identity Pet Fair

Art director Jamie Sheehan
Designer Jamie Sheehan
Studio Sheehan Design
Client Pet Fair Productions
Typeface Orator
Software traditional mechanical; QuarkXPress
Colors 1/C black plus a rainbow foil
Print run 2,500

Concept "I wanted to make a symbol recognizable to pet ownership they could be used any way, on anything, and put most anywhere. This was the most difficult letterhead I ever executed due to photographing chrome and keeping everything straight. The easy-looking solutions are always the most tedious to execute. But it was well worth it."

Logo identity Yoo Hoo (coffee shop)

Art director Heidi Kearsley
Designer Heidi Kearsley
Illustrator Heidi Kearsley
Studio Kearsley Group
Client Yoo Hoo
Typeface custom-created/illustrated
Software traditional mechanical

Concept "This design was actually taken from a sketch on a napkin, photocopied directly and pasted up."

Business card/coffee card Yoo Hoo

Art director Heidi Kearsley
Designer Heidi Kearsley
Illustrator Heidi Kearsley
Studio Kearsley Group
Client Yoo Hoo
Typefaces Mistral, Roger Excoffon
Software traditional mechanical
Colors 2/C flat, thermographed
Print run 1,000

Concept "Working with thermography can be tricky. The best advice is to make good friends with the person running the press; then you can do just about anything you want."

Business card Francesca La Cagnina (photo stylist)

Art director Heidi Kearsley
Designer Heidi Kearsley
Studio Kearsley Group
Typefaces Lucia, Sackers Gothic, Agfa Engravers 2
Client Francesca La Cagnina
Software traditional mechanical
Colors 2/C flat
Print run 1,000

Concept "Francesca needed something people would remember. My idea was to reflect her sense of style, with a twist people would react to (my lips on the back)."

Stationery John Koval

Art director Heidi Kearsley
Designer Heidi Kearsley
Illustrator Heidi Kearsley, clip art
Copywriter John Koval
Studio Kearsley Group
Client John Koval
Typeface Garamond 3
Software traditional mechanical
Colors 2/C flat PMS
Print run 1,000

Concept For this highly personalized design for a copywriter, the designer explains: "A spider has had so many meanings throughout history, one of which is wisdom. I thought the link between the thread and the classic column was interesting. On the envelope, the imagery and text are all on the back except for a very small bug drawn at the bottom of the front of the envelope. The bug is trying to hide from the spider."

Stationery/collateral Campaign for PICA

Creative direction John C Jay, Studio J
Art directors Joshua Berger, Niko Courtelis, Pete McCracken
Designers Joshua Berger, Niko Courtelis, Pete McCracken, Sung Choi
Copywriter Steve Sandoz, Wieden & Kennedy
Photography Susan Seubert (archival photography: Sally Schoolmaster)
Architectural drawings Brad Cloepfil, Allied Works Architecture
Production coordination Dennis Frasier, Wieden & Kennedy
Studio Plazm Design
Client Soleilmoon Recordings
Typefaces Helvetica Condensed, Roscent (Plazm fonts)
Software QuarkXPress, Adobe Illustrator, Adobe Photoshop
Colors 2/C black (identity); PMS spot color (presentation box)
Print run 10,000 (stationery, brochure); 50 (presentation box)

Concept "PICA, Portland's only contemporary arts organization, was slated to move into a new space in summer 1999. The 'Campaign for PICA' carried a dual purpose: to educate the community and to stimulate fund-raising. The metaphor of construction runs throughout the campaign, always referring to the vision of PICA's new space. To involve the fifty high-end donors who received an in-person presentation from PICA, we created a leave-behind box labeled 'building.' Inside, prospective donors found individually labeled, pre-cut plexi-shapes and wood blocks scavenged from the construction site, a hands-on connection to PICA's new home."

Stationery/collateral Joint

Art director Niko Courtelis
Designer Niko Courtelis
Studio Plazm Design
Client Joint
Typeface Olivetti Lettera 22
Software QuarkXPress; manual typewriter
Colors 2/C flat
Print run 1,000

Concept "This stationery for an editing company was letterpressed on onion skin paper, using pinhole perforations as a metaphor for editing."

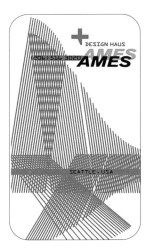

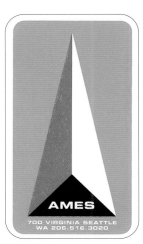

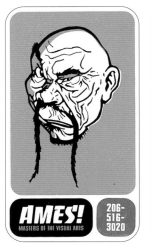

Identity campaign Ames cards

Art directors Mark Atherton, George Estrada, Barry Ament, Coby Schultz
Designers Mark Atherton, George Estrada, Barry Ament, Coby Schultz
Studio Ames
Client Ames
Typefaces Banco, Eurostyle, Franklin Gothic, Glyphic Series, Impact, Venus Bold
Software Adobe Illustrator; hand-rendered
Print run 500 of each, offset or screenprinting

Concept "Whenever we get a chance to use up wasted space on a print run, it usually turns into Ames cards. It's a great opportunity to give unused designs a home, and add to the Ames card quiver. We presently have about eight cards between the four of us."

Stationery K2

Art director K2 Snowboards
Designer Coby Schultz
Illustrator Coby Schultz
Studio Ames
Client K2 Snowboards
Typeface Clarendon
Software Adobe Illustrator
Colors 2/C offset
Print run 3,000

Concept "We used the 1996 season's logo and created a system for all of their business cards, envelopes and stationery. Bright, cool, out of the ordinary. Messed around in Adobe Illustrator until I found something that went with the flow."

Announcement Baby Scott birth announcement

Art director Thomas Scott
Designer Thomas Scott
Studio Eye Noise
Client Victoria and Thomas Scott
Typefaces Franklin Gothic, Gothic 13, Futura Extra Bold, Egyptian, Brush Magic Text, Joker, hand-rendered lettering
Software Adobe Photoshop, Adobe Illustrator
Colors 3/C offset
Print run 250

Concept "I had always wanted to do something in the boxing-poster style. Floating heads are so cool. I wish it could have been printed on letterpress."

Invitation Fritz and Germaine's wedding invitation and map

Art director Martin Ogolter
Designer Martin Ogolter
Photography courtesy of client; Martin Ogolter
Studio Martin Ogolter/y design
Client Fritz and Germaine
Typefaces Ronde, Meta
Software QuarkXPress, Adobe Photoshop, Adobe Illustrator
Colors 4/C process and 2/C flat
Print run 300–1,000

Concept "Fritz and Germaine did not spare any cost on this one. The invitation, reply card and envelope were a two-color letterpress job. I used the type from an old French specimen and had to create a few characters that were not available. The map was to be for general usage after the event; therefore, it did not get the same feel." Ogolter adds, "There was to be a big bonfire at the wedding, and so the couple supplied me with a picure of a previous one (shown on the reverse side of the map). It turned out that the prediction of the map became only too true when the barn burned down on their wedding night."

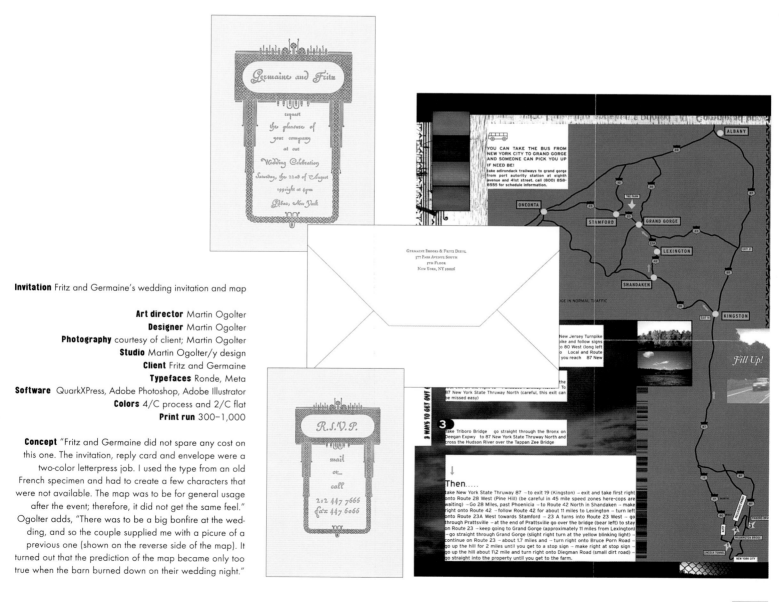

ATOM

SHORT FILMS
ATOM

GAMMARAY
ENTERTAINMENT

GAMMA
RAY entertainment

1 2 3 4

chemistry
COMMUNICATION SCIENTISTS

CHEMESTRY®

CHEMESTRY®
communication scientists

PHISH
DESTROYS AMERICA

5 6 7 8

SNOWBOARDS

K2
Snowboards

K2
SNOWBOARDS

t22
SNOWBOARDS

9 10 11 12

Ride
MADE IN THE U.S.A.

ride
MADE IN THE U.S.A.

Comet

RIDE
Mountain

13 14 15 16

Me
music

Me
records

17 18 19 20

1&2

Logo identities Atom Films (2)

Art director Mark Atherton
Designer Mark Atherton
Studio Ames
Client Atom Films
Typefaces Akzidenz, Hellenic
Software Adobe Illustrator

Concept "The solution for an independent film company Atom was obvious—so it was all stylizing. They ended up ripping off a couple of other logos we comped up for them, and we were forced to bring the hammer down—bastards!"

3&4

Logo identities Gamma Ray

Art directors Mark Atherton (dots); Coby Schultz (1950s)
Designers Mark Atherton (dots); Coby Schultz (1950s)
Studio Ames
Client Gamma Ray Entertainment
Typefaces Eurostyle, Biggen and a custom-created font
Software Adobe Illustrator
Colors 2/C flat (dots); 4/C (50s)

Concept "The client wanted a colorful 1950s-moderne look that had a space-age quality to it that matched their name. Their company went tits up in about two months. They didn't even have enough time to do business cards. One thing they did have was a good logo." The textured backgrounds were created in Adobe Illustrator to mimic linoleum.

5-7

Logo identities Chemistry

Art directors Alex Hillinger, Mark Atherton (HQ and scientist)
Designers George Estrada, Mark Atherton (HQ and scientist)
Studio Ames
Client Chemistry Communications
Typefaces Akzindenz Grotesk, Eurostyle
Software Adobe Illustrator

Concept "Chemistry is a start-up PR company, and the two people who run it are really good to work with, so

George and I just created a stockpile of logos and icons that could be used for any application. Chemistry is a really small company, but the logo implies a corporate operation."

8

Logo identity Phish Destroys

Art director Barry Ament
Designer Barry Ament
Studio Ames
Client Phish
Typefaces custom-created
Software Adobe Illustrator

Concept "We gave them a kung-fu-style tour package (posters, ads, T-shirts). This was the back of a 'masters of kung fu' T-shirt. This shirt was more for me than the band (I've never heard their music!); there's no connection between Phish and martial arts—other than the designer loves kung fu movies!"

9-15

Logo identities K2

Art directors Hayley Martin, Coby Schultz, K2 Committee, Mike Styskal
Designers Barry Ament, Mark Atherton, George Estrada, Coby Schultz
Studio Ames
Client K2
Typeface custom-created
Software Adobe Illustrator

Concepts
9) K2 1996 season: This logo, says Shultz, "would show up everywhere, on all product, ads, banners, brochures...had to be universal, yet cool. Definitely a 1970s soupy feel, with a touch of corporate America. Scanned rough from sketchbook and redrew in Adobe Illustrator." The logo is reproduced in 2/C flat.

10) K2 1999 season: Says Atherton, "K2 wanted a corporate logo that would be easy to screenprint and embroider onto clothing and other products. They also wanted a logo with an icon that could be used separately—thus the swoosh, or 'groove,' as they call it at K2. The groove represents a trail left by a snowboarder. Puma Shoe Company eventually had a

problem with this as it showed up on K2 shoes, and K2 was forced to make alterations." The logo is reproduced in 3/C flat.

11) "Mountain" T-shirt logo: "Strong, simple icon to symbolize a mountain," says Shultz. "I scanned sketch/type idea in and went to town."

12) "K2 techno" logo: According to Ament, "This one didn't fly with K2...but we like it enough to put it into our portfolio."

13) Ride logo ("control"): "I have a Boeing hat that has some 'fresh ass' type on it! It says Boeing 747...so I was influenced by the hat. I redrew the type and added a little more flavor to it." Estrada used a #2 pencil on a sketch pad, scanned in the image and redrew it in Adobe Illustrator.

14) Ride logo ("yukon"): The logo needed to communicate "motion-speed and wind-lip on a mountain." Again, Estrada hand-drew the logo, then scanned it and redrew in Adobe Illustrator.

15) "Comet" logo: This job was to "provide a logo for the snowboard 'Comet,' that had action (to match its name). Everything in the snowboard industry needs a logo. It's all about the logo. You get pretty good at them after a while," explains Schultz. The logo was drawn by hand, scanned, then redrawn in Adobe Illustrator.

16

Logo identity Ride Mountain

Art director Mike Styskal
Designer Coby Schultz
Studio Ames
Client Ride Snowboards
Typeface hand-painted
Software Adobe Photoshop

Concept Schultz designed this for "a Grizzly Adams-type of snowboarder-a big man with big feet." The original rendering was hand-painted on board, and placed over the artwork in Adobe Photoshop.

17

Logo identity The "Goodz" character

Art director Coby Schultz
Designer Coby Schultz
Illustrator Coby Schultz
Studio Ames
Client J Goodz
Software traditional mechanical

Concept "The character was to represent a DJ with headphones, spinning records—magic on the turntables. I really didn't know if the guy's music was any good or not. Did it for free."

18 &19

Logo identities Me Music

Art directors Mark Atherton (globe); George Estrada (boombox)
Designers Mark Atherton (globe); George Estrada (boombox)
Illustrators Mark Atherton (globe); George Estrada (boombox)
Studio Ames
Client Me Music
Typefaces custom-created, Biggen
Software Adobe Illustrator

Concepts Atherton explains, "The client, a music/multimedia company, wanted a clean, timeless kind of logo that would work on everything from CDs to T-shirts and more. They also wanted to appear as a serious and stable company. The company folded a few months later." Estrada describes the "boombox/retro" design of his logo for the mix-tape department, "I wanted the logo to reflect the 'old-school' look of mix tapes; it's a throwback to when mix tapes were it."

20

Logo identity Ice Cream Kid

Art director Mark Atherton
Designer Mark Atherton
Illustrator Mark Atherton
Studio Ames
Client Coca Cola Corp., Ames
Software Adobe Illustrator
Colors 2/C flat

Concept This design was originally done for the Cherry Coke campaign. Coca Cola didn't take it, so now it appears on the Ames shop sign.

Ephemera/self-promotion Burning Bush Studio matchbook

Art director Frank Zepponi
Designers Frank Zepponi, Mike Styskal, Suzy Hutchinson
Illustrator Frank Zepponi
Studio Burning Bush Studio
Client Burning Bush Studio
Typefaces News Gothic; hand-rendered
Software Macromedia FreeHand
Color 1/C black on gold cover stock
Print run 10,000 each

Concept The designers sought to "continue marketing Burning Bush's brand of satirical style design."

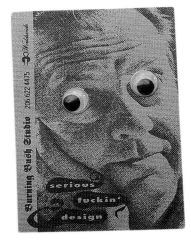

Business card/identity google-eyed business card ("Serious Fuckin' Design")

Art director Frank Zepponi
Designers Frank Zepponi, Mike Styskal
Studio Burning Bush Studio
Client Burning Bush Studio
Typefaces Fette Fractur, News Gothic, Courier, Regency Script, Frutiger; hand-rendered lettering
Software Macromedia FreeHand
Color 1/C black on gold cover stock
Print run 1,000

Concept The goal was to "establish BBS as a nontraditional commercial arts venture."

Ephemera/self-promotion
Burning Bush Studio "George Bush" Mailer

Art director Frank Zepponi
Designers Frank Zepponi, Mike Styskal
Illustrator Frank Zepponi
Studio Burning Bush Studio
Client Burning Bush Studio
Typefaces Futura, Brush Script, Meta, Fette Fractur, Franklin Gothic
Software Macromedia FreeHand
Colors color lasers
Print run 75

Concept This is a piece created to "establish relevant meaning and name-familiarity for BBS."

Clothing tags/labels Tommy Bahama

Art director Lanny French
Designer Hank Trotter
Studio Twodot Design
Client Foundation
Typefaces Brush Script, Split Wide, Futura
Software Macromedia FreeHand; traditional mechanical
Colors 4/C process
Print run 25,000 (estimated)

Concept "I was a sub-sub-contractor on this project. Foundation was doing all the print design for Tommy Bahama and needed help finishing one season's line. The only change the art director made to these pieces happened without my knowledge. When the hangtags came back, all the colors had been switched to reflect the color palette of the clothing line. I still like the results."

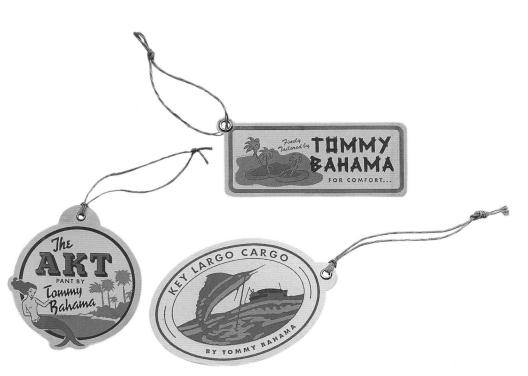

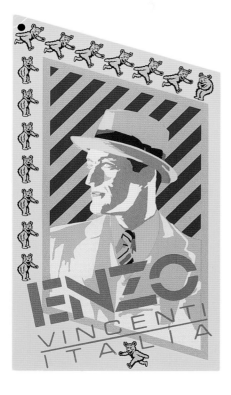

TAGLIA: SIZE

MODELLO: STYLE

Clothing tags/labels Enzo

Art director Heidi Kearsley
Designer Heidi Kearsley
Illustrator Heidi Kearsley; clip art
Studio Belltown Productions
Client Saturdays World
Typeface Glaser Stencil
Software traditional mechanical
Colors 4/C process, with 2 spot PMS colors
Print run 2,500

Concept "The 'Enzo man' is adapted from an image out of *Advertising Arts and Crafts*, Volume II, 1927, borrowed from the private collection of Art Chantry. This packaging was designed to look like it was imported from Italy. The text was translated from English to Italian, and back to English, to make it sound 'foreign.' I spent time going through Italian phone books matching first names with last names to come up with a macho-sounding name: we did a legal check and came clear. Within weeks, a rival line came out with a line called Enzo. We debated confronting them, and decided we could cash in on some of their marketing, so we didn't."

Self-promotion Christmas Creeps

Art director Thomas Scott
Designer Thomas Scott
Illustrators Thomas Scott, Michael Mojher
Studio Eye Noise
Client Bolt Digital Audio
Typefaces Firebug Caps, Constructivist Square, Franklin Gothic, Akzidenz Grotesk Extended
Software Adobe Illustrator
Colors 2/C, metallic inks
Print run 250

Concept "The studio's third Christmas card with 'Santa Clops' was this matchbook-bound collection of eight holiday monsters. Using inappropriate colors and type for the holidays was an attempt to stand out during the season. Some recipients were not amused, but one client told me his kids loved it and were requesting the Christmas Creeps for their bedtime story."

Clothing tags/labels Back to Square One

Art director Heidi Kearsley
Designer Heidi Kearsley
Production Engineer Debra Shishcoff
Studio Kearsley Group
Client International News
Typeface hand-rendered
Software traditional mechanical; QuarkXPress
Colors 4/C flat silkscreen; 1/C flat silkscreen on back
Print run 7,500

Concept The designer was given a directive: "From the human element to the fast-moving digital world we live in, this is fashion and our world."

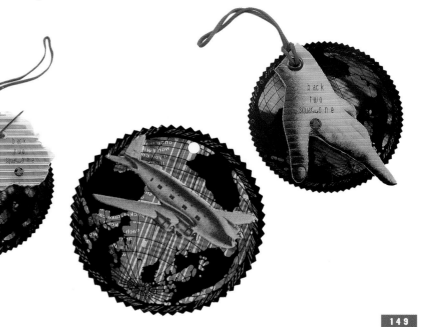

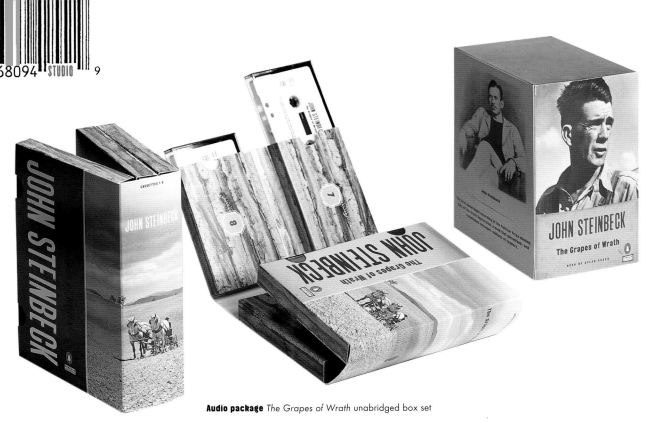

Audio package *The Grapes of Wrath* unabridged box set

Art director Martin Ogolter
Designer Martin Ogolter
Photographers Horace Bristol, Marion Post Walcott (The Library of Congress)
Studio Martin Ogolter/y design
Client Penguin Audiobooks
Typeface Elephant
Software QuarkXPress, Adobe Photoshop
Colors 4/C process
Print run 3,000

Concept The multiple surfaces of the box offer quite a few opportunities. However, there were budget constraints. Ogolter remarks that luckily "the U.S. government had some of the best photographers of the period document the Dust Bowl and the Depression. The Library of Congress (free pictures!!) was perfect."

Stationery/identity Chemistry

Art directors Alex Hillinger, Mark Atherton
Designer Mark Atherton
Illustrator Mark Atherton
Studio Ames
Client Chemistry Communications
Typefaces Berthold Imago, Akzidenz
Software Adobe Illustrator
Colors 2/C offset
Print run 1,000

Concept "Chemistry's tag line is 'the science of communication,' so I referenced old science school books for the overall feel. It needed to be sensible, but not pretentious; technical, but not 'cyber.' The Chemistry mailer functions as a company description, and shows how the Chemistry client list and marketplace interact."

Ephemera/program covers University Honors Program (Fall 1998 and Spring 1999 bulletins)

Art director Dr. Bill Eamon
Designer Ronnie Garver
Studio University Communications, New Mexico State University
Client University Honors Program
Typefaces various (unidentified) type scrounged up from a small letterpress collection
Software QuarkXPress, Adobe Photoshop, traditional mechanical elements
Colors 3/C flat (1/C cover, 2/C inner signatures) offset
Print run 2,300

Concept "When asked to redesign an existing design for the semester bulletin, I took into account the goals of the current director of the program, which included bringing a broader range of students into honors courses. The overall idea was to strip down the look and give the program an unpretentious, hip, accessible look that would undercut people's ideas of honors as elite or ethereal. I simplified the design and brought in some texture. Only having access to some hot type, and not a press, I inked up the letters and hand-printed them. I then cut and pasted characters to form words. I used the closest thing that I could get to a paper bag for the cover paper, which helped with the overall feel."

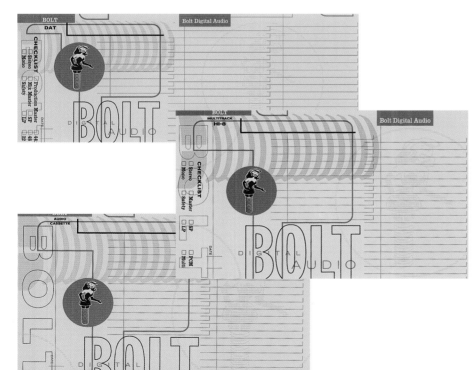

Ephemera Bolt Digital Audio cassette j-cards

Art director Thomas Scott
Designer Thomas Scott
Illustrator Thomas Scott
Studio Eye Noise
Client Bolt Digital Audio
Typefaces Franklin Gothic Extra Compressed, Akzidenz Grotesk Extended, Clarendon
Software Adobe Illustrator
Colors 2/C (black, match red)
Print run 1,000 each

Concept "These are blank tape covers for a small recording studio specializing in independent rock bands. Three different sizes were needed for three tape formats. The cards and the studio mascot, Betty Bolt, deliberately avoid a digital or high-tech look, to be more in spirit with working class rock and roll. Produced on a low budget, the press sheet included the studio's business card."

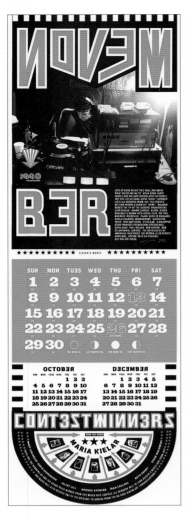

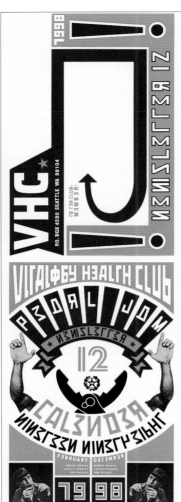

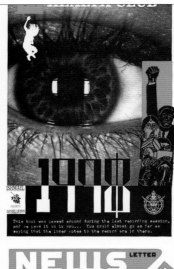

Ephemera fan club newsletter (Pearl Jam issue 12)

Art directors Barry Ament, Coby Schultz, George Estrada
Designers Barry Ament, Coby Schultz, George Estrada
Illustrators Barry Ament, Coby Schultz, George Estrada
Studio Ames
Client Pearl Jam
Typeface custom-created in Adobe Illustrator
Software Adobe Illustrator
Colors 2/C flat
Print run 25,000

Concept "We've been doing the Pearl Jam newsletter for seven years, and we do a calendar every year—usually on a budget, thus the two-color job on this one. Hats off to all things Russian."

Logo identity Insect

Art director Marcus Durant
Designer Marcus Durant
Illustrator Marcus Durant
Studio X-Ray Design
Client Insect Records
Typeface Compacta Bold (altered)
Software traditional mechanical

Concept "I designed this logo in 1991, influenced by both the Sub Pop (an independent label) logo and the Alternative Tentacle Records 'virus' concept. The image is that of a boll weevil emerging from a wheat seed. The relationship between the two is a symbiotic one, not unlike the relationship between a band and its audience. There is also word play—the mod term, 'in,' and a segment of the population, 'sect.'"

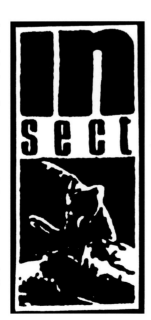

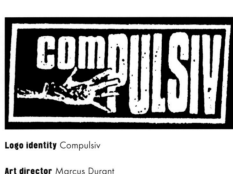

Logo identity Compulsiv

Art director Marcus Durant
Designer Marcus Durant
Illustrator Marcus Durant
Studio X-Ray Design
Client Compulsiv Records
Typeface Compacta Bold (altered)
Software traditional mechanical

Concept "Sometimes you reach before you think."

Logo identity X-Ray

Art director Marcus Durant
Designer Marcus Durant
Studio X-Ray Design
Client X-Ray Design
Typefaces Compacta Bold (altered)
Software traditional mechanical

Concept "This is the lens from a pair of 'X-Ray Specs.' I was a *Grit* kid and fell in love with gag gifts [*Grit*, a publication that advertised in comic books in the 1960s and 1970s, offered novelty prizes as incentives for youngsters to sell subscriptions]. It was also my introduction into graphic design. I threw in a couple from the 'hallucination generation' for good measure—comical deception with some psychedelic symbolism."

MARSILIO
PUBLISHERS

Logo identity Boom Boom

Art directors Dana Collins, Mark Brooks
Designer Dana Collins
Studio Dana Collins Art for Industry
Client Boom Boom Records
Typefaces handcut paper
Software Adobe Photoshop, QuarkXPress

Concept "Boom Boom records is a small, start-up company who specializes in making 12" vinyl LP records to be used by dance club DJs. Boom Boom prides itself on heavy bass dance mixes. The letterforms were cut out of black paper. I put the letters down on stereo speaker and created a horrific bass 'brrphhhtttttphrrrrtthh' sound from the speaker. I continued this process until the letterforms vibrated themselves into the placement you see here."

Logo identity Black+Blue

Art director Martin Ogolter
Designer Martin Ogolter
Studio Martin Ogolter/y design
Client Black+Blue Entertainment
Typeface Akzidenz Grotesk
Software Adobe Illustrator

Concept "Black+Blue is a film production company. The negative space of the two *b*s in a 'frame' as the logo mark seemed a more interesting solution than another man with a movie camera."

Logo identity Marsilio

Art director Martin Ogolter
Designer Martin Ogolter
Studio Martin Ogolter/y design
Client Marsilio Publishers
Typefaces Metsys, Mantinia
Software Adobe Illustrator

Concept "This logo for a small publisher of mostly translations had to convey the spirit of publishing high-quality writings, old and new, and somewhat controversial. The sans serif *m* combined with the old Italian *p* seemed appropriate enough for all involved."

Logo identity Up Records

Art director Hank Trotter
Designer Hank Trotter
Studio Twodot Design
Client Up Records
Typefaces Franklin Gothic
Software Macromedia FreeHand
Colors 3/C flat

Concept "This was inspired by the Century 21 logo created for the 1962 World's Fair, for which the Space Needle [a Seattle architectural landmark] was built. The arrow is an obvious representation of the word 'up.' The compact, solid nature of this design reproduces well small on CDs."

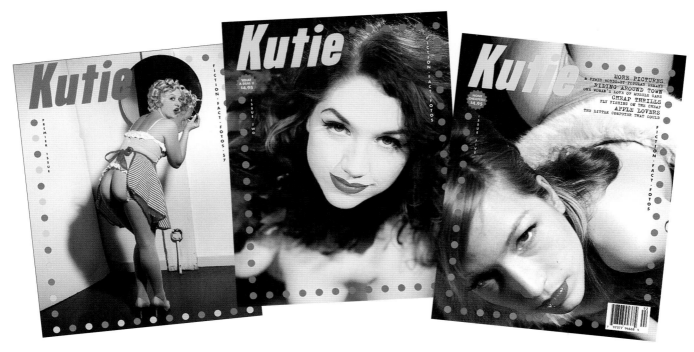

Publication *Kutie* magazine

Art director Hank Trotter
Designer Hank Trotter
Photographers Charles Peterson: premiere issue, issue two; Margarita Salaverria: issue five
Studio Twodot Design
Client *Kutie* magazine, Twodot Design
Typefaces Event Gothic, Futura, Trixie
Software QuarkXPress
Colors 4/C process
Print run 3,500

Concept "*Kutie* is a men's magazine based on the model of the late 1950s/early 1960s men's magazines. I find these magazines much more interesting than today's men's magazines. The models of the time look like real women, not surgically enhanced stereotypes. I was sharing office space with Art Chantry when I started *Kutie*. He and his client Dave Crider, of Estrus Records, were using a lot of pinup imagery then. They were very encouraging when I said I wanted to start a magazine that used the older mags as a model. *Kutie* is a labor of love that may just pay for itself. But it does provide a pure creative outlet that endures no compromise before its release. The dotted border that frames the cover evokes the effect of stage or reader board lights. The guts of the mag have a standard head and subhead treatment. It's really a rather restrained thing—certainly not designer-run-amok like many other solo pieces."

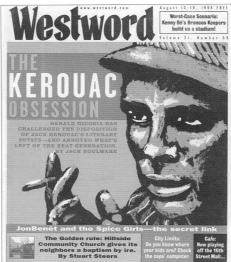

Publication cover Westword Music Awards
Showcase '98 supplement

Art director Dana Collins
Designer Dana Collins
Illustrator Dana Collins
Studio Westword newspaper
Client Westword newspaper
Typefaces Clarendon Bold, Futura Bold
Software QuarkXPress, Adobe Photoshop
Colors 4/C process
Print run 100,000 on a big ol' newspaper
web press

Concept "I thought the number of categories
available to the nominated bands was a bit
ad nauseum. So I visually poked fun at the
number of categories through the use of repe-
tition. I chose to use a blatant 'American
advertising art style' for the illustration,
because I was poking fun at what popular
music has become: a great way to sell tooth-
paste, soda, automobiles, etc., to the young
MTV'd consumer. I drew the little man's head
with a charcoal pencil. I scanned the illustra-
tion into Adobe Photoshop and did the layout
in Quark."

Publication cover Westword newspaper: "Kerouac"

Art director Dana Collins
Designer Dana Collins
Illustrator Dana Collins
Studio Westword newspaper
Client Westword newspaper
Typefaces Garage Gothic, Clarendon Bold
Software QuarkXPress, Adobe Photoshop
Colors 4/C process
Print run 100,000 on a big ol' newspaper web press

Concept "This cover story was actually a 'save.' The
intended feature was scooped by another local newspa-
per the day before we were to go to press. I had three
hours to complete the cover and its related feature story,
which had been printed at one of the sister newspapers in
a different city during the previous week. I didn't want to
ape what the sister paper did—that would be too easy.
And I am so sick of beatnik language being misinterpret-
ed (especially in modern day graphic design) as happy-
go-lucky, flower-child stuff. So I took the risk of missing the
deadline and jumped on the opportunity of trying to cap-
ture it appropriately. I drew Jack Kerouac with a charcoal
pencil, and scanned the illustration into Adobe Photoshop
and did the layout in Quark. This project actually turned
out to be more fun than stressful."

Publication cover Westword newspaper: "Hell"

Art director Dana Collins
Designer Dana Collins
Photographer Anthony Camera
Studio Westword newspaper
Client Westword newspaper
Typefaces headline "Hell" is a hand-rendered,
custom face
Software QuarkXPress, Adobe Photoshop
Colors 4/C process
Print run 100,000 on a big ol' newspaper web press

Concept "The cover story was about when illegal aliens
from certain countries are deported from the USA for crim-
inal activity, their home countries do not always take them
back. When this happens, the deportees wait in an INS
detention center (in this case, Denver) for an undeter-
mined time. The facility discussed in this story was a partic-
ularly scary place. I hand-did the type for 'Hell' because I
couldn't find a face condensed enough to execute my
idea. To help bring home the message, I 'uglied' the type
by use of a photocopier."

Publication cover Slant, "The Punk Issue"

Art directors Jesse Marinoff Reyes, Howard Brown
Designer Jesse Marinoff Reyes
Illustrator Gary Panter
Studio Jesse Marinoff Reyes Design
Client Urban Outfitters
Typefaces hand-rendered (Gary Panter), Dynalabel/punch-label
Software traditional mechanical
Colors 2/C flat
Print run 100,000

Concept "Slant was a poster-sized (17" X 22¾") newsprint tabloid published by Urban
Outfitters as an in-house magazine to be distributed in their stores. It was intended to be a kind
of pop culture 'zine that would appeal to their (mostly) young clientele. This particular theme
issue commemorated punk rock, and to this end, I recruited a number of artists and designers
who had been active during the punk rock era to design pages or illustrate feature stories—
including Winston Smith, Carl Smool, Stephen Kroninger and Art Chantry. For the cover, I
acquired the talents of Gary Panter, an Emmy-award winning artist for CBS Television's Pee
Wee's Playhouse, who had been famous for his work in punk rock back in the late 1970s and
early 1980s. Everybody, Gary especially, was terribly amused at the prospect of 'turning back
the clock' on their careers. Gary provided the pen-and-ink drawing of the giant punks destroy-
ing a city, and I immediately determined to use a two-color solution, and—much in the spirit of
the low-budget, bad printing that typified punk media back in the day—to purposefully run the
two colors off-register, forcing them to vibrate and 'annoy.' Much more authentic that way."

Catalog cover Penguin May–August 2000

Art director Paul Buckley
Designer Mark Melnick
Studio The Viking Penguin Design Group
Client Penguin
Typefaces Eagle Bold, insignia, Bodega Sans
Software QuarkXPress, Adobe Photoshop, Adobe Illustrator
Colors 4/C process
Print run 16,000

Concept "This piece is a catalog—not sold to consumers, but given away to booksellers. Therefore, I was given much more license to do something unusual, as no one was worried that an unattractive or concept-laden cover would fail to sell. What becomes paramount is how the catalog enhances 'The Brand' (i.e., Penguin), so I was amazed that none of the people who normally inflict their aesthetic terrorism chose to do so, even though I've compared one of the most respected and recognized brands in the world to the lowest order of seafood (okay, a close second to carp) around."

Publication *Plazm* magazine

Art directors Joshua Berger, Niko Courtelis,
Pete McCracken
Designers Rick Valicenti, Patricking/Thirst (*Plazm* #14); Ed Fella (*Plazm* #17); Pete McCracken (*Plazm* #21)
Illustrators Rick Valicenti, Patricking/Thirst (*Plazm* #14); Ed Fella (*Plazm* #17)
Photographer Mark Ebsen (*Plazm* #21)
Studio Plazm Design
Client *Plazm* magazine
Typefaces Thirsttype (*Plazm* #14); hand-rendered (*Plazm* #17); wood type (*Plazm* #21)
Software QuarkXPress, Adobe Illustrator, Adobe Photoshop; traditional mechanical (*Plazm* #17)
Colors 4/C process
Print run 10,000

Concept "Plazm Media Collective comprises three interlinked divisions, with a fourth in development. They are: *Plazm* magazine, Plazm Fonts, Plazm Design and Plazm.com.

"*Plazm* magazine was founded in 1991 to provide a forum for free expression, a location for discourse in our artistic community, and a printed laboratory for critical theory and grass roots artistic endeavor. Since its inception, *Plazm* has seen design as a tool to heighten the impact of submitted works. As the magazine has evolved, and the designer's role has become pronounced, *Plazm* continues to encourage co-equal collaboration between designers and artists.

"[As] *Plazm* magazine attracted critical attention and artistic participation, its experiments in design quickly led to typographic innovations as well. A group of font designers allied themselves with the magazine, and, in 1993, Plazm launched a digital type foundry—Plazm Fonts.

"Plazm Design applies its collaborative and experimental process to commercial projects for clients such as Adidas, Intel, Lucasfilms, MTV, PICA (Portland Institute for Contemporary Art), Nike and Champion Paper."

Plazm 14:
"Rick [Valicenti] came up with this idea that he wanted to

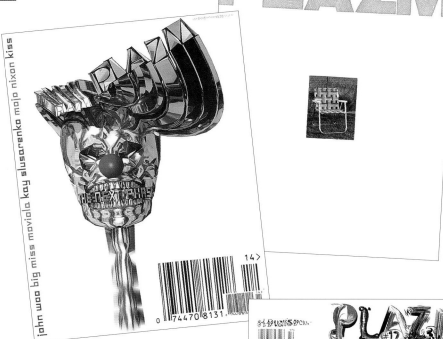

explore: the next phase of Michael Jackson's evolution. We were in the process of revisions—he had presented first a cover that was maybe only a few years down the road for Michael, mostly a retouched treatment of Michael's face. The second round included a chrome outgrowth that said 'plazm' and protruded from Michael's head. I had a couple of minor comments and adjustments, [and] the next morning Rick sent me a file with what turned out to be the final cover. His explanation: 'We peeled back his skin and reflected it back onto itself.'"

Plazm 17:
"Ed [Fella] would only do the project if he a) didn't need to use a computer, and b) if he didn't think it was 'work.' So we did our best to assure him that there was no pay and he could only have fun. He sent us an original drawing to which we only added a UPC code."

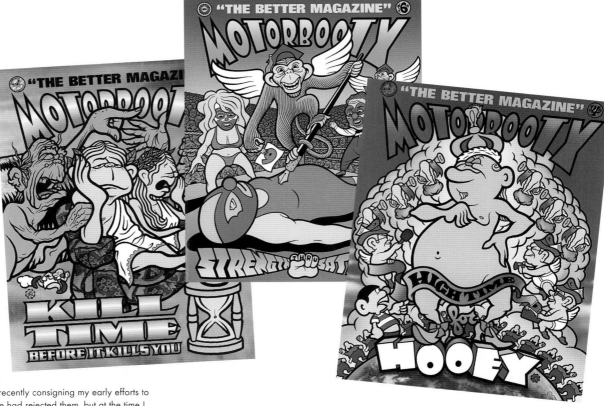

Publication *Motorbooty*

Art director Mark Dancey
Designer Mark Dancey
Illustrator Mark Dancey
Studio Clownskull Graphics
Client *Motorbooty*
Typefaces masthead is hand-rendered; tag line is Focus font; interior is Times and Gill Sans with many hand-rendered titles
Software images created by hand, processed in Adobe Photoshop and assembled in QuarkXPress
Colors 4/C process
Print run 18,000

Concept "We like to tell people that *Motorbooty* exists to mock the people, places and piercings that so badly need mocking, but its origins were far less altruistic: It was begun so that at least one magazine in the world would print cartoons by Mark Dancey. While recently consigning my early efforts to the flames, I realized why everyone had rejected them, but at the time I was determined that they see print. A vehicle was needed, so we mixed some Zap Comics-inspired cartoons, threw in the usual smart-assed, fanzine garbage, appropriated the title from an old Parliament album, and there it was—live and ugly. Luckily, I was able to recruit some really hilarious writers from among my sarcastic record-collecting friends, and we printed comics by the likes of Terry LaBan, Lloyd Dangle, Mary Fleener, Peter Bagge and Chris Ware, so things improved. *Motorbooty* became less an underground vanity project than an unpaid and largely thankless public service dedicated to ridiculing the cheats, charlatans and clowns among us. At least that's what we like to tell people.

"The idea with the masthead was to use the M from the 1950s *Mad* magazine—that nice fat M with tall, spikey points. When I discovered the paperback reprints of the comic book *Mads*, I studied them intently and tried to copy the title font they were using. When we started our magazine that was about the only font I could really do, so I used it."

Comic cover *Pie*

Art director Steven Cerio
Designer Steven Cerio
Illustrator Steven Cerio
Studio Steven Cerio's Happy Homeland
Client Wow Cool Books
Typefaces hand-rendered
Software traditional mechanical
Colors 4/C offset
Print run 400

Concept This is the cover to Cerio's first solo comic book and he notes that the composition was influenced by EC comic covers from the 1950s. "The cryptic nature of the imagery was formulated to entice 1960s underground-comic aficionados and children. Content was well suited for both."

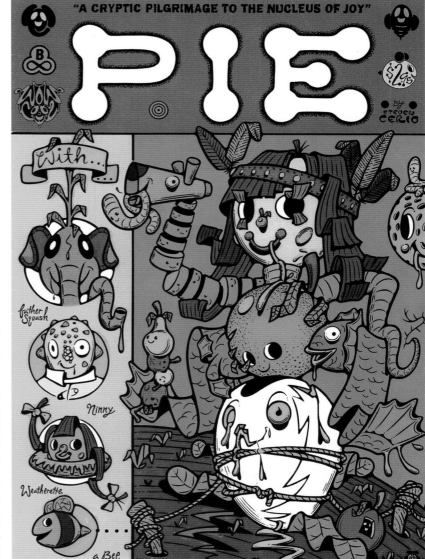

Index

Copyright/Permissions

All images have been reproduced with the knowledge and consent of the artists concerned.

Ames: pieces on pages 58, 59, 62, 66, 72, 79, 82, 86, 104, 105, 121, 124, 129, 130, 133, 144, 146, 156 © Ames Bros. Inc.

Backbone Design: pieces on pages 58, 59, 81, 94, 101, 136, 137 © Backbone Design, Inc.

Gail Belenson: pieces on pages 19, 26, 39 © Gail Belenson.

Mark Brooks: pieces on pages 114, 116, 117 © 1995 Mark Brooks.

Paul Buckley: pieces on pages 13, 24, 29, 37, 43–45 © Paul Buckley.

Steven Cerio: pieces on pages 16, 56, 62, 71, 83, 89, 99, 134, 135, 156 © Steven Cerio Illustration.

Peter Ciccone: page 106: *Greats Vol. 1, Rare Surf Vol. 2* and *Squad Car* © AVI Entertainment Group Inc.; page 106: *Untamed Melodies* © Norton Records; page 106: *Shadows Are Go!* © Astralwerks Records; page 107: *Roots Reggae, Static Age* and *Futuremusik* © Astralwerks Records.

Dana Collins: pieces on pages 83, 90, 153, 154 © 2000 Dana Collins. All rights reserved.

Rodrigo Corral: pieces on pages 14, 16, 31, 38, 41, 52 © Rodrigo Corral and Farrar Straus Giroux.

Mark Dancey: pieces on page 156 © 1994, 1995, 1999 *Motorbooty* magazine.

Marcus Durant: pieces on pages 74, 75, 90, 152 © Marcus Durant.

Archie Ferguson: pieces on pages 13, 20, 27, 35, 40, 47–49 © Archie Ferguson.

John Fulbrook III: pieces on pages 12, 17, 21, 30 © John Fulbrook III.

John Gall: pieces on pages 23, 26, 28, 29, 30, 34, 38, 42, 43, 52, 53 © John Gall.

Ronnie Garver: page 63: Dia de los Muertos © 1998 Ronnie Garver; page 65: Hi-Fives/Pigs on Wheels © 1999 Ronnie Garver/William Chad Ballard; page 76: posters © 1999 Ronnie Garver; page 151: University Honors Program © 1998/1999 New Mexico State University.

Heidi Kearsley: pieces on pages 135, 140, 141, 149 © Heidi Kearsley.

Jamie Keenan: pieces on pages 12, 18, 27, 28, 42, 46, 49 © Jamie Keenan.

Lindsey Kuhn: pieces on pages 65, 69, 70, 75, 77, 84, 87, 88 © Lindsey Kuhn.

Chin-Yee Lai: pieces on pages 17, 25, 34, 51 © Chin-Yee Lai.

Ingsu Liu: pieces on pages 40, 41, 47 © Ingsu Liu.

Todd Lovering: piece on page 70 © 2000 Todd Lovering.

Mark Melnick: piece on page 155 © Mark Melnick.

Benjamin Niles: pieces on page 110, 113, 114 © Atlantic Records, a Time–Warner Corporation.

Edward ODowd: pieces on page 18, 36, 50, 68, 97, 108, 109, 111, 112 © Edward ODowd.

Martin Ogolter/y design: pieces on pages 15, 20, 25, 33, 112, 145, 150, 153 © Martin Ogolter/y design.

Sunja Park Design: pieces on pages 102, 117, 121, 124, 125 © A&M Records.

Plazm Design: pieces on pages 94, 95, 113, 142–143 © Plazm Media, Inc.

Jesse Marinoff Reyes: pieces on pages 22, 23, 31, 32, 36, 51, 154 © Jesse Marinoff Reyes.

Thomas Scott/Eye Noise, Inc.: pieces on pages 66, 67, 103, 134, 145, 149, 151 © Eye Noise, Inc.

Jamie Sheehan: pieces on pages 68, 73, 84, 85, 130, 131, 136, 140 © Jamie Sheehan.

Mike Styskal: pieces on page 131 © Ride Snowboards; pieces on page 148 © Burning Bush Studio.

Ashleigh Talbot: pieces on pages 39, 57, 63, 82, 139 © 2000 Ashleigh Talbot.

Hank Trotter: pieces on pages 56, 57, 60, 69, 72–74, 87–89, 96, 98, 100, 107, 111, 118, 119, 128–129, 131, 138, 148, 153 © Hank Trotter.

Shawn Wolfe Design: pieces on pages 61, 64, 67, 80, 81, 109, 114, 115, 120, 122, 123, 132, 135, 139 © 1999 Shawn Wolfe Design.